THE BRAVEST LITTLE STREET IN ENGLAND

KAREN CLIFF,
TRAFFORD LOCAL STUDIES &
THE FIRST WORLD WAR VOLUNTEERS

First published 2018

Amberley Publishing
The Hill, Stroud
Gloucestershire, GL5 4EP

www.amberley-books.com

Copyright © Trafford Council, 2018

The right of Tafford Council to be identified as the
Author of this work has been asserted in accordance
with the Copyrights, Designs and Patents Act 1988.

ISBN 978 1 4456 7901 3 (print)
ISBN 978 1 4456 7902 0 (ebook)

British Library Cataloguing in Publication Data.
A catalogue record for this book is available from
the British Library.

Origination by Amberley Publishing.
Printed in the UK.

CONTENTS

FOREWORD

It gives me great pleasure to commend Trafford Local Studies' latest project *The Bravest Little Street in England*. I cannot think of a more worthwhile local history project for them to undertake than this, which tells the story of Trafford's most famous street in Altrincham, of its inhabitants and the incredible number of its men who enlisted within weeks of the outbreak of war in August 1914, many never to return.

It is a subject close to my heart and one that I have been studying myself for a number of years, though my main interest has been in those men who did not return, so I am honoured that, in my own very small way, I have been able to contribute to this project. Although the street gained its fame during and just after the First World War, it has contributed to the social history of Altrincham for over 150 years from 1800 through to the 1950s, and its rich social history is also included in this book. I am looking forward to learning more about the history of the street, its residents, and a mix of its families, its boarding house guests and their personal, sometimes colourful, stories.

From my own personal experience, I am well aware of the amount of effort that goes into a project such as this and it is a credit to the efforts of the library staff and their army of volunteers who, over the past four years, have been researching this from the library's own and other external resources.

George Cogswell
Sale, Cheshire

www.traffordwardead.co.uk
www.greatermanchesterblitzvictims.co.uk

INTRODUCTION

In 2013 the Greater Manchester Partnership of Archives and Local Studies initiated a project to work together to commemorate the centenary of the First World War (1914–18) in the Greater Manchester area. As part of this project Trafford Local Studies recruited a team of volunteers to research the period and find out how the war had affected the lives of the people in the Trafford area of Greater Manchester, both in the field of conflict and at home. Using original council archives, personal family records, local newspapers, online resources and photographs, it quickly became apparent that there was a great deal of primary source material available, especially for Chapel Street in Altrincham, which had become known through time as the 'Bravest Little Street in England' for the number of men who had taken part in the war. A roll of honour had been erected in Chapel Street to recognise their bravery and George V had sent a telegram of commemoration. Reports of the event were published in newspapers as far afield as Australia and New Zealand, which emphasised the contribution such a small street had made to the war effort.

In order to capture and preserve this unique information for future generations it was decided that a book would be published that would tell the whole story of Chapel Street and the people who lived there, from its early days in the 1790s through to when the last buildings were demolished in the 1950s.

We have chosen the title 'The Bravest Little Street in England' for this book. This phrase has been associated with Chapel Street over time, including prior to the First World War. The book chronicles the history of Chapel Street and illustrates the stories of the 158 men who are listed on the 'Chapel Street Roll of Honour'. We hope that the stories of these men, which are often very poignant, pay tribute to the contribution they made and will provide an insight into their lives, which have up until now, 2018, remained hidden for 100 years.

This is the story of Chapel Street, the bravest little street in England…

CHAPTER 1

ORIGINS OF CHAPEL STREET

The first building to be erected on the site of Chapel Street was the Methodist Chapel in 1788 after which Chapel Street is thought to have been named. An article published in the local newspaper on 15 May 1914 stated, 'Chapel Street obtained its name from the fact that the Wesleyan Chapel stood at its lower end.' The earliest identified detailed map of the Altrincham township, prepared by William Crossley in 1790, clearly shows the Methodist chapel. At the time William Crossley's survey was taken, the chapel was surrounded by open fields and subsequently formed a significant corner feature at the entrance to the street. It appears from William Crossley's plan that the land on which Chapel Street was developed was owned at the time by a Mr Royl (sic) and Mr Henard. Mr Ashley and Mr Faulkener were named as adjoining landowners of the ground on which New Street and Albert Street were later developed.

It is probable that the first houses on Chapel Street were erected from around the early 1800s. From statements made to a prominent Local Government Board Inquiry, held between 7 May and 29 May 1914, it appears that in its formative years Chapel Street provided a quite agreeable residential setting, with a number of established small cottage industries including bobbin turning, silk weaving, blacking manufacture and a bakery. The census for 1841 confirms that the street had been well established by the 1840s. The report further stated at the inquiry that the early residents of Chapel Street 'watched on a summer evening the worshippers at Bowdon Church entering the venerable lane'.

Reporting on this inquiry, there is an intriguing reference in the *Altrincham, Bowdon and Hale Guardian* of 15 May 1914 to the account of a weaver 'who used to say that he could sit at his loom and gaze across the golden cornfields that lay between his house and Bowdon church'.

The quasi-rural idyll these descriptions portrayed unfortunately did not last long. Chapel Street was being developed in a piecemeal fashion by a number of the more affluent residents of Altrincham township wishing to generate rental income arising from the steadily expanding population.

The resulting houses, built sporadically in small randomly adjoining or adjacent terraces, offered little more than basic shelter from the elements. Built of solid brick external walls with slated roofs and a mixture of timber and paved floors, home comforts were little more than a fireplace for cooking and warmth.

The houses had no permanent lighting and, much more significantly, no mains water or drainage. As a consequence conditions for the occupants of the houses were extremely harsh. Water was only available from a limited number of ground sources via standpipes or wells. These became increasingly polluted through the seepage of uncontrolled and indiscriminate surface deposits from every form of waste material imaginable from both domestic and commercial sources. By the 1830s Chapel Street had changed from a reported pleasant rural prospect to a most unhealthy environment in which to live.

The street was not fully developed at this time. The tithe map of 1837 indicates that around 75 per cent of the houses on the street had been constructed. The schedule accompanying the map indicates that there were around forty cottages and houses, which can be seen roughly indicated on the layout plan of the street.

Little seems to have been done to address the environmental conditions the residents of the street had to endure over the ensuing years, and the situation remained unaddressed through to 1849 when Isaac Turton, Overseer to the Poor, identified New Street and Chapel Street as some of the worst housing in the area with a lack of paving, sewers or drainage.

There followed a comprehensive report prepared by Robert Rawlinson in 1851 for the Central Board of Health. Charles Balshaw gave evidence to the Rawlinson Inquiry to the effect 'I have recently built ten houses in Chapel Street but in the consequence of the want of drains, I have been unable to let them'. It would appear that Charles Balshaw's properties were some of the last to be completed, as the street plan of 1852 shows Chapel Street fully developed apart from three small plots of land.

Rawlinson's report states 'Chapel Street is 203 lineal yards long with 81 (*sic*) houses and is not paved or drained. Many of these houses are let as common lodging houses and the cellars of several are used as distinct dwellings'.

The street remained unpaved until after 1853 when on 9 December of that year the Local Board of Health accepted a tender for it to be levelled and paved. Once implemented, the paving would have made a significant improvement to the appearance of the street and the comfort of the residents. Over time, further improvements were introduced, giving a degree of stability for many of the residents, although several properties were still operating as lodging houses.

The Ordnance Survey map dated 1878 shows that Chapel Street was fully developed apart from one small plot, thought to be a coal yard. While there were dramatic changes to the lives of the residents through the period of the First World War, maps produced over the subsequent sixty years show no significant changes to the street layout.

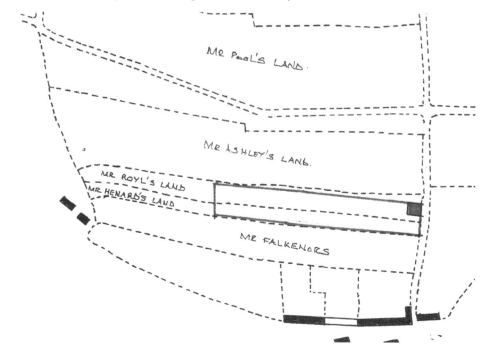

Part of the plan of the township of Altrincham compiled by William Crossley, 1790. The chapel is highlighted, next to the lane originally known as Chapel Walk and now named Regent Road. The area outlined behind the chapel indicates the area of land on which Chapel Street was subsequently built. The lane between Mr Ashley's and Mr Pool's land is now Normans Place, the extension of which remains a footpath known as The Narrows. (Image courtesy of John Rylands Library, University of Manchester)

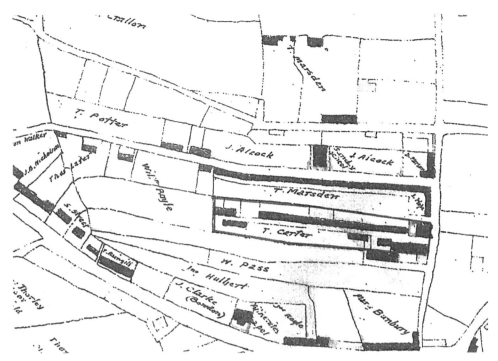

Tithe map of Chapel Street, 1837. The largest portion of undeveloped land on Chapel Street at this time is shown to be owned by T. Carter. (Image courtesy of Trafford Council)

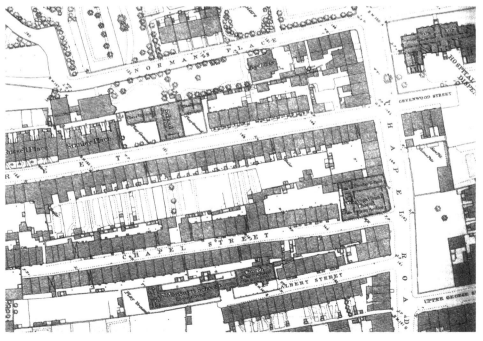

Chapel Street as it appeared on the Large Scale Ordnance Survey map, 1878. (Image courtesy of Ordnance Survey)

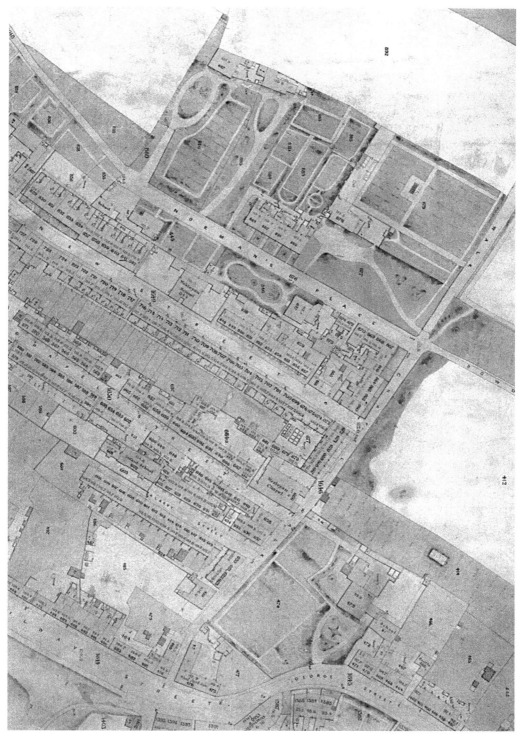

Local Board of Health map of Chapel Street, 1852. (Image courtesy of Trafford Council)

Irish Connections

A great many of the residents of Chapel Street had Irish ancestry, which can in part be attributed to the large proportion of migration that began around the mid-1800s as a result of the potato famine in Ireland (1845–52). This brought many Irish people to England in search of employment and a better life. So great was this influx of people that the area of Manchester around Ancoats became known as 'Little Ireland'.

Many came from an agricultural background and were drawn to the outlying rural areas of Cheshire, such as Altrincham, Dunham Massey and Sale, which were then largely agricultural areas. Here they found opportunities to work on the land and, although the work was often seasonal, there were many employment opportunities available on the farms. Evidence for this migration can be found on the early censuses for Chapel Street, which indicate the area was occupied by a large number of Irish people who were employed as agricultural labourers.

By the late 1800s agricultural work was declining with a transition from agricultural to industrial labour. The construction of the Manchester Ship Canal (opened in 1895) and the newly created industries of Trafford Park, and later Broadheath Industrial Estate, provided further opportunities for employment. The 1901 census for the area around Altrincham and Dunham records Irish residents working as bricklayers, engine drivers, foremen and timekeepers. There was also a tradition of Chapel Street men serving in the military, which had been well documented in the local newspapers. These opportunities for employment often provided more stable periods of regular work but the working conditions that came with them were often harsh, and living conditions, especially in Chapel Street, were even worse, as illustrated in the local newspapers and surviving photographs of Chapel Street. Despite this, many Irish men brought their families with them and settled in the area. After the First World War the local newspaper reported on 11 April 1919 that 'Chapel Street did not wait for conscription, and her sons, most of them Irishmen be it remembered, left their homes and gave their lives with the high-souled chivalry of true Crusaders'.

Military History of Chapel Street

The history of Chapel Street and its long association with military service can be traced back to John Leyland, who lived in Chapel Street in 1851 and had served in the 1st Royal Dragoons at the Battle of Waterloo in 1815. There are references to men serving in the Army in the mid-to late 1800s, including the two Boer Wars through to the First World War. This evidence pre-dates the commonly held belief that the bravery of the Chapel Street men was attributed only to the First World War and had been well documented in the local newspapers in the early 1900s. Some of the men also served in the Second World War (1939–45). A letter in the local newspaper dated 26 June 1901, in relation to the Borough Band, asked the question,

> How it is that none of the Chapel Street Boys have been played away or welcomed home? I am sure they deserve it for I doubt if any street in England has sent as many men to the war. Not only that but some of the best are serving the Empire in China, India and Egypt and I am sure that the town should welcome them as it has done others. Later, on 18 January, the newspaper reported Chapel Street, Altrincham, is undoubtedly a fine recruiting ground, and it would be interesting to know the number of men from that street who have served in the different departments of the British Army. There have been too many to defy all attempt at calculation, but if the estimated number is anywhere near the mark Chapel Street has supplied sufficient men to form a good sized regiment. Chapel Street residents claim the honour of having sent more men to war than any other in the Kingdom.

HIS MAJESTY'S

First or Royal REG.^T OF *Dragoons*

Whereof *General Thomas Garth* is Colonel.

These are to Certify,

I.
Age and Enlistment.
THAT *Private John Leyland* born in the Parish of *Altringham* in or near the Town of *Altringham* in the County of *Cheshire* was enlisted for the aforesaid Regiment at *York* in the County of *York* on the 25 Day of *September 1805* at the Age of *Twenty five* for *Unlimited Service*.

II.
Service.
THAT he hath served in the Army for the space of *Twenty One* Years and *Sixty* Days, after the Age of Eighteen, according to the subjoined

STATEMENT OF SERVICE.

IN WHAT CORPS.	PERIOD OF SERVICE.		Serjeant Major.		Qr. Mast. Serjeant.		Serjeant.		Corporal.		Trumpeter or Drummer.		Private.		Service under an Act Agreed Engaged &c.		Total Service.	
	From	To	Yrs.	Days	Yrs.	Days	Yrs.	Days	Yrs.	Days	Yrs.	Days	Yrs.	Days	Yrs.	Days	Yrs.	Days
1.st Dragoons	1805 25 Septem.	1824 23. November													19	60	19	60
Service for Waterloo															2		2	
Total of Service....															21	60	21	60
East & W. Indies.																		

III.
Authority and Cause of Discharge.
THAT by Authority of *H. R. H. the Comr. in Chief* dated *11.th October 1824.* HE IS HEREBY DISCHARGED in consequence of *Reduction &c.*

IV.
Not disqualified for Pension.
THAT he is not to my knowledge, incapacitated by the Sentence of a General Court Martial, from receiving Pension.

V.
Character, &c. &c. &c.
THAT his general Conduct as a Soldier has been *Good & efficient*

VI.
Settlement of all Demands.
THAT he has received all just Demands of Pay, Clothing, &c., from his Entry into the Service to the date of this Discharge, as appears by his Receipt underneath.

VII.
Acknowledgment of the Receipt of all Demands.
I *Private John Leyland* do hereby acknowledge that I have received all my Clothing, Pay, Arrears of Pay, and all just Demands whatsoever, from the time of my Entry into the Service to the time of this Discharge.

Certified by _____ Capt. Commanding the Troop or Company. Signature of the Soldier. *Jno. Leyland*

VIII.
Description &c. &c. &c.
TO prevent any improper use being made of this Discharge, by its falling into other Hands, the following is a Description of the said *Private John Leyland*
He is about *Forty Four* Years of Age, is *Five* Feet *Nine* Inches in height, *Brown* Hair, *Grey* Eyes *Dark* Complexion, and by Trade or Occupation a *Cotton Spinner*

Given under my Hand, and the Seal of the Regiment, at *Pershill B.* this *15* Day of *October 1824.*

Signature of the Commanding Officer _____

Horse Guards, 23.^d Nov. 1824, confirmed _____

Statement of service for Private John Leyland, 1824.

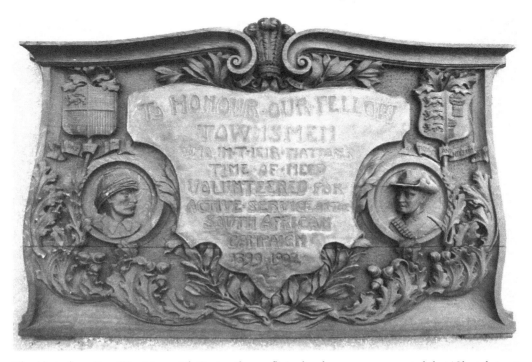

The Altrincham Boer War Memorial. During the conflict a local newspaper reported that 'Chapel-street residents claim the honour of having sent more men to the war than any other street in the kingdom' and went on to say that 'Truly the "Chapel-street boys" are patriotic in the best sense of the word, and they have every reason to feel proud of their record of service for King and country.' (Image courtesy of Trafford Council)

Despite this earlier acknowledged history of the bravery of the men from Chapel Street, there was no memorial or reference point to acknowledge this exclusively until the Chapel Street Roll of Honour in 1919.

Following the Boer War a decision was made by Altrincham Council to place a memorial in Altrincham Town Hall in memory of the volunteers from Altrincham who had served in the South Africa campaign. It was designed by Mr Joseph Phillips of St George's Studio, Altrincham, and was described in the local newspaper on 29 October 1904: 'the tablet is of oak and in the centre is a panel of beaten copper'. It was unveiled on Saturday 3 December 1904 'and was originally intended to bear the names of all the volunteers on the memorial, but when it was found impossible to get them the idea was abandoned'.

CHAPTER 2

FIRST WORLD WAR

When the First World War broke out on 4 August 1914 men from all over the country rushed to enlist, including the men of Chapel Street, who enthusiastically rallied to the cause. The local newspaper published an article entitled 'Street of Soldiers' on 8 September 1914, which stated:

A few men were already serving with the colours. Others who were in the reserves at once re-joined their regiments, and the martial spirit which the Chapel Street boys always displayed broke into a high wave of enthusiasm when the appeal for additional men was addressed to the nation. No fewer than eighty one men, whose homes are in Chapel Street, are now with the Army. As there are not more than sixty one houses in the street, this gives an average of more than one soldier from each home. The names of the men who have left are as follow; Naughton, four brothers; Tyrell, four brothers; Hennerley, four brothers; Hanley, four brothers; Booth, three brothers; Bagnall, three brothers; Connor, two brothers; Burns two brothers; Gormley, two brothers; De Courcey, two brothers; Taylor, two brothers; Ratchford, two brothers; Arnold, two brothers; Croft, Morley, Leonard, Broon, Hennerley, Green, Taylor, Smith, Davies, Brennan (wounded), Collins, Corfield, Ryan, Murphy, Hughes, Thompson, Scahill, Haley, Hines, Souter, Barber, Riley, French, Naughton, O'Shea, Clynes, Stacks, Williams (two), O'Hara (two), Robson (two), Smith, Coombes, Kelly, Burns (two) and Priest.

The Chapel Street Roll of Honour

The earliest reference we can find for the proposal of a memorial exclusively for Chapel Street is in the archives for Altrincham Council and was recorded in the minutes of the Highways and Lighting Committee on 17 March 1919, which stated, 'It was reported that the residents of Chapel Street desired to put up a roll of honour on the wall of All Saints' Church in Regent Road to the memory of those inhabitants in Chapel Street who have fallen in the war.' The minutes went on to say that the 'consent of the vicar of St Margaret's Church had been asked for, but not received, and the inhabitants wanted to know whether placing the memorial on posts on the footpath could be considered as an alternative position'. The surveyor said 'that he had seen the site and the memorial would not pose an obstruction. It was resolved that the vicar's permission be sought, but if this was refused, permission be granted for the memorial to be fixed to the footpath'.

An article in the local newspaper dated 4 April 1919 recorded that the position of the memorial was a subject of negotiation between its promoters, the vicar of St Margaret's and Altrincham Urban District Council. A request was made for it to be placed on the wall of the church but the wardens of the church property, acting for the vicar, Mr Hewlett Johnson, who was unfortunately ill at the time, refused permission. The promoters of the memorial stated that in the event of permission being refused, they would like it placed on the footpath near the wall. The site was inspected by the council surveyor and this arrangement was agreed to by the Highways Committee and sanctioned by Altrincham Council.

The structure of the Chapel Street memorial was of a type that was known at the time as a street shrine, which had become popular during the First World War as a means of honouring the fallen. Such shrines were often located in working-class areas and in most cases were

associated with a local church. Construction was usually from wood and paper and they were often decorated with flowers and tokens to remember those who had lost their lives, as surviving photographs of the Chapel Street memorial illustrate. At the time this type of memorial served the need to remember loved ones, but they were often frowned upon, and following a campaign from a national newspaper, and with support from the Lord Mayor of London and Queen Mary for more permanent memorials, they were gradually replaced by the more standardised official stone structures we still see today.

The memorial consisted of three paper panels inscribed with the names of the men set inside a wooden frame. The commemoration took place on Saturday 5 April 1919 and was unveiled by the Earl of Stamford and attended by hundreds of local people. George V sent a telegram of support, which was read out at the unveiling.

On 8 April 1919, the local newspaper reported the unveiling of the Chapel Street Roll of Honour:

> Chapel-Street Honoured, Memorial Unveiled by the Earl of Stamford.
> Some thousands of people made their way on Saturday afternoon to Chapel-street to witness the unveiling of a memorial which has been erected in the street itself in honour of the great part it played in winning the war.

The article went on to describe the scene:

> Before his Lordship [the Earl of Stamford] unveiled the memorial there was a procession, made up of the men belonging to Chapel-street, and at least a hundred others who fought in the war. They gathered in the New Market-place, and were paraded by Sergeant-Major Norton, of the Grenadier Guards, himself one of the seven brothers whose home is in Chapel Street. Four of the brothers, one a Gordon Highlander, were on parade with ribbons that told of their service. The sergeant-major, who has been in uniform for 18 years, wore the decorations of the D.C.M., the Mons Medal, the Italian Bronze Medal, and two South African Medals. He was mentioned in dispatches, and has a certificate for gallantry in the field. Private Hennelly displayed the Mons Star of 1914 and Private Riley the Military Medal. There were others with South African and Mons ribbons, and there was one, whose name we think was Corfield, who on the completion of his service after eighteen months in the trenches re-enlisted and went back into the firing line and only received his discharge after the armistice. There were few indeed without a decoration of some kind or other, and Altrincham looked at the parade with a genuine feeling of pride. The procession was led by the Altrincham Borough Band over a route that must have measured a couple of miles, and on every side its course was watched with interest and delight. The gallant boys of Chapel-street, 70 strong as we have said, followed the band with a sprightly tread, and behind them, bearing them honourable company, were a hundred demobilised men and a landau with three or four disabled. On reaching the Town Hall there was a short halt to allow the public representatives, who were to take part in the unveiling ceremony to join the procession. When the procession got to Chapel-street it was with difficulty that a way could be forced for it through the dense and cheering crowd. It was managed somehow, mainly through the good offices of the police and the assistance of the sons of Chapel-street, whose sense of order was adequate to the occasion.

A film of the whole event was made at the time, which captured the excitement of the crowd. The local newspaper reported on 11 April 1919:

> The unveiling ceremony lent itself admirably to the kinema operator, and on Tuesday it was unfolded at the Altrincham Picture Theatre in a series of interesting pictures, in which the

chief features are admirably reproduced. For many days to come the historic celebration is certain to command attention. Many other pictures were also taken, and we are glad to know that through the kindness of Mr. J. Butler, through whose efforts so much of the success was due, every house in Chapel-street is to receive a photograph of the Roll of Honour and a printed copy of the King's message.

A copy of the Chapel Street film is held by Trafford Local Studies.

The telegram from George V was read by the Earl of Stamford to the people who attended the commemoration and reads:

> OHMS Buckingham Palace 3.13pm
> G. J. Turner Esq.
> Chairman Urban District Council
> Town Hall
> Altrincham

Your telegram of today was duly submitted to the King and I am commanded to convey the thanks of His Majesty to the inhabitants of Altrincham for their loyal assurances to which the message gives expression and the King congratulated them and especially those living in Chapel Street that out of its sixty houses 161 men served in the war, 30 of whom made the supreme sacrifice and His Majesty is proud to think that a Roll of Honour has been subscribed for and will be unveiled today as a record of the patriotism and fighting spirit so prominently displayed by the people of Altrincham.

Following the commemoration on 25 April 1919 a poem composed by T. Kingston Clarke entitled 'Chapel Street' appeared in the local newspaper.

'Chapel Street'

In our old chartered town,
Our shortened street of 60 tenements,
To fight the fiendish Hun,
Sent eight score hefty men,
And three times ten will ne'er return again.

Here was no camouflage
Of cowardice – unconscionable cant!
At duty's call they went,
Shirking no sacrifice
For freedom's cause well purchased at the price.

And so when Chapel-street,
Brave Chapel-street was decked in flut'ring flags,
Like Nelson's 'Victory'
Gay festooned side to side,
Thence we foregathered in a chastened pride.

With band and Baronets,
Our Civic Magistrate,
His Lady and the Mayor

With retinue; and trusty Councillors,
The Royal message read,
Our Earl paid homage to the 'deathless dead.'

In words most apt and wise,
Plainly sincere; nor lacking elegance,
As he disclosed the roll,
Me thought, when Time unveils the curtained years,
Stamford high place should hold among his peers.

T. Kingston Clarke
No. 23 Market Street, Altrincham

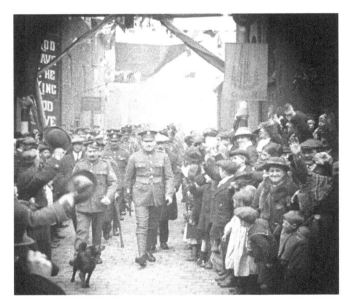

The procession of soldiers before the unveiling ceremony for the Chapel Street Roll of Honour, 5 April 1919. (Image courtesy of the North West Film Archive at Manchester Metropolitan University)

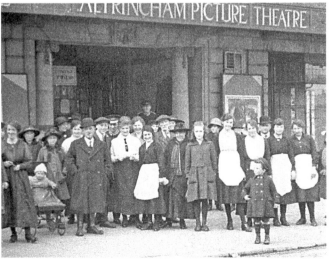

A crowd of onlookers outside the Altrincham Picture Theatre watching the procession that preceded the unveiling of the Chapel Street Roll of Honour, 5 April 1919. (Image courtesy of the North West Film Archive at Manchester Metropolitan University)

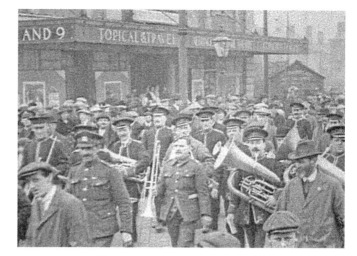

The Altrincham Borough Band
paraded through the town
to herald the unveiling of the
Roll of Honour, 5 April 1919.
(Image courtesy of the North
West Film Archive at Manchester
Metropolitan University)

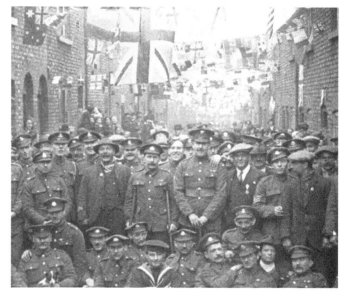

Soldiers at the unveiling of the
Chapel Street Roll of Honour,
5 April 1919. (Image courtesy
of the North West Film Archive
at Manchester Metropolitan
University)

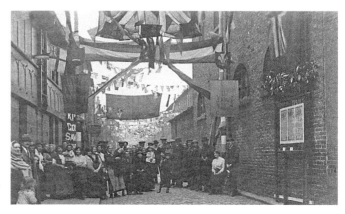

Celebrations on Chapel Street on
5 April 1919. The Chapel Street
Roll of Honour is visible on the
right of the image. (Image courtesy
of Trafford Council)

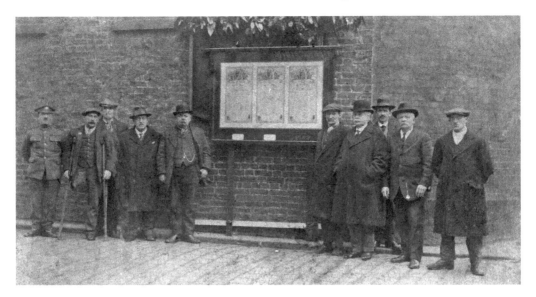

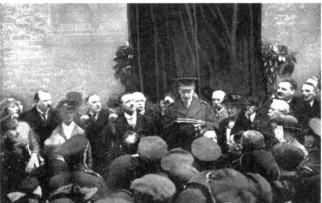

Above: The Chapel Street Roll of Honour in situ on Chapel Street, 1919. (Image courtesy of Trafford Council)

Left: Lord Stamford reads the king's telegram to the crowd at the unveiling ceremony, 5 April 1919. (Image courtesy of the late Alfred Ingham)

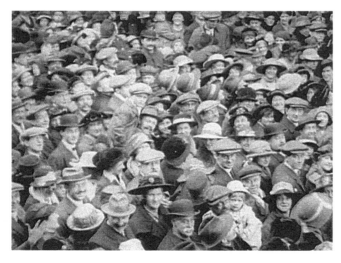

The crowd at the unveiling ceremony for the Chapel Street Roll of Honour, 5 April 1919. (Image courtesy of the North West Film Archive at Manchester Metropolitan University)

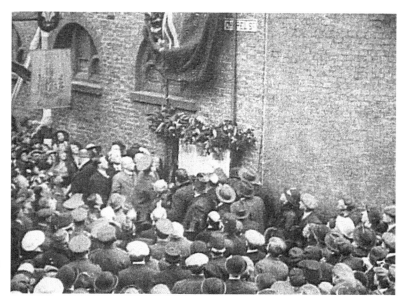

The unveiling of the Chapel Street Roll of Honour, 5 April 1919. (Image courtesy of the North West Film Archive at Manchester Metropolitan University)

SATURDAY, APRIL 5, 1919.

Extract from Lord Stamford's diary, 5 April 1919. (The extract, taken from the Stamford Papers held at the John Rylands Library, University of Manchester, was accessed with kind permission of Dunham Massey, National Trust)

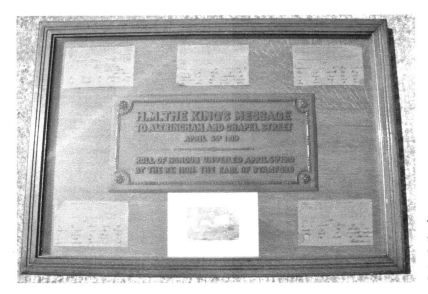

The original
telegram from
George V, 1919.
(Image courtesy of
George Cogswell)

Attestation, Enlistment and Mobilisation

The authors have used the word 'enlist' as a general term to describe the process of starting a period of service in the armed forces. 'Enlistment' was the voluntary process of joining the forces. However, once conscription was introduced, the voluntary aspect was removed and procedures changed.

Technically the correct term would be 'attest' as attestation was the first stage in enlisting. It was a formal process at which the potential recruit attended, promised to serve the monarch and answered questions about himself, including whether he had previously served in the armed forces. He signed a form in front of a witness to indicate that his answers were true. He would have a brief medical examination at which he was weighed and measured, after which a magistrate or senior officer would sign the form to confirm that the recruitment process had been fairly and properly conducted. The soldier's period of service, pay and pension were calculated from the date of attestation.

Once a soldier had attested he would be under obligation to serve and failure to do so would be considered as desertion. Soldiers, especially older or married men, may have been placed in the reserve for a period after attestation but it was more normal during the war for attestation and joining a battalion to take place within a very short period, sometimes on the same day. Soldiers were mobilised from the reserve and many of the Chapel Street men who had served before the war came into the Army through this route.

The Group Scheme, introduced by Lord Derby, obliged all those men between fifteen and sixty-five to join a national register to identify how many were involved in each trade or occupation. It failed in its purpose of stimulating volunteer recruitment. Conscription was introduced under the Military Service Act 1916 and, once the Army started to use it, conscripts did not go through the process of attestation. Instead forms were still completed but men were deemed to have enlisted under the terms of the Act.

Demobilisation and Discharge

Although there were variations between the many battalions in how soldiers left the services, in general regular soldiers were discharged to Class 'Z' Reserve and expected to rejoin if circumstances demanded. Once a soldier was demobilised he was sent home on a month's leave and not allowed to wear the uniform after that time. The term 'disembodiment' was

used for those who had volunteered in the early part of the war or were volunteers who entered the Army from the Territorials. Once a soldier was discharged, the Army had no further calls on his service. Conscripts were discharged in the months following the end of the war, though some did volunteer to participate in clean-up operations in the theatres of war. Soldiers who, for a variety of reasons, were no longer fit for active service, or who were identified in training as 'not likely to become an efficient soldier', or who had completed their term of service were discharged.

Medals

The majority of the soldiers on the Chapel Street Roll of Honour would have been awarded medals for their wartime service.

Second Anglo-Boer War Medals

Military service records show that at least twenty-one of the Chapel Street soldiers recorded on the memorial had served in the Second Anglo-Boer campaigns. The Queen's South Africa Medal was awarded to those who served in South Africa during the Second Boer War from 11 October 1899 to 31 May 1902. Clasps were awarded to recipients to indicate particular actions and campaigns such as the Relief of Mafeking. The King's South Africa Medal was awarded only to those servicemen who fought in 1902, and who had served for eighteen months. Two date clasps were granted: South Africa 1901 to all who served in South Africa between 1 January 1901 and 31 December 1901; and South Africa 1902 to all who served in South Africa between 1 January 1902 and 31 May 1902.

First World War Medals

All those who served in the campaigns of the war were awarded campaign medals. These were awarded in the early 1920s and all who served in a theatre of war, or served overseas during the period of the war, received the British War Medal and most received the Victory Medal.

In addition, those who served in the first campaigns in France or Belgium between 4 August and 22 November 1914 were awarded the 1914 Star, sometimes referred to as the 'Mons Star'. These were, in the main, regular soldiers or soldiers in the Army Reserve who had served in the Army before the war broke out. The 1914–15 Star was awarded to any who fought against the German enemy, in any theatre of war, between 4 August 1914 and 31 December 1915, who did not qualify for the 1914 Star.

A Silver War Badge, first issued in September 1916, was awarded to those who retired or were honourably discharged through illness or injury sustained in the war. This badge was not issued automatically and soldiers had to make a claim to receive it. This claim had to be approved based on the evidence in the soldier's service record. The badge was intended to be worn on the right breast on civilian clothing to show that men had taken part in the war. The aim was to remove accusations of cowardice from those who were no longer fit to fight. It avoided confrontation from members of the public for men who did not have obvious physical wounds, as it became apparent as the war progressed that many men were discharged suffering from some mental affliction caused by the trauma of taking part in the fighting.

Gallantry Medals

The Distinguished Conduct Medal (D.C.M.) was awarded to other ranks including non-commissioned officers and warrant officers. It was normally, but not in all cases, accompanied by a citation published in the *London Gazette*. Vincent Maguire, listed as McGuire on the memorial, and Joseph Norton from Chapel Street were awarded this medal. Joseph was also awarded the Italian Bronze Medal for Military Valour and received a Mentioned in Despatches three times.

The Military Medal was introduced in March 1916 and awarded retrospectively from August 1914. It was awarded to the same group of soldiers as the DCM, but ranked below that award. Hugh Arnold and James Riley were awarded this medal.

Allied governments such as the French, Belgians and Italians granted medals to soldiers serving in the British forces, the most common of which were the French awards of Croix de Guerre and Medaille Militaire. It was reported in the local paper in July 1916 that John Brennan had been awarded the French Military Cross, presumably the Croix de Guerre, for saving the life of a French general. However, it has not been possible to verify this from any other source.

Identification of the Soldiers Named on the Chapel Street Memorial

It has not been possible to identify all the soldiers listed on the Chapel Street Memorial or prove that some of those that have been identified had lived in Chapel Street. In some cases clear evidence has been established that a man recorded on the Chapel Street Memorial lived in Chapel Street but it has not been possible to identify any aspect of his military service or confirm the information on the memorial. There are several reasons for this.

The sources available for identification at the time of writing are limited in the information they can provide. These include reports in local newspapers, chiefly the *Altrincham, Bowdon and Hale Guardian*; the censuses; street directories; records of military service; the electoral registers; absent voter lists; and the parish records, principally those for the Catholic Church of St Vincent de Paul in Altrincham. None of these are comprehensive records nor were they designed to be so. For example, the newspapers during the wartime period mainly reported the award of gallantry medals, deaths or woundings or perhaps published the occasional letter written from the front, telling of the part of local soldiers in successful engagements with the enemy.

Approximately 60 per cent of the military records of those who served in the First World War were destroyed or damaged by bombing in the Second World War, with the result that there is no complete series of records and a considerable number of those records that survive are fragmentary. The service records of those who continued to serve in the forces beyond 1920 have not been released at the time of writing. The most complete set of military records are the Medal Roll Index cards and the medal rolls but these contain very limited information and do not exist for soldiers who did not serve abroad.

While many of the men came from families who had been established residents in Chapel Street for several decades, a number of lodging houses in the street provided temporary homes to many itinerant workers. The majority of those on the memorial worked as labourers and probably moved regularly to follow work, and their period of habitation did not happen to coincide with the decennial censuses nor did they appear in the annually compiled street directories. Before 1918 the vote was restricted to males who owned property and many of those who lived in Chapel Street did not qualify and, when the law changed to give them the vote, not all were registered so they do not appear on the electoral registers from the immediate post-war period.

Many of the men were of Irish extract and had commonly occurring surnames and forenames, which were drawn from a limited range of names. Some men had been born or raised in Ireland prior to living in Chapel Street and often no indication is given in the censuses as to the precise location in Ireland so it has not proved possible to trace their Irish records.

Sometimes the spelling of surnames on the memorial does not match that in other sources of evidence and there are many variant spellings of surnames in the records. The family listed as Scarle on the memorial appears as Scahill, Scarr, Schahill, Schill, Skehall, Scoils, Scail, Skann and Seahill in the records. These factors make the identification of the correct man difficult.

In addition there were, in some cases, more than one man in the Altrincham district with exactly the same name as those listed, and of the right age to have served in the war, but no evidence has been located to differentiate between them.

It is clear from military records that survive that the correct regiment has not always been recorded on the memorial. The list of those on the Chapel Street Memorial was drawn up after the war by a committee of residents. According to Alfred Ingham's description of the unveiling of the memorial in *Cheshire: Its Traditions and History*, published in 1920:

> The Members' Committee, who were also present, comprised Messrs J. Butler and C. Nickson (marshals), T. Furness, J. Ratchford, J. W. Davies, D. Hennerley, J. Norton, J. Rowan, P. de Courcy and T. Corfield.

Most of these names were of men who had fought in the war. They had been away from Chapel Street for a period of the war and did not necessarily know or remember the precise details of the regiment in which each man served. As can be seen in the entries on individual soldiers, it was common for soldiers to join one regiment but to serve in one or more others during the course of the war. The committee members may only have known the regiment in which individuals originally enlisted and were unaware of the details of any transfers between regiments that had taken place since 1914.

A few of those who were listed on the memorial seem, from the available evidence, to have quite a tenuous link with Chapel Street. However, it may be that their connection with the street was much stronger than the currently available evidence suggests.

In the course of research the team have located the names of thirty-two soldiers who are known to have lived at some point in Chapel Street, and who are known to have served in the war, whose names do not appear on the Chapel Street Roll of Honour. The names of twenty-one men have been identified from Army service records, absent voter lists or the census. An additional eleven surnames that are not recorded on the Roll of Honour were included in a list of soldiers who joined up, published in the local newspaper in early September 1914. Four of the men are known to have been killed in the conflict. The names of these soldiers are included later in the book after the names of those who are named on the memorial.

It is not clear why such individuals were omitted but George Cogswell, who has developed and maintained the Trafford War Dead website for a number of years, has pointed out that some families may have preferred not to have their son included if he had died as they did not wish to be reminded of the loss of loved ones on a daily basis, each time they passed the memorial. Other families refused to give up on lost ones and maintained a belief that they were still alive. Some families in Chapel Street were fairly mobile and had lived at a number of addresses elsewhere in Altrincham or in another town. They may have moved away from the area, with the result that individuals were not remembered in the collation of names.

CHAPTER 3

THE CHAPEL STREET ROLL
OF HONOUR

There is a discrepancy in the number of men who served in the First World War in different sources. One hundred and sixty-one names are referred to in the King's Telegram; however, the newspaper reports vary between 158 and 161 names.

The Chapel Street Roll of Honour has 158 names including the twenty-nine who died. Two of the men who died are listed with slightly different spellings: Martin Donnelly/Dunothey and Arthur Garner/Garne.

John Andrews
Family Origins: Not known
War Record: First World War 1914–1918
Military Service: Cheshire Regiment
Lived at No. 48 Chapel Street

John was listed in Slater's Street Directory from 1913 to 1915 living at No. 48 Chapel Street with his occupation described as a musician. He was also listed on the electoral register for 1914, which indicates that he would have been aged over twenty-one and owned property. Despite there being many references to the name John Andrews in military records for the Cheshire Regiment we cannot be certain which, if any, would be relevant as there is no other supporting evidence to confirm his identity.

He is listed on the Chapel Street Roll of Honour as John Andrews, Cheshire Regiment.

Hugh Arnold (1882–1959)
Family Origins: Father, Ireland; Mother, Liverpool/Ireland
War Record: First World War 1914–1918
Military Service: Lance-Corporal, 4th Field Company, Canadian Engineers, Service No. 11
Lived at No. 25 Chapel Street

Hugh was born on 6 June 1882 in Altrincham and baptised on 18 June at the Church of St Vincent de Paul. His parents were Hugh and Mary, née Dalton. In 1891 Hugh, aged eight, was living at No. 25 Chapel Street with his parents, sisters Annie, aged twenty-one, Kate, aged thirteen, Nellie, aged eleven, and brothers Henry, aged eighteen, James, aged six, William, aged five, Joseph, aged three, and Owen, aged two. There was also another brother Thomas, born in 1866, who was not in residence. The family were still at the same address in 1901. Hugh was educated at St Vincent's School, Altrincham, and worked as an apprentice bricklayer.

In 1902 he married Catherine Price from Leith, Scotland, and they had two children, Mary, born 1906, and Hugh, born 1909. In 1911 Catherine and the children were living at No. 3 Paradise Place, Altrincham. Hugh was not present as he had already sailed from Liverpool to Halifax, Nova Scotia, on 1 April of that year. In November his wife and children followed him to Canada where the family settled in Hamilton, Ontario.

Hugh enlisted at Ottawa in February 1915 and joined the Canadian Engineers, serving with the 4th Field Company for the duration of the war. He sailed for England on 18 April 1915. Unfortunately, soon after his arrival, he developed renal colic and had to spend time in hospital. In September 1915 he was sent to France and was wounded by shrapnel at Courcelette on the Somme the following year.

He was awarded the Military Medal on 17 January 1917 for conspicuous gallantry and devotion to duty for his part in a trench raid north-east of Calonne, France. 'This Sapper went forward with the assaulting party troops and personally blew in a number of enemy dugouts, emplacements, and a large bomb store. In one case he cut the chains of a machine gun holding explosives and assisted in bringing it back.'

Hugh was appointed lance-corporal in August 1917, but unfortunately, soon after, he began to suffer from poor health. Following two bouts of sickness he returned to England where he spent time in hospital in both Salford and Wigan as a result of a bullet wound in his right hand. While in hospital, he developed acute appendicitis and had an appendectomy. In June 1918 he was invalided to Canada and continued to suffer from general debility. He was discharged from the Army at Toronto on 12 September 1918 for reasons of physical unfitness.

Hugh later went on to work as a building inspector and continued in this capacity until the late 1940s. He died on 3 February 1959 in Canada and is buried with his wife at Woodland Cemetery, Hamilton, Ontario.

Hugh's brothers Thomas, James, Joseph and Owen are named on the Chapel Street Memorial. He is listed on the Chapel Street Roll of Honour as Hugh Arnold, Canadian Engineers.

James Arnold (1884–1927)

Family Origins: Father, Ireland; Mother, Liverpool/Ireland
War Record: Anglo-Boer War 1899–1902; First World War 1914–1918
Military Service: Private, 3rd Battalion, Cheshire Regiment Militia, Service No. 5527
Private, 2nd Cheshire Regiment, Service No. 6463
Corporal, 1st and 3rd Battalions, Cheshire Regiment
Sergeant, 1st Garrison Battalion, Cheshire Regiment, Service No. 6463
Lived at No. 25 Chapel Street

James was born on 19 September 1884 in Altrincham and baptised on 5 October that year at the Church of St Vincent de Paul. His parents were Hugh and Mary, née Dalton. In 1891 James, aged six, was living at No. 25 Chapel Street with his parents, sisters Annie, aged twenty-one, Kate, aged thirteen, Nellie, aged eleven, and brothers Henry, aged eighteen, Hugh, aged eight, William, aged five, Joseph, aged three, and Owen, aged two. There was also another brother, Thomas, born in 1866, who was not in residence.

James enlisted in December 1899 and served with the 3rd Cheshire Regiment Militia. He gave his occupation as a plasterer. In January 1901 he joined the 2nd Battalion, Cheshire Regiment, and for his service in South Africa he was awarded the Queen's and King's South Africa Medals with a clasp (Transvaal).

In 1904 James married Maria Yarwood and by 1911, aged twenty-six, was living at No. 46 Islington Street, Altrincham, with Maria and their three children – Helen, aged five, Emma, aged three, and James, aged two. He was employed as a lamplighter but continued to serve in the Army Reserve. He was recalled to the Cheshire Regiment in August 1914 and sent to France on 20 September until mid-January 1915. In April 1916 he was posted to the 1st Garrison Battalion of his regiment, in Gibraltar, and promoted to sergeant in March 1917. Maria died in 1918 and a letter from the War Office dated 2 September 1918 referred to James as being sent on home leave for three months, to make final arrangements for the

care of his three children. Between October and December that same year, he married Sarah Dykeman. He was discharged in December and returned to live at Islington Street. James died on 22 March 1927, aged forty-three.

His brothers Thomas, Hugh, Joseph and Owen are named on the Chapel Street Memorial. He is listed on the Chapel Street Roll of Honour as James Arnold, Cheshire Regiment.

Joseph Arnold (1887–1950)
Family Origins: Father, Ireland; Mother, Liverpool/Ireland
War Record: First World War 1914–18
Military Service: Private, 3rd Battalion, Cheshire Regiment Militia, Service No. 7305
Lance-Corporal, 9th Battalion, Cheshire Regiment, Service No. 12409
Lived at Nos 25 and 30 Chapel Street

Joseph was born on 27 April 1887 in Altrincham and baptised on 5 June at the Church of St Vincent de Paul. His parents were Hugh and Mary, née Dalton. In 1891 Joseph, aged three, was living at No. 25 Chapel Street with his parents, sisters Annie, aged twenty one, Kate, aged thirteen, Nellie, aged eleven, and brothers Henry, aged eighteen, Hugh, aged eight, James, aged six, William, aged five, and Owen, aged two. There was also another brother, Thomas, born in 1866, who was not in residence. The family were still at the same address in 1901.

Joseph joined the 3rd Battalion, Cheshire Regiment, in 1903 and served for sixteen months before buying himself out of service for a pound. He married Annie Burns on 4 July 1908. In 1911 he was employed as a die setter at Linotype and Machinery Company in Broadheath and lived with his wife and son, John Henry, aged nine months, at No. 30 Chapel Street, the home of his father-in-law Martin Burns.

Joseph was one of the first to join up on 30 August 1914 and served as a private with 8th Battalion, Cheshire Regiment. He fought in France from 19 July until 31 October 1915 and was appointed lance-corporal with 9th Battalion, Cheshire Regiment. In February 1916 he was discharged from the Army suffering from chronic bronchitis as a result of gas poisoning and was awarded the Silver War Badge. By 1920 he was living at No. 19 Heyes Street, Altrincham and later returned to live at No. 30 Chapel Street where he was listed on the 1939 register. He may have been suffering from ill health as he was described as 'incapacitated'. He died aged sixty-three in December 1950.

His brothers Thomas, Hugh, James and Owen are named on the Chapel Street Memorial. He is listed on the Chapel Street Roll of Honour as Joseph Arnold, Cheshire Regiment.

Owen Arnold (1889–1948)
Family Origins: Father, Ireland; Mother, Liverpool/Ireland
War Record: First World War 1914–18
Military Service: Sapper, Acting Sergeant, Royal Engineers, Service No. 269955
Lived at No. 25 Chapel Street

Owen was born on 19 March 1889 in Altrincham and baptised on 5 May at the Church of St Vincent de Paul. His parents were Hugh and Mary, née Dalton. In 1891 Owen, aged two, was living at No. 25 Chapel Street with his parents, sisters Annie, aged twenty one, Kate, aged thirteen, Nellie, aged eleven, and brothers Henry, aged eighteen, Hugh, aged eight, James, aged six, William, aged five, and Joseph, aged three. There was also another brother, Thomas, born in 1866, who was not in residence. The family were at the same address in 1901.

Owen married Margaret Gregory on 1 August 1908 and in 1911 was living with his wife and daughter, Nellie, aged one, at No. 15 Heyes Street, Altrincham. He worked as a labourer

before enlisting in the Army where he served as a sapper, later being promoted to acting sergeant in the Royal Engineers.

The electoral register of 1918–25 indicated that Owen was living at No. 3 Hope Square, Altrincham but some time after he must have relocated, as the 1939 register listed him as living at Flat 5 Burlington House in Blackpool, working as a hewer, fitter and capstan hand. He died in Blackpool on Christmas Eve 1948. Probate was granted to James Owen Arnold.

His brothers Thomas, Hugh, James and Joseph are named on the Chapel Street Memorial. He is listed on the Chapel Street Roll of Honour as Owen Arnold, Royal Engineers.

Thomas Arnold (1866–1949)

Family Origins: Father, Ireland; Mother, Liverpool/Ireland
War Record: Anglo-Boer War 1899–1902
Military Service: Private, 3rd Battalion, Cheshire Regiment Militia; Private No 947 Royal Lancaster Regiment; Colour Sergeant 1380, 2nd and 3rd Battalions, Royal Irish Rifles
Lived at No. 13 Chapel Street

Thomas was born on 1 Jul 1866 and his birth was registered under the name of Thomas Dalton in Altrincham in the first quarter of 1867. There is an entry in December 1866 for Dalton with the name Thomas Arnold added in the baptism register at the Church of St Vincent de Paul. His parents were Hugh and Mary, née Dalton. Who did not marry until 1870. In 1871 Thomas aged four was living at No. 13 Chapel Street, aged four, with his parents Hugh and Mary Arnold, grandmother Annie Dalton and sister Annie, aged two.

Thomas was employed as a labourer and enlisted in the Royal Lancaster Regiment on 4 January 1885. In June 1885 he was transferred to the Royal Irish Rifles in Halifax, Nova Scotia, Canada. He served in Halifax, Nova Scotia, Alexandria, Cairo, Malta, Bombay, Calcutta, and Ladysmith & Natal, South Africa. He was promoted to colour sergeant but was discharged in October 1902 as being medically unfit. He gave a Gloucester address on his pension form. In 1911 he lived in Workhouse Lane, Minchinhampton, Gloucestershire, with his wife Lucy and children Nora, aged seven, Kate, aged six, and Eileen, aged two months. He worked as a carter for a coal merchant.

The family emigrated to New Zealand in March 1912, sailing on the *Ruahine*. In 1914 he was listed on the electoral roll for Gisborne and worked as a brewery hand. There is no evidence for him serving in the First World War. He continued to live in Gisborne until he died on 17 October 1949 and was buried in Taruheru Cemetery.

His brothers Hugh, James, Joseph and Owen are named on the Chapel Street Memorial. He is listed on the Chapel Street Roll of Honour as Thomas Arnold, Canadian Regiment.

James Bagnall

Family Origins: Not known
War Record: First World War 1914–18
Military Service: Cheshire Regiment
Associated with Chapel Street

James is listed on the Chapel Street Memorial as serving with the Cheshire Regiment but at the time of writing (2018) we have been unable to locate any information that connects him to Chapel Street and cannot establish whether he was a relative of the other Bagnall family that were listed living at No. 28 Chapel Street. There is a reference to a Private James Bagnall serving with the Cheshire Regiment, Service No. 40444 and Labour Corps, Service No. 677096 in military records, but we cannot be sure this is him.

He is listed on the Chapel Street Roll of Honour as James Bagnall, Cheshire Regiment.

John Bagnall (b. 1893)
Family Origins: Father, Altrincham; Mother, Dunham Massey
War Record: First World War 1914–18
Military Service: Canadian Army
Lived at No. 28 Chapel Street

John was born in 1893 in Altrincham and baptised on 5 February at the Church of St Margaret, Dunham Massey. In 1901 John, aged eight, was living at No. 28 Chapel Street with his parents William and Mary, née Garner, and siblings William, aged fourteen, and Samuel, aged twelve.

In November of that year his mother died aged forty-nine, possibly as a result of childbirth and was buried at the Church of St Mary, Bowdon, on 12 November. A baby named Dorothy Bagnall was also buried two weeks later on 30 November. John's father, who worked as a jobbing labourer and gardener, was left to care for the family alone.

John is listed on the Chapel Street Memorial as serving with the Canadian Army and it is possible that he emigrated or was sent to Canada sometime after the death of his mother in 1901. Being the youngest member of the family, he would not have been able to work or bring in any money, so it would have been practical to send him away.

He cannot be traced on the 1911 census so it is possible that he went as a young boy prior to this date. It would have been very difficult for his father to care for three young sons as his employment was not of a permanent nature. However, there is more than one reference for the name John Bagnall arriving in Canada between the years 1907 and 1914, which makes him difficult to identify.

John's older brother William is also listed on the Chapel Street Memorial.

He is listed on the Chapel Street Roll of Honour as John Bagnall, Canadian Army.

William Bagnall (1886–1915)
Family Origins: Father, Altrincham; Mother, Dunham Massey
War Record: First World War 1914–18
Military Service: Cheshire Militia Private, 2nd Battalion, Cheshire Regiment, Service No. 8382
Lived at No. 28 Chapel Street

William was born on 9 September 1886 in Altrincham and baptised on 3 March 1887 at the Church of St Mark, Dunham Massey. In 1901 William, aged fourteen, was living at No. 28 Chapel Street with his parents William and Mary, née Garner, and siblings Samuel, aged twelve, and John, aged eight.

In November of that year his mother died aged forty-nine, possibly as a result of childbirth, and was buried at the Church of St Mary, Bowdon, on 12 November. A baby named Dorothy Bagnall was also buried two weeks later on 30 November. William's father, who worked as a jobbing labourer and gardener, was left to care for the family alone.

In 1907, aged twenty and after working as a labourer for a period of years, William, having served in the Cheshire Militia, signed up for the Cheshire Regiment for seven years. He was sent to India and was stationed at Madras, Wellington and later Jubbulpore. His service records for this period indicate he had a poor disciplinary record, mainly for being dirty and for often being late for parade. He was also given detention for refusing to obey an order.

William's health was affected by the conditions and, during his service in India, he suffered from four periods of sickness. This did not detract from his record of service and he was described as of 'Good Character' and awarded a Good Conduct Badge.

William was one of the three Bagnall brothers John, Samuel and William mentioned in local newspaper 'Street of Soldiers' on 8 September 1914. He completed his period of service with the Cheshire Regiment on 30 January 1914 but later rejoined for a further two years and was

sent to France on 16 January 1915. Unfortunately, he was injured during the first week of February 1915 and died of wounds at Ypres on 5 February. In his record of soldier's effects, his account of £12 10s and 5d was returned to his father. He was buried at the Ypres Town Cemetery (Extension) in Belgium.

William's brother John is also listed on the Chapel Street Memorial; however, his other brother Samuel Bagnall is not listed.

He is listed on the Chapel Street Roll of Honour as William Bagnall, Cheshire Regiment.

James Barrett

Family Origins: Not known
War Record: First World War 1914–18
Military Service: Army Service Corps
Associated with Chapel Street

There were three men named James Barrett, or variants of that surname, born in the Altrincham registration district in the period from which soldiers were recruited, but it has not proved possible to identify which, if any, had any connections with Chapel Street.

James was listed on the Chapel Street Memorial as having served in the Army Service Corps. There are many soldiers with the name James Barrett or similar in that regiment, but none can be linked to the Altrincham area. The nearest possibility is a Private James Smith Barrett, who served with the Army Service Corps, Mechanised Transport, Service No. M2/078385, who was born in Halifax and lived in Broughton, Salford, in 1901.

He is listed on the Chapel Street Roll of Honour as James Barrett, Army Service Corps.

John Behen (b. 1876)

Family Origins: Father, Ireland; Mother, Ireland
War Record: First World War 1914–18
Military Service: Private, 1st Battalion, King's Own Lancaster Regiment, Service No. 3507
Lived at No. 2 Chapel Street

John was born on 24 June 1876 in Newbridge, County Kildare, Ireland, and baptised on 2 July at Newbridge. His parents were John Behen and Maria, née Gainor. In 1901 John, aged twenty-four, was living at No. 118 Tibb Street, Manchester, at the home of his brother-in-law George Mason, together with his sisters Elizabeth Mason, aged twenty-nine, and Mary Behan, aged twenty-six.

In July 1902, John married Rose Hannah de Courcy at the Church of St Vincent de Paul, their address being recorded as No. 2 Chapel Street. In 1911 John was living at No. 15 Police Street, Altrincham, with his wife and two children – Ivy, aged six, and John, aged three – along with his sister Mary and four lodgers. John was employed as a joiner's labourer. He continued to be recorded on the electoral register for Police Street up until 1915.

He enlisted in August 1914, serving in France from December. The local newspaper of 25 June 1915 reported, 'Private J. Behan of the King's Own Royal Lancaster Regiment is an inmate of the Knotty Ash Infirmary, Liverpool. He was in the trenches when the Germans began to discharge their asphyxiating gasses.' It also reported that 'he is improving nicely', but unfortunately John was discharged from the Army on 31 August 1915 with a Silver War Badge as a result of his continuing ill health.

The 1939 register indicated that John, identified by his birth date of 24 June 1876, was living separately from his wife, with John residing in Southport and Rose in Manchester.

He is listed on the Chapel Street Roll of Honour as John Behen, King's Own Lancaster Regiment.

James Bellholden (1865–1937)

Family Origins: Father, Wakefield, Yorkshire; Mother, Burslem, Staffordshire
War Record: Anglo-Boer War 1899–1902; First World War 1914–18
Military Service: Private, 2nd Battalion, King's Royal Lancaster Regiment, Service No. 771
Private, 5th Battalion, Cheshire Regiment, Service No. 3211
Private, 324 and 315 Protection Companies, Royal Defence Corps, Service No. 18969
Lived at Nos 2, 15 and 59 Chapel Street

James was born in Barnsley, Yorkshire, in 1865, the son of James and Fanny Ann, née Palmer. In 1881 James, aged fifteen, was living at No. 9 Ellesmere Place, Altrincham, with his parents and siblings Mary, aged twelve, Thomas, aged seven, William, aged four, and Henry, aged nine months.

In 1884 James aged nineteen joined the 2nd Battalion, King's Royal Lancaster Regiment. He gave his trade as whitesmith, which was the same as his father's occupation. In 1891 he was based at the School of Musketry in Hythe, Kent. He served in the Anglo-Boer War from December 1899 to March 1900 and again from June 1900 to January 1903, and was awarded the King's and Queen's South Africa medals with clasps for 1901 and 1902.

In 1903 James was discharged from the Army. He married Mary Ellen, née Tracey, that same year and from 1905 was listed as living at No. 15 Chapel Street. In 1911 he was still living at the same address with his wife Mary and her two brothers. James was employed as a labourer in the milling department of the Linotype and Machinery Company located in Broadheath, Altrincham.

In February 1915, then aged forty-nine, he attested for the 5th Battalion, Cheshire Regiment, where he gave his address as No. 2 Chapel Street, even though the address for his wife as his next of kin was No. 59 Chapel Street. James was the oldest man from Chapel Street to serve in the First World War and he was transferred to the Royal Defence Corps and carried out all his war service on home soil, possibly employed in security and guard duties.

James was demobilised in April 1919. He returned to live at No. 2 Chapel Street and worked as a gardener. He was still living there at the time of his death in 1937, aged seventy-one, from bronchial pneumonia. His inquest was reported in the local newspaper on 5 February 1937.

He is listed on the Chapel Street Roll of Honour as James Bellholden, Cheshire Regiment.

Edward Birmingham (1875–1946)

Family Origins: Not known
War Record: Anglo-Boer War 1899–1902; First World War 1914–18
Military Service: Private, 1st Battalion, Royal Dublin Fusiliers, 5th Mounted Infantry, Service No. 5991; Private, 9th Battalion, Royal Dublin Fusiliers, Service No. 16127
Lived at Nos 4, 24, 44 and 48 Chapel Street

Edward was born on 22 June 1875. However, no birth records from around this period have been found to indicate he was born in England and it is possible, because he served in Irish regiments, that he was of Irish descent. On his marriage certificate his father was named as Martin Birmingham.

Around 1899, possibly earlier, he joined the Army, serving with the 1st Battalion, Royal Dublin Fusiliers. The official casualty roll stated that he was wounded on 26 September 1901 at Itala Fort in South Africa.

He married Margaret Decourcy on 8 August 1903 at the Church of St Vincent de Paul, Altrincham, and on 13 July 1904 a daughter, Mary Frances, was born. She was baptised at the same church on 13 August and the family's address was listed as Albert Street in

Altrincham. Another daughter, Margaret, was born on 28 July 1906 and she was baptised on 22 September that year at Ashton on Mersey. The family were listed as living at No. 22 Hyde Grove in Sale, although Edward was also recorded for that same year in Slater's Directory as living at No. 44 Chapel Street. The local newspaper, dated June 1909, recorded a Margaret Birmingham of No. 4 Chapel Street summoning her husband Edward Birmingham, of No. 48 Chapel Street, for persistent cruelty and asked for a separation. Edward stated that 'he had much to complain of regarding his wife'. This was granted and Edward had to pay 7s 6d weekly for the support of his wife and two children. Despite this they later went on to have five more children.

When the First World War broke out in August 1914 Edward enlisted once again, this time on 4 November with the 9th Royal Dublin Fusiliers. One month later, on 19 December, he embarked for France where he served for most of the conflict, but his military record indicates that he had been wounded and was discharged on 1 May 1918.

The 1931 electoral register listed Edward living at No. 24 Chapel Street but by 1939 he had moved to No. 51 Bloomsbury Lane, Altrincham, and was living with his daughter Florence and son-in-law John Keane. He was employed as a fitter's labourer. Edward died on 14 March 1946.

He is listed on the Chapel Street Roll of Honour as Edward Birmingham, Royal Dublin Fusiliers.

John Booth (b. 1894)

Family Origins: Father, Knutsford, Cheshire; Mother, Knutsford, Cheshire
War Record: First World War 1914–18
Military Service: Private, 3rd Battalion, Lancashire Fusiliers; Private, 1st Battalion, Cheshire Regiment, Service No. 10168; Private, 613 Home Service Employment Company, Labour Corps, Service No. 390048
Lived at Nos 40 and 50 Chapel Street

John was born on 11 February 1894 in Knutsford and baptised on 17 March at the Church of St Vincent de Paul, Knutsford. His parents were Joseph and Mary, née Mulvey. In 1901, John, aged seven, was living at Market Place, Knutsford, with his parents and siblings Joseph, aged eleven, Thomas, aged six, and Margaret, aged eight months. By 1911, John had three more siblings: William, Sarah Ann and Ellen. The family were living at No. 40 Chapel Street. John was employed as a labourer at the Linotype and Machinery Company located in Broadheath, Altrincham.

John enlisted in the 1st Battalion, Cheshire Regiment, in June 1913. On his service record, he stated that he was employed as an ironworker and had previously served in the 3rd Lancashire Fusiliers. He gave his address as No. 50 Chapel Street. John was posted to France in August 1914. The local newspaper dated September 1914 published an article entitled 'Street of Soldiers', which listed those men who had joined up to fight and included 'Booth, three brothers'. He was also one of the three Booth brothers – Joseph, Thomas and John – mentioned in an article in the local newspaper dated 25 June 1915 entitled 'Brothers' Ill-luck'. It reported that 'Private John Booth belonged to "D" Company of the 1st Cheshire Regiment and served right to the time of the battle for Hill 60 without a scratch. During that engagement, however, a shell burst within a few yards of him and severely shattered one of his legs. He is an inmate of Whitechapel Military Hospital, London, and is reported to be making great progress.' John was transferred to the 613 Home Service Employment Company, Labour Corps, and in 1918 he appeared before the Army Medical Board, where he was found to be physically unfit for service. Mr Peter Hennerley in his booklet 'The Bravest Little Street in England' stated that John Booth had a leg amputated as a result of the Hill 60 action.

John married Martha Anna Massey at the Church of St Vincent de Paul, Altrincham, on 9 December 1919. In 1939 he was employed as a process worker and living at No. 65 Princess Street, Altrincham, with Martha and their children. John's father, Joseph, and brothers, Joseph and Thomas, are listed on the Chapel Street Memorial.

He is listed on the Chapel Street Roll of Honour as John Booth, Cheshire Regiment.

Joseph Booth Jnr (1890–1915)
Family Origins: Father, Knutsford, Cheshire; Mother, Knutsford, Cheshire
War Record: First World War 1914–18
Military Service: Private, 2nd Battalion, Cheshire Regiment, Service No. 8851
Associated with No. 50 Chapel Street

Joseph was born in Knutsford in 1890. His parents were Joseph and Mary, née Mulvey. In 1901, Joseph, aged eleven, was living at Market Place, Knutsford with his parents and siblings, John, aged seven, Thomas, aged six, and Margaret, aged eight months.

In January 1908 Joseph enlisted with the Cheshire Regiment at Knutsford and in December 1910 he was posted to Jubbulpore, India, with the 2nd Battalion, Cheshire Regiment. He remained in India until December 1914, where he suffered two bouts of malaria. The local newspaper dated September 1914 included an article entitled 'Street of Soldiers' which listed those men who had joined up to fight and included 'Booth, three brothers'. Joseph returned to serve at home for a short period and was then transferred to France in January 1915. The poor weather conditions had an effect on his health and in February he was hospitalised at No. 11 Stationary Hospital as a result of frostbite and bronchitis. He was one of the three Booth brothers Joseph, Thomas and John mentioned in an article in the local newspaper dated 25 June 1915 entitled 'Brothers' Ill-luck'. It reported 'Joseph is a private in the 2nd Cheshire Regiment, and went out with one of the early batches of the British Expeditionary Force, but since May 8, when he was reported to be missing, nothing has been heard of him. In July 1915, the Foreign Office received confirmation of Joseph's death from the German government, stating that Joseph had been killed in action on 8 May 1915 and buried by Germans on Hill 30 in front of Wieltje on 10 May. He is commemorated on the Ypres (Menin Gate) Memorial.

Joseph's father Joseph and brothers John and Thomas are listed on the Chapel Street Memorial.

He is listed on the Chapel Street Roll of Honour as Joseph Booth Jnr, Cheshire Regiment.

Joseph Booth (b. 1868)
Family Origins: Father, Knutsford, Cheshire; Mother, Galway, Ireland
War Record: First World War 1914–18
Military Service: Pioneer, Labour Corps, Royal Engineers, Service No. 124233; Private, Labour Corps, Service No. 295254
Lived at Nos 40 and 50 Chapel Street

Joseph was born on 2 December 1868 at Knutsford, Cheshire, and baptised at the church of St Vincent de Paul, Knutsford, on 12 December. His parents were Joseph and Margaret, née Manion. In 1871, Joseph, then aged two, was living at Sack Lane, Aston by Budworth, Cheshire with his parents and siblings, Sarah, aged six, John, aged five, and William, aged three months. His father died in 1872, aged just twenty-seven. In 1881 Joseph, aged thirteen, was living at Gas Yard, Knutsford with his widowed mother and siblings, Thomas, aged eight, Richard, aged four, and Margaret, aged one. Joseph married Mary Mulvey in 1890 and in

1891 he was living with his wife and son, Joseph, aged one, in Market Place, Knutsford, and working as a mat maker. In 1901 he was still living at the same address with his wife and children, Joseph, aged eleven, John, aged seven, Thomas, aged six, and Margaret, aged eight months and working as a bricklayer's labourer. By 1911 Joseph and his family had moved to Altrincham where they initially lived at 40 Chapel Street, later moving to 50 Chapel Street. Joseph was employed as a general labourer at the Linotype and Machinery Company, Broadheath.

In 1915, at the age of forty-seven, he joined the Army, serving as a Pioneer in the Royal Engineers. His Medal Roll Index card indicated he was sent to France in October 1915 and he later served as a Private in the Labour Corps, before being transferred to the Army Reserve in April 1919. His eldest son, Joseph was killed in action in May 1915.

Joseph's sons Joseph, John and Thomas are listed on the Chapel Street Roll of Honour.

He is listed on the Chapel Street Roll of Honour as Joseph Booth, Royal Engineers.

Thomas Booth (b. 1895)
Family Origins: Father, Knutsford, Cheshire; Mother, Knutsford, Cheshire
War Record: First World War 1914–18; Second World War 1939–45
Military Service: Private, Cheshire Regiment, Service No. 9715
Lived at No. 40 Chapel Street

Thomas was born on 12 March 1895 in Knutsford and baptised on 29 March at the Church of St Vincent de Paul, Knutsford. His parents were Joseph and Mary, née Mulvey. In 1901 Thomas, aged six, was living in Market Place, Knutsford, with his parents and siblings Joseph, aged eleven, John, aged seven, and Margaret, aged eight months. His father was employed as a bricklayer's labourer. By 1911 Thomas had three more siblings – William, Sarah Ann and Ellen – and the family were living at No. 40 Chapel Street with Thomas employed at a local golf club.

In April 1914 Thomas was listed as a musketry recruit in the Cheshire Regiment stationed at Porthcawl in Wales. The local newspaper dated September 1914 included an article entitled 'Street of Soldiers', which listed those men who had joined up to fight and included Booth. On completion of his training in February 1915 he was sent to France. He was one of the three Booth brothers, Joseph, Thomas and John who were mentioned in an article in the local newspaper dated 25 June 1915 entitled 'Brothers' Ill-luck'. It reported that 'Thomas is also a private in the Cheshire Regiment. He has been in the trenches since February and has written home recently stating he "is in the best of health and spirits".' Thomas was demobilised in June 1919 and on 12 July that year married Florence Hennerley at the Church of St Vincent de Paul, Altrincham.

There is a record in the Altrincham Urban District Council minutes dated September 1924 referring to a letter from a Mr T. Booth, the honorary secretary of the Chapel Street Roll of Honour, asking permission for a glass shelter to be erected over the memorial.

In 1939 Thomas and his wife Florence were recorded as living in Milner Avenue, Altrincham, where Thomas was working for a maintenance unit in the RAF. Unfortunately Florence died later that year. Mr Peter Hennerley, in his booklet 'The Bravest Little Street in England', wrote, 'Thomas probably feeling at low ebb lied about his age to fight in WWII. He is said to have spent two weeks hiding from the Nazis in a loft when he got surrounded.'

In 1949 Thomas married Alice Brooks.

Thomas's father Joseph and brothers Joseph and John are also listed on the Chapel Street Roll of Honour.

He is listed on the Chapel Street Roll of Honour as Thomas Booth, Cheshire Regiment.

John Brennan (b. 1885)

Family Origins: Father, Altrincham; Mother, Tipperary, Ireland
War Record: Anglo-Boer War 1899–1902; First World War 1914–18
Military Service: Private, Cheshire Militia, Service No. 6368
Gunner, Royal Field Artillery, Service No. 75790; Lance-Corporal, Labour Corps, Service No. 121334
Lived at Nos 35, 36 and 56 Chapel Street; 9 Chapel Yard

John was born on 28 April 1885 in Altrincham and baptised on 10 May at the Church of St Vincent de Paul. His parents were Thomas and Ann, née Gogin. In 1891, John, aged five, was living at No. 9 Chapel Yard with his widowed mother Ann and sister Mary, aged seven. By 1901 John and his mother were living at No. 56 Chapel Street where John was working as a caddie. John enlisted in the Cheshire Militia in November 1901, giving his age as seventeen, and was discharged to civil employment in South Africa in August 1902, having been awarded the Queen's South Africa Medal with clasps.

In 1911 John had returned to Altrincham and was living at No. 1 Back Moss Lane with his mother, at the home of his brother-in-law John Shaughnessy. He enlisted in January 1914 with the King's Own Royal Lancaster Regiment.

John embarked for France in August 1914 as a gunner in the Royal Field Artillery and served with 24th Battery, 38th Brigade. He was wounded in the retreat from Mons and then at the first Battle of Ypres. John wrote letters from the Front which were published in the local newspaper describing his experiences:

> It is a big thing out here, and the guns are playing a big part. This is not like South Africa; it is all artillery duels. I am waiting for a letter. We value a letter more than money. It gives you encouragement as you are always thinking about home. I hope if I return safely to have a few more medals in addition to my South African ones. The pen with which I am writing, together with the ink, I borrowed from a Frenchman.

It was reported in the local newspaper in January 1916 that he had been awarded the French Military Cross for saving the life of a French general and in July he returned to Chapel Street for a short period, after spending time in an Ipswich hospital being treated for injuries received to his hand. The local newspaper reported, 'The Street was decorated with flags and streamers and the services of a local entertainer and his son were requisitioned to lead the merry-making and singing of popular choruses.'

In November 1917 John was transferred to 203rd Area Employment Company of the Labour Corps, becoming a driver; his rank was given as lance-corporal. In September 1918 he was discharged because of sickness and awarded the Silver War Badge. He appeared on the absent voters list and electoral registers for Chapel Street in 1918 and 1919 at No. 36 and then No. 35 Chapel Street.

He is listed on the Chapel Street Roll of Honour as John Brennan, Royal Field Artillery.

John Brennan (b. 1892)

Family Origins: Father, not known; Mother, Altrincham
War Record: First World War 1914–18
Military Service: Private, 7th Battalion, South Lancashire Regiment, Service No. 16986
Private, 4th Battalion, Royal Welsh Fusiliers, Service No. 316844
Lived at Nos 53, 59 and 60 Chapel Street

John was born on 22 June 1892 in Altrincham and baptised on 24 July at the Church of St Vincent de Paul. His mother was Mary Brennan, but no father was recorded. In 1901,

John, aged eight, was living with his mother at No. 59 Chapel Street. On 30 November of that year his mother married Richard Maher, a road contractor from Liverpool, at the Church of St Vincent de Paul. The couple gave their address as No. 60 Chapel Street. In 1911, John, aged nineteen, was working as a grocer's assistant and living as a lodger at No. 53 Chapel Street, the house of Margaret Collins.

John married Catherine Lamont on 25 July 1915 in the West Derby district of Lancashire. He enlisted in 1915 and served in the South Lancashire Regiment and the Royal Welsh Fusiliers. In August 1915, he entered the theatre of war in France. He was discharged from the Army on 25 February 1919.

In 1939, John, aged forty-seven, was living with his wife Catherine and sons Ernest, aged nineteen, and Donald, aged seventeen, at No. 25 Phythian Street in Liverpool. The *Liverpool Daily Post* newspaper recorded the silver wedding of John Brennan, the son of the late Mrs Mary Maher of Altrincham, and Catherine Lamont on 25 July 1940.

He is listed on the Chapel Street Roll of Honour as John Brennan, Royal Welsh Regiment.

Edward Bretonall

Family Origins: Not known
War Record: First World War 1914–18
Military Service: Cheshire Regiment
Associated with Chapel Street

We have been unable to trace any information on the name Edward Bretonall or name variants in military records or any man of that name with a connection to Chapel Street. It is possible that the name may be spelled incorrectly on the Roll of Honour.

He is listed on the Chapel Street Roll of Honour as Edward Bretonall, Cheshire Regiment.

Ernest Brownhill (1897–1966)

Family Origins: Father, unknown; Mother, Altrincham
War Record: First World War 1914–18
Military Service: Private, 2/5th Battalion, Cheshire Regiment, Service No. 2861; Private, 2nd Battalion, Welsh Regiment, Service No. 53518
Lived at No. 25 Chapel Street

Ernest Calnum was born on 9 January 1897 in Altrincham and baptised on 2 March at the Church of St John under the surname of Gerrard. His mother's name was Emily Gerrard and at the time of his birth she was not married. His father's name was not recorded. In 1901, Ernest, aged four, was living with his grandmother Mary, aged sixty-one, and his mother Emily, aged thirty-two, at No. 55 Islington Street in Altrincham. A sister, Maud, was born in 1904, also named Gerrard. In 1906, Emily married Patrick Madden.

In 1911 Ernest, aged fourteen, was living at No. 25 Chapel Street with his step-father Patrick Madden, mother Emily and siblings Maud Gerrard, aged seven, Bernard Madden, aged four, and Mary Madden, aged two.

At some point between 1911 and 1914 he dropped the surname Gerrard and took on the name Brownell, which was incorrectly written as Brownhill on the Chapel Street Roll of Honour. He kept this name until his death. It is possible that he used an old family name, as his great-grandmother's second husband was named Timothy Brownell. He enlisted with the Cheshire Regiment at Altrincham in November 1914 where he gave his trade as a window cleaner.

In August 1916 Ernest was sent to France and after one month was transferred to the 2nd Battalion, Welsh Regiment. In July 1917 he received a field punishment for failing to comply with an order. In 1918 he was gassed twice, once in June and then again in August.

According to the local newspaper, later that year, in October, 'while holding the line he was hit in the chest and right arm by shrapnel'. He returned to England on 15 November 1918 and on 17 December 1918 was sent to the Crown Hill Military Convalescent Hospital in Devon where he stayed until 10 February 1919. He was discharged from military service in March 1919.

Ernest continued to live at No. 25 Chapel Street working as general labourer. He was listed on the electoral registers up to 1931. He married Catherine Groark in September 1933 in Altrincham and by 1939 he and his family were living at No. 16 John Street, Altrincham. Ernest died in Altrincham on 7 April 1966.

He is listed on the Chapel Street Roll of Honour as Ernest Brownhill, 2nd Welsh Regiment.

Patrick Burke (b. 1879)

Family Origins: Father, Ireland; Mother, Ireland
War Record: First World War 1914–18
Military Service: Private, 23rd Works Battalion, King's Liverpool Regiment, Service No. 55292; Private, 18th and 19th Labour Battalion, Cheshire Regiment, Service No. 61298; Private, 59th Labour Company, Labour Corps, Service No. 34900; Private, 725th Labour Company, 832nd Area Employment Company, Labour Corps, Service No. 34900
Lived at No. 19 Chapel Street

Patrick was born around 1879 in County Sligo, Ireland, and later moved to England. Military records note that prior to enlisting he worked as a labourer at Ashmore, Benson & Sons, a gas and constructional iron plant in Stockton-on-Tees. This physical work caused a hernia that was later recorded on his military records. He enlisted at Altrincham in December 1916 and joined a Labour Battalion of the Cheshire Regiment, which was later redesignated to the 59th Battalion, Labour Company. He served in several companies of the Labour Corps as well as the 23rd Works Battalion of the King's Liverpool Regiment and saw active service in France for two years. In February 1918, aged thirty-nine, he suffered a second hernia, which was attributed to damp and exposure.

In December 1918, Patrick was given leave and returned to Altrincham where he married Mary Andrews just before Christmas. He served in 832nd Area Employment Company, Labour Corps, towards the end of the war and was transferred to the Army Reserve in March 1919. His Army discharge record gave his address as No. 19 Chapel Street. Patrick was registered as an absent voter at that address in 1919 and as a voter in the spring of 1920. By the autumn of that year he had moved to No. 5 Lord Street, Altrincham, and lived there until 1929 along with his wife Mary, who was listed with him on the electoral registers from 1922 onwards. There were four children registered in the Altrincham area with the surname Burke and a mother's maiden name of Andrews: Ellen, born in 1922, Patrick, born in 1923, Sheila, born in 1928, and Angelina, born in 1929.

He is listed on the Chapel Street Roll of Honour as Patrick Burke, Royal Irish Rifles.

Peter Burke (b. *c.* 1875)

Family Origins: Not known
War Record: First World War 1914–18
Military Service: Royal Engineers
Lived at No. 47 Chapel Street

The census indicates that Peter was born around 1875 in County Mayo. In 1898 Peter married Mary Heneghan, also from County Mayo, and the marriage was registered in the Altrincham district. By 1901 Peter was living at No. 47 Chapel Street with his wife Mary, his son John,

aged one, and brother Tom at No. 47 Chapel Street. His occupation is given as nurseryman/carter. A local newspaper reported in September 1903 that Peter Burke of Chapel Street was fined 5s for contravening the rabies order. By 1911 he and his wife and five children, John, aged eleven, Peter, aged eight, Thomas, aged six, Mary, aged four, and James, aged two, had moved to Paradise Street, Altrincham.

It has not been possible to identify conclusively Peter's military Service No. or find further details of his military service.

He is listed on the Chapel Street Roll of Honour as Peter Burke, Royal Engineers.

John Burns (b. 1877)

Family Origins: Father, unknown; Mother, Ireland
War Record: First World War 1914–18
Military Service: Private, 10th Battalion, Cheshire Regiment, Service No. 15742
Lived at Nos 7, 8, 32 and 42 Chapel Street

There is an Army service record for John Henry Burns that lists both Nos 7 and 8 Chapel Street as his address. He enlisted in the 10th Battalion, Cheshire Regiment, on 4 September 1914, aged twenty-nine years and one hundred and six days, which would place his birth date at 21 May 1885. According to his attestation form he was born in the parish of St Vincent de Paul, Altrincham, and was working as a labourer at the time of enlistment. The description of him on his attestation form notes that he had a prominent head of left radius. He was discharged in November after eighty-one days service on the grounds that he was 'medically unfit for service' and awarded a gratuity of £7 10s. He gave his brother, Martin Burns of 30 Chapel Street, as his next of kin.

The Martin Burns recorded above, who lived at no. 30 Chapel Street in 1891, 1901 and 1911, was born in Altrincham on 9 June 1862 and was baptised at the Church of St Vincent de Paul on 19 June. His parents were Lawrence and Annie, née Haley, and his mother was noted as his next of kin as Mary Ann of No. 42 Chapel Street on his military history sheet in his Army service record when he joined the 13th Brigade in 1880, Service No. 21811. While Martin had a brother John, he was too old to have been a soldier in the First World War. Martin married Catherine Hennerley at the Church of St Vincent de Paul on 27 April 1889. On the entry in the marriage register the name Stones is written next to Burns. This was because his mother, Mary Ann Burns, married John Stones of Chapel Street on 28 May 1867 at the same church.

So who was John Henry Burns who served in the 10th Battalion, Cheshire Regiment? He was not the John Henry Burns, son of Martin and Catherine Burns, née Hennerley, born on 16 December 1887 and baptised at the Church of St Vincent de Paul on 8 January 1888. He died, aged sixteen, on 17 January 1904 and was buried at Bowdon.

Martin's mother, Mary Ann Stones, had a son by John Stones named John Henry Stones on 20 May 1877 who was baptised at the church of St Vincent de Paul on 10 June. He would have been Martin's step-brother, which would explain the relationship on the attestation of John Henry Burns. His birthday is very close to that on the attestation form of John Henry Burns and the month is the same but the year is eight years out, but, like many volunteers, he may have adjusted the year as he considered his actual age to be too close to the maximum of thirty-eight for recruitment of those who had not previously served in the Army.

In 1881 John, aged three, was living at No. 42 Chapel Street with his mother and sisters Anne, aged thirteen, and Mary, aged nine, and three lodgers, two of whom had the surname Haley, his mother's maiden name. There lived at No. 48 Chapel Street in 1891 a John Henry Stone, aged fourteen, a gardener, the stepson of John McCafferty. John McCafferty had married Mary Ann Stones, formerly Burns and the mother of John Henry Burns, at the Church of St Vincent de

Paul in 1887. In 1901 John was head of household at No. 32 Chapel Street and working as a labourer. He has not been located with certainty in 1911 but may have been the John Burns, labourer, aged thirty-eight, who lodged at No. 15 Police Street, Altrincham. After the war there was a John Burns listed on the electoral registers for No. 11 Chapel Street in 1919 and 1921 but it is not known whether this was the same man. His death has not been located.

His step-nephews Robert and Thomas Burns are listed on the Chapel Street Roll of Honour.

He is listed on the Chapel Street Roll of Honour as John Burns, Cheshire Regiment.

Robert Burns (1892–1956)
Family Origins: Father, Altrincham; Mother, Altrincham
War Record: First World War 1914–18
Military Service: Private, 2nd Battalion, King's Liverpool Regiment, Service Nos 10761 and 3757602
Lived at Nos 3, 5 and 30 Chapel Street

Robert was born on 15 January 1892 in Altrincham and baptised in February at the Church of St Vincent de Paul. His parents were Martin and Catherine, née Hennerley. In 1901 Robert, aged nine, was living at No. 30 Chapel Street with his parents and siblings John Henry, aged thirteen, Annie, aged eleven, Katey, aged eight, Thomas, aged six, Ada, aged four, Jessie, aged two, and Jane, aged three months. An article in the local newspaper dated April 1906 reported that Robert Burns and James Tatton of Chapel Street were sent to a reformatory school for three years for stealing a horse, cart and a set of harness, with a value of £35, belonging to a fishmonger named McDermott. The boys said they had intended to have a ride around the town and to Macclesfield, and start buying rags and bones. Their parents were ordered to pay 1s per week towards the maintenance of the boys. In 1907 Robert's mother died aged forty.

Robert was serving with the King's Liverpool Regiment in India by April 1915. He served with the 2nd Battalion, which remained in India throughout the war. After the war Robert continued to serve in the King's Liverpool Regiment and was listed on the absent voters lists at both Nos 3–5 Chapel Street and No. 30 Chapel Street until at least 1923. He then spent some time in the Liverpool area, where he married Elsie Pitts in 1928. By 1939 the couple and their children had moved to Wythenshawe and were living at No. 10 Leycett Drive. Robert was working as a waterman at the Manchester City Water Works, Altrincham depot. He died in Wythenshawe Hospital in August 1956 and was buried in Manchester Southern Cemetery.

Robert's brother Thomas and his step-uncle John are also listed on the Roll of Honour.

He is listed on the Chapel Street Roll of Honour as Robert Burns, King's Liverpool Regiment.

Thomas Burns (1895–1921)
Family Origins: Father, Altrincham; Mother, Altrincham
War Record: First World War 1914–18
Military Service: Private, 8th Battalion, Cheshire Regiment, Service No. 11300
Lived at No. 30 Chapel Street

Thomas was born on 14 September 1895 in Altrincham and baptised in October at the Church of St Vincent de Paul. His parents were Martin and Catherine, née Hennerley. In 1901 Thomas, aged six, was living at No. 30 Chapel Street with his parents and siblings John Henry, aged thirteen, Annie, aged eleven, Robert, aged nine, Katey, aged eight, Ada, aged four, Jessie, aged two, and Jane, aged three months. His mother died in 1907, aged forty. In 1911, Thomas, aged fifteen, was an apprentice fitter at the Linotype and Machinery

Company, Broadheath and was still living at No. 30 Chapel Street with his widowed father and siblings.

Thomas's Medal Roll Index card indicates that he first served in the Balkans in 1915. The 8th Battalion, Cheshire Regiment, after serving at Gallipoli, moved from Egypt to Mesopotamia in February 1916 and remained there for the duration of the war. While there he contracted a form of malaria. The records of the sick and wounded men of the Persian Gulf Expedition contain two undated fragments that referred to a Private Thomas Burns of the 8th Battalion, Cheshire Regiment and Service No. 11300 as having heatstroke.

Thomas was demobilised in April 1919 and the electoral registers showed him still living at No. 30 Chapel Street in 1921. He died in November of that year, aged twenty-six, from what was described in the local newspaper as 'consumption of the throat, probably caused by being gassed during the war' and was buried with full military honours at Altrincham Cemetery, with some of his old comrades acting as bearers. A bugler sounded the last post. The chief mourners were his father, Mr Martin Burns, sisters Annie, Kitty and Ada and Mr Joseph Arnold, brother-in-law, and Mr Joseph Henry, his uncle, Mr J. Fenna represented the Linotype and Machinery Company.

Thomas's brother Robert and his uncle John are also listed on the Chapel Street Roll of Honour.

He is listed on the Chapel Street Roll of Honour as Thomas Burns, Cheshire Regiment.

Edward Caine
Family Origins: Not known
War Record: First World War 1914–18
Military Service: Cheshire Regiment
Lived at No. 36 Chapel Street

There are two possibilities for the name Edward Caine, neither of which can be confirmed. Edward Caine was listed on the 1911 census living at No. 36 Chapel Street as a lodger in the house of Mary Haughton along with John Gibson, Mary Gibson and Thomas Higgins. He gave his place of birth as County Sligo, Ireland, and was unmarried, working as a labourer. It is possible that he is the Edward Caine listed on the Chapel Street Memorial but there are no military records to confirm this.

Edward Caine was born in Altrincham on 29 December 1893 and baptised on the 10 October 1894 at the Church of St Vincent de Paul. The only connection to Chapel Street we have been able to find is that his father had been a resident there in 1861. In 1901 he was living at Hamon Road with his widowed mother, sisters Annie, aged twenty, Kate aged eight, and brothers William, aged sixteen, Leonard, aged twelve, and Frederick, aged three. By 1911 Edward had moved with his mother and one brother Fred, to Egerton Terrace, Altrincham where he was employed as an iron foundry apprentice at the Linotype works. It is also possible that he is the Edward Caine listed on the Chapel Street Memorial but again there are no military records to confirm this.

The local newspaper dated 19 September 1919 confirmed the death of Edward's brother Leonard, who served with the Cheshire Regiment. Despite being a well-known local man Leonard is not listed on the Chapel Street Memorial.

Edward is listed on the Chapel Street Roll of Honour as Edward Caine, Cheshire Regiment.

Thomas Chesters
Family Origins: Not known
War Record: First World War 1914–18
Military Service: Cheshire Regiment
Associated with Chapel Street

We have been unable to trace any information for the name Thomas Chesters or name variants in military records or a connection with Chapel Street. It is possible that the name may be spelled incorrectly on the memorial.

He is listed on the Chapel Street Roll of Honour as Thomas Chesters, Cheshire Regiment.

Charles Clarke (b. 1895)

Family Origins: Father, Ireland; Mother, Altrincham
War Record: First World War 1914–18
Military Service: Lance-Corporal, Royal Marine Light Infantry, Service No. 16079
Lived at No. 16 Chapel Street

Charles was born in Altrincham on 8 April 1895 and baptised on 19 May at the Church of St Vincent de Paul. His parents were Thomas and Mary, née Arnold. In 1901 Charles, aged five, was living at No. 16 Chapel Street with his parents and siblings Nora, aged ten, Thomas, aged seven, Hugh, aged four, John, aged two, and an unnamed female infant. In 1911 Charles, aged fifteen, was employed as a printing apprentice and was living with his family at No. 41 Oakfield Road, Altrincham.

In August of that year Charles enlisted in the Royal Marine Light Infantry (Portsmouth Division) and his service record indicated he was underage until April 1912. He was assigned to HMS *Hindustan* in February 1913, which was part of the 3rd Battle Squadron seeking out mines in the English Channel.

Charles was discharged in 1919 and his address at this time was given as No. 9 Greenwood Street, Altrincham. Later that year, he enrolled in the Royal Fleet Reserve. Charles married Hilda Holt in June 1928 and continued to serve with the reserves. The local newspaper dated 5 June 1942 reported, in an article about his brother Hugh, that 'Charlie whose peace time job is in the Altrincham postal service, joined the Navy in 1911 and he is now a Corporal gunnery instructor.'

Charles was discharged in 1943 suffering from chronic bronchitis and asthma. His address on discharge was given as No. 35 St Mark's Avenue, Altrincham.

Three of Charles' brothers – Hugh, Thomas and John (Jack) – also served in the Royal Marines. Thomas was killed on the battleship HMS *Bulwark* in November 1914; Hugh served in both world wars; and Jack died in August 1940. Only Charles is listed on the Chapel Street Roll of Honour.

He is listed on the Chapel Street Roll of Honour as Charles Clarke, Royal Marine Light Infantry.

George Clarke

Family Origins: Father, Ireland; Mother, Altrincham
War Record: First World War 1914–18
Military Service: Royal Marine Light Infantry
Associated with No. 16 Chapel Street

One man named George Clarke was listed on census returns for Chapel Street, who was of the right age to have served in the First World War. He was George Henry Clarke, aged one in 1881, who lived with his parents John William and Mary Ann, née Sowerbutts, at No. 2 Chapel Street. He was baptised at Dunham Massey on 14 January 1880. By 1891 he had moved to Hulme with his mother and siblings. He married Lucy Tailor in the district of Farnham, Surrey, in 1904 and was residing in Brighton in 1911 with his wife while working as a railway labourer. There is no evidence that he served in the Royal Marine Light Infantry or had any further connection with Altrincham.

Apart from Lance-Corporal Charles Clarke, who served in the Royal Marine Light Infantry, Service No. 16079, and whose details are recorded above, there is evidence for one other man named Clarke or Clark from Altrincham who served in that regiment. That man was his brother Thomas Clarke, born in Altrincham on 9 July 1893 and baptised on 6 August at the Church of St Vincent de Paul. He was the son of Thomas, from Roscommon, Ireland, and Mary, née Arnold, daughter of Hugh Arnold of No. 27 Chapel Street.

In 1901, aged seven, he was living at No. 16 Chapel Street with his parents and siblings Nora, aged ten, Charles, aged five, Hugh, aged four, John, aged two, and baby Clarke, aged less than one month. By 1911 the family had moved to No. 41 Oakfield Road, Altrincham, and Thomas was employed as a shorthand typist. An address in Greenwood Street, Altrincham, a few yards from Chapel Street, was recorded on the service forms of Thomas, Charles and Hugh. Charles, Hugh and John were recorded living at No. 9 Greenwood Street on the absent voters lists for 1918 and 1919.

Thomas enlisted as a private in the Royal Marine Light Infantry, Service No. PO/16152, in October 1911. He was based at Deal, Kent, until August 1912 and then mainly at Portsmouth, Hampshire. His last posting was to HMS *Bulwark*. He lost his life on 26 November 1914 when the ship was destroyed by a large internal explosion while at anchor off Sheerness, Kent. Seven hundred and thirty-six men died in the explosion, which was possibly caused when cordite charges that had been placed near the boiler room overheated. He was buried at Gillingham Woodlands Cemetery, Kent.

As Charles was recorded on the memorial it is somewhat surprising that his brothers were not listed. Apart from Thomas, who lost his life, one was Gunner Hugh Clarke, Royal Marine Artillery, Service No. 14867. He was born in Altrincham on 28 December 1896 and baptised at the Church of St Vincent de Paul on 14 February 1897. He enlisted in January 1916, served mainly on HMS *Lord Nelson* and was discharged in November 1919. The other was Private John Clarke, 7th Battalion, Cheshire Regiment, Service No. 66544, born in Altrincham on 17 May 1899 and baptised on 25 June at the same church. They had all lived at No. 16 Chapel Street and lived at the same other addresses as Charles.

There was a G. Clarke listed on the Altrincham and District Roll of Honour but it is possible that the name George was recorded in error on the Chapel Street Roll of Honour instead of Thomas, or perhaps Hugh who was also a Royal Marine.

He is listed on the Chapel Street Roll of Honour as George Clarke, Royal Marine Light Infantry.

Frank Collins (1892–1915)

Family Origins: Father, Galway, Ireland; Mother, Galway, Ireland
War Record: First World War 1914–18
Military Service: Private, 1st Battalion, Cheshire Regiment, Service No. 10816
Lived at No. 54 Chapel Street

Frank was born in Altrincham on 23 October 1892 and baptised on 8 September 1892 at the Church of St Vincent de Paul. His parents were Michael and Ellen, née Smith. In 1901 Frank, aged nine, was living at No. 54 Chapel Street with his parents and siblings James, aged eighteen, Mary, aged fourteen, and Margaret, aged thirteen. In September 1902, while still at Chapel Street, another brother, Luke, was born. The 1911 census indicates that the family had moved from Chapel Street to No. 10 Lord Street, Altrincham. At the age of twenty-three Frank was working as a golf caddy.

When war broke out Frank enlisted with the Cheshire Regiment at Hale and was sent to Birkenhead on 21 August 1914. The local newspaper reported him as missing in early June 1915. The *Manchester Evening News* dated 3 June reported: 'News has reached Altrincham

that Private Frank Collins (22) of the 1st Cheshire Regiment, son of Mr and Mrs Collins of Lord Street, Altrincham, has been killed in action.' A week later, on 11 June, the local newspaper confirmed the same news, along with a photograph of him in uniform.

Frank's military record gave his death as 27 May 1915. The residue of his Army account, £6, 5s and 4d was forwarded to his father Michael Collins. His name is recorded on the Menin Gate Memorial at Ypres. Frank's brother James is also listed on the Chapel Street Roll of Honour.

He is listed on the Chapel Street Roll of Honour as Frank Collins, Cheshire Regiment.

James Collins (b. 1882)
Family Origins: Father, Galway, Ireland; Mother, Galway, Ireland
War Record; First World War 1914–18
Military Service: Corporal, 21st Service Battalion, Manchester Regiment, Service No. 19082; Private, 3rd Battalion, Cheshire Regiment, Service No. 27373
Lived at Nos 23, 54 and 63 Chapel Street

James was born in Altrincham on 16 November 1882 and baptised on 3 December 1882 at the church of St Vincent de Paul. His parents were Michael and Ellen, née Smith. In 1901 James, aged eighteen, was living at No. 54 Chapel Street with his parents and sisters, Mary, aged fourteen, Margaret, aged thirteen, and Frank, aged nine. In September 1902, while still at Chapel Street, another brother, Luke, was born. The 1911 census indicated the family had moved from Chapel Street to No. 10 Lord Street, Altrincham. James was listed as twenty nine, single and working as a farm labourer.

On 7 November 1914 he married Ada Hooley at the Knutsford Registry Office in Cheshire. Their son James had been born in April 1910, prior to their marriage. The address of his birth was given as No. 26 Priory Street, Bowdon, which was the former address of James's wife Ada and her family. Shortly after his marriage James joined the 21st Service Battalion, Manchester Regiment, on 20 November at Manchester where he gave his occupation as a coal dealer and his age as twenty-four years and four months. He must have shown promise early as he was promoted to lance-corporal on 1 December and a few months later on 18 March 1915 to corporal. A daughter, Ada, was born on 2 April 1915 and shortly after this, on 16 April 1915, he was recorded as being absent without leave for four days. For this he was ordered to forfeit four days' pay. He was discharged on 3 May 1915 on the grounds of not being likely to become an efficient soldier. His application for discharge papers dated 23 April 1915 stated that his 'anterior fontanelle never closed up, complains of persistent headaches'.

On 20 July 1915 he enlisted for Home Service with the 3rd Battalion Cheshire Regiment for the duration of the war and gave his address as No. 63 Chapel Street. Shortly after this, in September 1915 he was examined at Birkenhead by the Army Medical Board and recommended again for discharge due to the fracture on his skull.

There is a record of an armlet being sent to him by the Cheshire Regiment and delivered to him at No. 23 Chapel Street by the police in January 1916. This was to signify that he had been honourably discharged. James's brother Frank also enlisted but was killed in 1915. He is also listed on the Roll of Honour.

He is listed on the Chapel Street Roll of Honour as James Collins, Cheshire Regiment.

Thomas Collins (b. 1875)
Family Origins: Father, Altrincham; Mother, Baguley
War Record: Anglo-Boer War 1899–1902; First World War 1914–18
Military Service: Private, 1st Provisional Battalion, Imperial Yeomanry, Cheshire Regiment, Service No. 22709; Private, 8th Battalion, Cheshire Regiment, Service No. 11440
Lived at Nos 29 and 59 Chapel Street

Thomas was born in 1875 in Altrincham and baptised on 27 January 1875 at the Church of St Margaret, Dunham Massey. He was registered and baptised under the name of Tom rather than Thomas. His parents were George and Rachel. In 1881 Tom, aged six, was living at No. 67 New Street, Altrincham, with his parents and siblings Mary Ann, aged eleven, Edith, aged ten, George, aged eight, and Sarah, aged one. By 1891 another daughter, Grace, had been born and the family had moved to No. 59 Chapel Street. By 1901 they had moved to New Street, Altrincham.

Tom enlisted with the Cheshire Imperial Yeomanry in January 1901 where he gave his occupation as a blacksmith's striker. His attestation papers describe him as 5 foot 4 inches, weighing 8 stone and 6 pounds with a light complexion, grey eyes and light brown hair. He had a large tattoo on his left and right forearm. His address was listed as No. 5 New Street, Altrincham, and his next of kin as Rachel Collins of the same address. He served in the Anglo-Boer War, but unfortunately was badly injured when he was kicked by a horse in November 1901 and declared medically unfit in December of that year. He was discharged at Shorncliffe, aged twenty-four years and two months. His discharge papers state that he was serving with the 21st Cheshire Company, Imperial Yeomanry, attached to the 1st Provisional Battalion.

Tom was a witness to the marriage of his sister Sarah to William Gleave at the Church of St Margaret, Dunham Massey in November 1898. This was after his father had died as he was listed as deceased on the marriage certificate. He was also a witness to the marriage of his other sister Grace to William Wilkinson Wyatt at the Church of St George, Altrincham, in February 1903. His signature on the certificate closely resembles the one that is on his attestation papers of 1901.

Tom Collins was mentioned in an article in the local newspaper in February 1902 entitled 'Ex-soldier disgraceful conduct at Altrincham', in which he attacked his mother Rachel and his sister Mary Ann. The article referred to him as recently having returned home from serving in South Africa. His address was given as No. 59 Chapel Street. In December 1909, another local newspaper reported that Thomas Collins of Chapel Street was fined 5s for playing with cards for money. By 1911 he was once again living at No. 5 Cellar, New Street, Altrincham, with his widowed mother and sister Mary Ann.

When the war started in August 1914 he would have been around thirty-nine years old; however, there are attestation papers dated 18 August 1914 for a Private Thomas Collins, 8th Battalion, Cheshire Regiment, Service No. 11440, who was twenty-eight years and eight months old. It is likely that this is the same person, as all the other details are almost identical. The papers stated that he had formerly served with the Cheshire Yeomanry and that his occupation was a blacksmith. He gave his address as No. 29 Chapel Street. His height was noted as 5 feet 5 inches and he was described as having a fresh complexion, blue eyes and greyish hair with tattoo marks on his right arm (a palm tree) and left arm (a sailor with a Union Jack and ballet girl). The signature on the marriage certificate of both Sarah and Grace Collins matches that on both sets of attestation papers. The evidence indicates that Tom had re-enlisted.

Tom's service was to be short lived as he was discharged in September after serving for only one month. The reason given was 'not likely to become an efficient soldier'.

He is listed on the Chapel Street Roll of Honour as Thomas Collins, Cheshire Regiment.

Thomas Corfield (b. 1872)

Family Origins: Father, Galway, Ireland; Mother, Galway, Ireland
War Record: Anglo-Boer War 1899–1902; First World War 1914–18
Military Service: Private, 2nd and 3rd Battalion, Cheshire Regiment (Militia), Service Nos 2240 and 2246; Private, Special Reserve, Cheshire Regiment, Service No. 6805; Private, 1st Garrison Battalion, Cheshire Regiment, Service No. 3/10493
Lived at Nos 8, 40, 45, 47 and 49 Chapel Street

Thomas was born on 8 August 1872 in Altrincham and baptised on 8 September 1872 at the Church of St Vincent de Paul. His parents were James and Bridget, née Hardiman. In 1881 Thomas, aged nine, was living at No. 1 Cellar, Albert Street, Altrincham with his parents and siblings James, aged seven, Ellen, aged ten, Mary, aged five, and Annie, aged three months. By 1891 the family had moved to No. 49 Chapel Street and Thomas, aged eighteen, was working as a labourer.

Thomas enlisted in the 3rd Cheshire Regiment (Militia) in January 1891 and in 1894 transferred to the Militia Reserve, where he gave his address as No. 47 Chapel Street. He served with the militia until 1899 and then in January 1900 joined the 2nd Battalion of the Cheshire Regiment, serving in South Africa.

An extract from a letter to his mother was printed in the local newspaper dated May 1900 under the title 'Letters from the War' in which Thomas detailed his experiences. The article described how he had 'a hard march of over 150 miles, the railway bridges all being blown up. They were then located about 60 miles from Bloemfontein, and a 1,000 miles from Cape Town'. It went on to say he had 'not had his clothes off for five weeks, and they all had been on quarter rations because the trains could not get anywhere near'. In another letter to his parents, Thomas wrote that he had met Walter Oxley from Chapel Street at Cape Town.

In March 1903 Thomas appeared in court for using bad language while living at No. 40 Chapel Street, and in August that same year he was back in court again and fined for being drunk and disorderly at Sale Petty Sessions. He appeared in court wearing his two South African campaign medals. The bench expressed regret that a man wearing such medals should be in such a position. By 1911 Thomas was employed as a brick setter's labourer and lodging at No. 45 Chapel Street with Mary Scahill and her children.

When war broke out in 1914, Thomas rejoined the Army almost immediately and enlisted at Altrincham in August 1914. During the early months of his service, he was punished several times for misconduct. In August 1915 he was posted to 'C' Company of the 1st Garrison Battalion, Cheshire Regiment, and served in Gibraltar until he was discharged in June 1917. Thomas returned to live at No. 8 Chapel Street and wrote from this address in 1922 to request replacements for his South African medals with five clasps, which he had lost. A letter dated February 1923 acknowledged payment by postal order of £1 2s 6d for the replacements.

He is listed on the Chapel Street Roll of Honour as Thomas Corfield, Cheshire Regiment.

Charles Croft (1878–1915)

Family Origins: Father, Handforth, Cheshire; Mother, Sheffield, Yorkshire
War Record: First World War 1914–18
Military Service: Private, 4th Battalion, Cheshire Militia, Service No. 3499; Private, 2nd Battalion and 9th Battalion, Cheshire Regiment, Service Nos 5396, 24973 and 11722
Lived at No. 22 Chapel Street

Henry Charles was born in 1878 in Sheffield and baptised on 9 October. His parents were Charles and Elizabeth, née Burns. In 1881 he was living at No. 5 Elton Street in Nether Hallam, Sheffield, with his maternal grandmother, Ellen Burns, his mother, Elizabeth, who was described on the census as a soldier's wife, and sisters Ellen, aged five, and Ann, aged one.

He enlisted with the Cheshire Militia in January 1897 while living in Stockport. He was aged seventeen years and nine months. In February, while still serving in the militia, Charles enlisted with the Cheshire Regiment, where he gave his occupation as a dyer. His first period of military service was short lived as, in July 1897, while serving in Buttevant, County Cork, he was diagnosed with a lateral curvature of the spine. His medical papers stated that the 'patient will never be able to perform his duties as a soldier. The disability is not the result of military service.' He was subsequently discharged from the Army. In 1911 Charles, aged thirty-one, was living as a lodger at No. 22 Chapel Street and working as a general labourer.

Despite his disability, he re-enlisted in August 1914 under the name of Charles Croft, giving his age as twenty-nine years and five months, when in fact he would have been around thirty-six years old. However, he was once again discharged in October 1914 on the grounds that he was 'not likely to become an efficient soldier'. At some point after October 1914 he once again re-enlisted with the Cheshire Regiment and on this occasion was drafted to France in March 1915, as part of 84th Brigade, 28th Division. Charles was presumed killed in action on 8 May 1915, when his battalion was under attack at Verlorenhoen in the second Battle of Ypres. He was thirty-seven years old. The register of soldiers' effects recorded that the £6 8s 2d that remained in his account was paid to his mother Elizabeth. Charles Croft is commemorated on the Menin Gate Memorial, Ypres.

He is listed on the Chapel Street Roll of Honour as Charles Croft, Cheshire Regiment.

William Curley (1882–1918)

Family Origins: Father, Not known; Mother, Ireland
War Record: First World War 1914–18
Military Service: Gunner, C Battery, 81st Brigade and D Battery, 79th Brigade, Royal Field Artillery, Service No. 78269
Lived at Nos 28, 59 Chapel Street and No. 5 Chapel Yard

William was born in the fourth quarter of 1882 in Altrincham. It is likely that his parents were Thomas Curley and Catherine Ambrose, who married at Manchester in 1874. In 1891 William, aged eight, was living at No. 5 Chapel Yard, Altrincham, with his widowed mother Catherine and siblings Lily and Arthur, both aged nine, and a lodger, Robert Marton. In 1901 William was working as a horse keeper/groom and living at No. 9 King Street, Altrincham, with his mother, his sister Lily and her husband George Bowyer, who was head of the house. William married Ellen Shaw in 1903 and by 1911 he was employed as a labourer in a foundry.

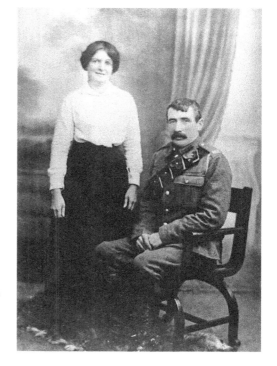

Gunner William Curley with his wife Ellen, née Shaw. Mr Peter Hennerley, in his booklet 'The Bravest Little Street in England', described how William's widow, Ellen, was devastated by his death and their son, James, was chosen to lay the first wreath at the unveiling of the Chapel Street Roll of Honour in April 1919. (Image courtesy of Kathleen Winkley)

The couple were boarding at No. 25 Dale Street, Broadheath, with their two children, Beatrice Ellen, aged two, and Lillian, aged nine months. They went on to have a son, James, in 1912.

William's Service Medal and Award Rolls indicated he was drafted to France in July 1915 as a gunner in the Royal Field Artillery. He appeared on the absent voters' list for 1918 with an address of No. 59 Chapel Street. According to the entry on Trafford War Dead, William was gassed in the final days of the war and despite surviving the journey home, died in the Military Hospital at Levenshulme, Manchester, on 28 December 1918. He was buried in Hale Cemetery. The address of his widow, Ellen, was given as No. 28 Chapel Street.

Mr Peter Hennerley, in his booklet 'The Bravest Little Street in England', stated that William's widow Ellen was devastated by his death and their son, James, was chosen to lay the first wreath at the unveiling of the Chapel Street Roll of Honour in April 1919.

He is listed on the Chapel Street Roll of Honour as William Curley, Royal Field Artillery.

John Davis

Family Origins: Not known
War Record: First World War 1914–18
Military Service: Cheshire Regiment
Associated with Chapel Street

It is possible that the John Davis listed on the Chapel Street Memorial was John William Davies, who was a member of the Chapel Street committee who took on the responsibility for establishing the memorial. There is only one other reference to the name John Davis around that period linked to Chapel Street and that was a John Davis, aged thirty-eight, from Mold in Flintshire, who was listed as a lodger at No. 2 Chapel Street on the 1901 census and was at the time working as a street artist. He would have been aged fifty-one in 1914, so it is more than likely not him.

The local newspaper dated September 1914 included an article entitled 'Street of Soldiers', which listed those men who had joined up to fight and included a soldier with the surname Davies.

Military records list a John W. Davies, Service No. 10488, who enlisted with the 1st Battalion, Cheshire Regiment, in August 1914. That same month, he was also listed on the daily orders of the Cheshire Regiment and later that year on 7 October was posted abroad. Unfortunately he was wounded and subsequently discharged from service on 23 March 1916 under Kings Regulations 392. He was awarded the Silver War Badge.

The electoral registers for the Altrincham area showed that there was a John William Davis and Sarah Davis living at No. 8 Paradise Street, Altrincham, in 1918 and 1929. The 1939 register also recorded a John W. Davies, born on 11 June 1869 and listed as a 'Disabled War Pensioner', still living at the same address.

Martin De Courcey (1881–1953)

Family Origins: Father, Galway, Ireland; Mother, Galway, Ireland
War Record: Anglo-Boer War 1899–1902; First World War 1914–18
Military Service: Private, 5th and 6th Battalion, Manchester Regiment, Service No. 7713;
Private, 1st, 3rd and 22nd Battalions, Cheshire Regiment, Service No. 10421
Lived at Nos 4 and 22 Chapel Street

Martin was born on 16 June 1881 in Altrincham and baptised on 17 July at the Church of St Vincent de Paul. His parents were Patrick and Bridget De Courcey, née Burke. In 1891 Martin, aged nine, was living at No. 4 Chapel Street with his parents and siblings Mary, aged twelve, Joseph, aged eleven, Rose Anne, aged eight, Margaret, aged five, and Patrick,

aged seven months. Martin's father died in 1898 and his mother remarried that same year to William Blease.

In October 1900, an article in the local newspaper entitled 'Two Irishmen at Variance' reported that Martin had been convicted at Altrincham Petty Sessions of the assault of Peter Moran of No. 8 Chapel Street and fined 10s 6d or fourteen days hard labour. It went on to report that Martin had not appeared in court as he had joined the Army, enlisting in the Manchester Regiment the week before. He was transferred to the 5th Battalion of the Manchester Regiment in May 1901 and served in South Africa until his period of service came to an end on 28 July 1902. In 1911 Martin, aged twenty-eight, was boarding at No. 22 Chapel Street and employed as a brick setter.

In August 1914 Martin joined the 3rd Battalion, Cheshire Regiment, at Birkenhead as a Special Reservist and was later transferred to the 1st Battalion. He disembarked on 7 October 1914 and fought at the first Battle of Ypres where he was taken prisoner in November 1914 by the German forces. He remained a prisoner of war until hostilities ceased. The local newspaper dated June 1916 reported that his mother Bridget had received a postcard from Martin, who was held in Wittenburg, Germany, having previously been interned at Luxembourg. He wrote, 'I am in the best of health. Please send me on a parcel of foodstuffs and cigarettes.'

According to the absent voters list of spring 1919 he went on to serve in the 22nd Battalion Cheshire Regiment and his address was given as No. 4 Chapel Street. Martin married Ursula Burke in 1919 and by 1939 the family were living at No. 12 Hesketh Street, Stockport. There is a reference to the death of a Martin De Courcy registered in Manchester in 1953.

Martin's brother Patrick is also listed on the Chapel Street Roll of Honour.

He is listed on the Chapel Street Roll of Honour as Martin De Courcey, Cheshire Regiment.

Patrick De Courcey (b. 1890)

Family Origins: Father, Galway, Ireland; Mother, Galway, Ireland
War Record: First World War 1914–18
Military Service: Private, 3rd and 4th Battalions, South Wales Borderers, Service No. 19835
Lived at No. 4 Chapel Street

Patrick De Courcey was born on 7 August 1890 in Altrincham and baptised on 24 August at the Church of St Vincent de Paul. His parents were Patrick and Bridget, née Burke. In 1891 Patrick, aged seven months, was living at No. 4 Chapel Street with his parents and siblings Mary, aged twelve, Joseph, aged eleven, Martin, aged nine, Rose Anne, aged eight, and Margaret, aged five. Patrick's father died in 1898 and by 1901 his mother had married William Blease. In 1911 Patrick, aged twenty, was employed as a general labourer and still living at No. 4 Chapel Street with his mother Bridget and her new husband Henry Walker, whom she had married in 1910 following the death of her second husband William in 1909.

Patrick enlisted in the 3rd Battalion, South Wales Border Regiment, in August 1914 and entered the Balkans on 19 July 1915, serving in the Dardanelles. The local newspaper dated 15 October 1915 reported that 'Private Patrick De Courcy, who belongs to the South West Borderers, is an inmate of a military hospital at Malta, suffering from dysentery.' The report goes on to say that 'in a letter which was received at Altrincham on Saturday, he states that he is recovering as quickly as can be expected and that he hopes to be back with his regiment at an early date'. At some stage Patrick was transferred to the 4th Battalion, South West Border Regiment, but his ill health continued and he was discharged from the Army on 17 August 1917, returning to live at No. 4 Chapel Street. In 1919 he married Mary C. Bradley but research has been unable to establish where the couple resided.

Patrick's brother Martin is also listed on the Chapel Street Roll of Honour.

He is listed on the Chapel Street Roll of Honour as Patrick De Courcey, Cheshire Regiment.

Martin Donnelly/Dunothey (1883–1917)

Family Origins: Father, County Roscommon, Ireland; Mother, County Roscommon, Ireland
War Record: First World War 1914–1919
Military Service: Private, 3rd, 3/4th, 10th, 11th and 13th Battalions, Cheshire Regiment,
Service Nos 4316, 49484
Lived at 9 and 22 Chapel Street

Martin Donnelly/Dunothey was listed on the Chapel Street Memorial as having served in the war and a Martin Donnelly was named on the panel of the memorial that identified those men who had died for their country. It has been concluded that the two are the same man.

Martin Donnelly's birth was registered in the fourth quarter of 1883 in Athlone, Ireland. He was the son of Martin and Mary. In 1901, Martin, aged seventeen, was employed as an agricultural labourer and living at No. 9 Galeybeg, Lecarrow, County Roscommon, with his parents and sisters Mary, aged thirteen, and Jane, aged ten. At some point between 1901 and 1911 he travelled to England and began boarding at No. 9 Chapel Street, working as a labourer.

On 16 February 1916, Martin enlisted in the Cheshire Regiment at Altrincham and gave his address as No. 22 Chapel Street on his Army service record. His mother Mary, living in Lecarrow, was listed as his next of kin. By September 1916 he had arrived in France with the 3/4th Battalion and shortly afterwards he was transferred to the 11th Battalion. He spent two periods in France, the first of which resulted in a month in hospital in Lincoln with an injured right hand. He recovered sufficiently to return to France in June 1917. Martin was reported missing in action on 4 August 1917 and was presumed dead.

In 1919 Mary Oxley of No. 22 Chapel Street, who described herself on the official Army form as a 'friend', declared Martin had no known relatives and his personal effects were assigned to her. Martin is commemorated on the Menin Gate, Ypres.

He is listed on the Chapel Street Roll of Honour as Martin Donnelly/Dunothey, Cheshire Regiment.

Thomas Durkin

Family Origins: Ireland
War Record: First World War 1914–18
Military Service: Cheshire Regiment
Associated with Chapel Street

It has not been possible to identify this soldier with any certainty, or to link the name Thomas Durkin or a variant to Chapel Street. There is one reference to a Thomas Durkin in the census of the Altrincham area born on 24 August 1872 in Kilasser, County Mayo, Ireland, which could be him, but so far we have been unable to link him directly to Chapel Street. In 1901 he was a lodger at No. 33 Victoria Street, Altrincham, and employed as a railway plate layer. In the fourth quarter of 1910, he married Elizabeth Murphy (formerly McIntyre) who was a widow. Known as Bessie, she had married a Patrick Murphy in 1900 and in 1901, aged twenty-nine, was living with Patrick, aged fifty-six, at No. 43 Lloyd Street, along with Michel Raney and Dennis Looker, who were both listed as boarders aged twenty-eight. Patrick Murphy, also worked as a railway plate layer and it is likely that he was an associate of Thomas Durkin. Patrick died in the second quarter of 1953, aged fifty-seven.

The 1911 census listed Thomas living at No. 7 Moss View with his wife Bessie, stepdaughter Mary, aged eight, and stepson James Patrick, aged seven. He would have been aged around forty-two in 1914 and it is possible that he served in the Army during the war period, although we cannot locate any military records that can identify him.

He is listed on the Chapel Street Roll of Honour as Thomas Durkin, Cheshire Regiment.

David Dwyer

Family Origins: Not known
War Record: First World War 1914–18
Military Service: Cheshire Regiment
Associated with Chapel Street

David is listed on the Chapel Street Memorial as serving with the Cheshire Regiment, but it has not been possible to identify this soldier with any certainty, or to link the name David Dwyer or a variant to Chapel Street. There are medal cards for four men named David Dwyer but none of them appear to have any connection to the Altrincham area.

He is listed on the Chapel Street Roll of Honour as David Dwyer, Cheshire Regiment.

Patrick Egan

Family Origins: Not known
War Record: First World War 1914–18
Military Service: Cheshire Regiment
Associated with Chapel Street

Patrick is listed on the Chapel Street Roll of Honour as serving in the Cheshire Regiment but it has not been possible to identify this soldier with any certainty, or link the name Patrick Egan or a variant to Chapel Street.

There is an Egan family with a strong connection to Chapel Street. Thomas Egan, born in Bradford, Yorkshire, around 1873, and his wife Annie, born in Altrincham, lived at No. 34 Chapel Street in 1901 with their son, Thomas, aged eight months. The same family were at that address in 1911, with the addition of a son, James, aged eight, and daughter, Ellen, aged one. Thomas was listed as a labourer living at No. 34 Chapel Street in a street directory in 1906 and from 1910 to 1916. Thomas and Ann Egan were living at No. 20 Milner Avenue, Broadheath, Altrincham in 1939, a street inhabited by several of the men named on the Roll of Honour.

It is possible that the Patrick Egan listed on the Roll of Honour is in some way related to this family.

He is listed on the Chapel Street Roll of Honour as Patrick Egan, Cheshire Regiment.

John Ennion (1888–1917)

Family Origins: Father, Birmingham, Mother, Birmingham
War Record: First World War 1914–18
Military Service: Lance-Corporal, 3rd, 8th, 9th, 10th and 13th Battalions, Cheshire Regiment, Service No. 12653
Lived at Nos 32 and 54 Chapel Street

No connection has been established between the name John Ennion and Chapel Street and research has indicated that the name on the Chapel Street Memorial should, in fact, have read 'John Inions'.

John was born on 28 May 1888 in Chorlton-cum-Hardy in Manchester and baptised on 5 August at the Church of St Clement. His surname was spelt 'Onions' on his baptism record. His parents were John, a farm labourer, and Mary Annie, née Billing. John's father died in the first quarter of 1891 at the age of forty-three. That same year John, aged three, was living at Beech Road, Chorlton, with his widowed mother and siblings Rose, aged fifteen, William, aged seven, and newly born Frank. In 1899 Mary Annie remarried to George Hulme and the family went to live at No. 53 Acres Road, Chorlton. John married

Catherine Hennerley on 30 October 1909 at Knutsford in Cheshire. At this stage he was known as 'John Inions' and was employed as a groundsman at Anson Golf Club in Longsight in Manchester. In 1911 the couple were living at No. 42 Longridge Street, Longsight, with their eldest son Francis Leo. They went on to have two more sons, Jack and William, and a daughter, Kathleen.

John enlisted in the 8th Battalion, Cheshire Regiment, in August 1914 at Altrincham and gave his address as No. 32 Chapel Street, which was a lodging house run by Peter Gilligan. He stated that he had already served in the 3rd Battalion, Manchester Regiment, although no period of service was given. The address of his next of kin, his wife Catherine, or 'Kate' as she is referred to on his service record, was initially No. 32 Chapel Street, but this was crossed out and No. 9 Lloyd Square, off Regent Road, Altrincham, was added. On 25 October 1914 John was transferred to the 9th Battalion and appointed lance-corporal. His service record noted that he was deprived of his stripes on 9 July 1915 but the reason was not mentioned.

He embarked for France in July 1915 and was admitted to hospital at Rouen with a hand wound on 15 February 1916. A week later he returned to England on the hospital ship HMS *St Denis*. John's youngest son William, aged two, died of capillary bronchitis on 26 March 1916 and the address on the death certificate was given as No. 54 Chapel Street. John transferred to the 10th Battalion, Cheshire Regiment, on 8 December 1916, but was killed in action on 3 January 1917. He was buried at the Tancrez Farm Cemetery, in Belgium. Sadly he never saw his daughter Kathleen, who was born on 22 March 1917.

John's widow Catherine married John Good in 1919 and moved to Walton, Liverpool. Having left the area, she may have been unaware that her former husband's name had been incorrectly inscribed on the Chapel Street Memorial. John's medals were forwarded to her in Liverpool. In 1922, Catherine returned to live at No. 9 Lloyd Square, Altrincham, and wrote to the Army to say she had not received her late husband's memorial plaque. The Lieutenant Colonel in charge of infantry records sent a letter to the Chief Superintendent, Ordnance Factory (Plaque Section) Royal Arsenal, Woolwich, enclosing Catherine's application and asking for the necessary action to be taken, as it was thought the plaque had been missed in manufacture. As John's widow, Catherine was awarded a pension of 26s 3d for herself and their three children.

He is listed on the Chapel Street Roll of Honour as John Ennion, Cheshire Regiment.

William Featherstone

Family Origins: Not known
War Record: First World War 1914–1918
Military Service: Cheshire Regiment
Associated with Chapel Street

William is listed on the memorial as serving with the Cheshire Regiment, but it has not been possible to identify this soldier with any certainty or to link the name William Featherstone or a variant to Chapel Street and he is not listed on the Cheshire Regiment Roll of Honour. There is a reference to a Walter Featherstone on the Altrincham and District Roll of Honour, which is probably him. There are no deaths recorded on the General Register Office for Army deaths 1914–1921 for the surname Featherstone serving in the Cheshire Regiment. It is possible that this name is incorrect on the Roll of Honour.

He is listed on the Chapel Street Roll of Honour as William Featherstone, Cheshire Regiment.

Edward Fitzmaurice (b. 1886)

Family Origins: Father, County Mayo, Ireland; Mother, County Mayo, Ireland
War Record: First World War 1914–18
Military service: Private, 105th and 107th Training Reserve Battalion, Service Nos 66634 and T/4391; Private, 545th Agricultural Company, Labour Corps, Service No. 430599
Lived at No. 22 Chapel Street

Edward was born in 1886 in Swinford, County Mayo. He was the son of Edward, a farmer, and Mary. An Edward Fitzmaurice aged fourteen has been traced on the 1901 Irish census as living at Cuildoo, Swinford, with his parents and siblings John, aged sixteen, Ellen, aged eleven, and Anne, aged nine. There is also an Edward Fitzmaurice, aged twenty-six, on the 1911 Irish census living at Cuildoo with parents named Edward and Mary. Although the ages of his parents vary slightly from the 1901 census, it is likely that this is the same family as no other person named Edward Fitzmaurice with a similar date of birth has been located in this area.

Edward was lodging at No. 22 Chapel Street and employed as a munitions worker at the time of his enlistment in the Army at Chester in June 1917. His father Edward was named as his next of kin and the address given was Killasser, Swinford. He was assessed as Class B1, which made him unfit for general service abroad, but fit for base or garrison service at home or abroad. His Army medical history recorded that he had left internal strabismus, a form of visual impairment. Edward joined the 107th Training Reserve Battalion and was allocated to 105th Training Battalion, both based in Edinburgh. He was then allocated to 545th Agricultural Company, Labour Corps, at Chester. Edward did not serve overseas.

He is listed on the Chapel Street Roll of Honour as Edward Fitzmaurice, Cheshire Regiment.

James Ford (c. 1883–1915)

Family Origins: Father, Liverpool, Mother, Liverpool
War Record: First World War 1914–18
Military Service: Private, 1st Battalion, King's Own Royal Lancaster Regiment, Service No. 6523
Lived at Nos 7 and 22 Chapel Street

James's military records indicate that he was born around 1883 in Shrewsbury. His parents were Henry, an umbrella maker, and Katherine. By 1891 James, aged eight, was lodging at No. 7 Chapel Street with his parents and his elder brother William, aged eleven. In June 1900 James was eighteen and working as a labourer when he enlisted in the King's Own Royal Lancaster Regiment. According to his service record, he had been rejected for military service in the past, due to being underweight. James served at home until January 1901 and then served in Malta until 1903. During this period he was confined to his barracks a number of times for disobeying orders. His misdemeanours included being improperly dressed and returning to barracks at 12.15 a.m., creating a disturbance in camp, having a dirty kit, not putting lights out after 10 p.m., neglecting his rifle and being absent from roll call.

James transferred to the Army Reserve in November 1903, and his papers indicated that his intended place of residence was No. 22 Chapel Street. In 1911 he was a boarder in the household of Thomas Willett, living at No. 7 Station Road, Northwich, and his occupation was 'general hawker'. He was re-engaged in the Army in June 1912 and this time his papers indicated that his home address was No. 26 Station Road. He was posted to France in August 1914.

In September 1914 James's leg was severely wounded and in October that same year he was repatriated and transferred to the Royal Lancaster Hospital. Sadly, James died

on 13 June 1915 of a perforated duodenal ulcer and peritonitis. A telegram was sent to his mother in Warrington, informing her of his death, but it was returned stating 'Mrs Ford, 12 Dutton Street, Warrington is not known.' A War Office memorandum advised that James's personal effects and medals should be despatched to Mrs Louisa Heath of No. 26 Station Road, Northwich. James was buried with military honours in Lancaster Cemetery. A report in the local newspaper dated 18 June 1915, entitled 'Funeral of an Altrincham Soldier', stated that 'a large detachment of men from the Lancaster Barracks took part in the military honours accorded to the deceased, including wounded men home from the Front. Major Paten being in command and the firing party was under the command of Sergeant Instructor Rundle. Deceased was buried according to the rites of the Catholic Church.'

He is listed on the Chapel Street Roll of Honour as James Ford, King's Own Royal Lancaster Regiment.

Arthur Garne/Garner

Family Origins: Not known
War Record: First World War 1914–18
Military Service: Cheshire Regiment
Associated with Chapel Street

The name Arthur Garner is listed on two memorials in Altrincham, the Chapel Street Memorial and the Altrincham and District Roll of Honour as serving with the Cheshire Regiment. The Chapel Street Roll of Honour lists him both as Arthur Garne and Arthur Garner. Despite this, at the time of writing (August 2018) there are no references to anyone with that name or variants associated with Chapel Street and no incontrovertible evidence in military sources that identifies anyone with that name associated with Chapel Street or dying in service. There are three references to the name Arthur Garner in the Cheshire Regiment, but all three survived the war. There is a service record for an Arthur Edward Garner, a farm labourer who was born in Altrincham in 1895. He was the son of George Harry Garner and Lucy née Smith. The 1901 census recorded the family living at No. 37 Russell Street. By 1911 they had moved to No. 15 Tipping Street where Arthur was listed with his parents and siblings William, aged twenty, Annie, aged seventeen, Leonard, aged twelve, and Ernest, aged eleven.

Arthur enlisted in 1914 and served with the 11th Battalion, Cheshire Regiment, Service No. 16010, and was transferred to the Machine Gun Corps in July 1916, Service No. 22828, 75th Brigade Company and 248 Company. He was seriously wounded in 1917 and the local newspaper reported that 'Private A. Garner son of Mr. G. H. Garner of 27 Osborne Road, Altrincham was wounded in the head, arm and shoulder by shrapnel on September 27. His right thumb has been taken off. He is now in hospital at Keighley, North Yorkshire.' However, he survived his injuries but suffered a 30 per cent disablement and in June 1918 he was transferred to the Labour Corps serving with 546 and 345 Agricultural Companies, Service No. 592967. He was listed on the absent voters list for 1919 along with his brothers Leonard, 1st Cheshire Regiment, Service No. 210496, and William Ewart, Cheshire Regiment, Service No. 240940. He was demobilised on 1 March 1919 and returned to live at No. 27 Osborne Road, Altrincham, and was still alive in February 1922. There is a possibility that this was the Arthur Garner who was listed on the Chapel Street Memorial, as it may have been incorrectly reported that he had died at the time the Roll of Honour was commemorated in 1919.

He is listed on the Chapel Street Roll of Honour as Arthur Garne/Garner, Cheshire Regiment.

James Gormley (b. 1893)

Family Origins: Father, unknown; Mother, Knutsford, Cheshire
War Record: First World War 1914–18
Military Service: Driver, 8th Army Service Corps, Service No. T/30671
Lived at Nos 20 and 26 Chapel Street

James Thomas was born on 16 November 1893 in Altrincham and baptised at the Church of St Vincent de Paul on Christmas Eve that same year. His parents were Peter and Ellen, née Corfield. The 1901 census recorded that James, aged seven, was an inmate at Knutsford Workhouse, along with his mother, who was employed as a field worker, and his two brothers John, aged six, and Peter, aged five. The 1897 electoral register listed their father Peter as living at Back Chapel Street, but after this date his whereabouts are unclear. In 1911, James and Peter were lodging with the Oxley family at No. 20 Chapel Street and James was employed as a general labourer. On 19 October 1911 he enlisted in the 8th Reserve Park, Army Service Corps, and according to his Medal Roll Index card, entered the theatre of war in November 1914. The local newspaper dated September 1914 included an article entitled 'Street of Soldiers', which listed those men who had joined up to fight and included 'Gormley, two brothers'. On 26 October 1915 he married Mary Alice Oxley, the niece of his landlord Alfred Oxley, at the Church of St Vincent de Paul, Altrincham.

James appeared on the absent voters list for 1918 living at No. 26 Chapel Street. On 13 April 1919, he was discharged from the Army for being no longer physically fit for war and was awarded the Silver War Badge. After the war James and Mary Alice continued to live at No. 26 Chapel Street for a number of years and had at least one child. By 1939 they had moved to No. 16 Milner Avenue, Altrincham, and James was working as an engineer's labourer. James's brother Peter is also listed on the Chapel Street Roll of Honour.

He is listed on the Chapel Street Roll of Honour as James Gormley, Army Service Corps.

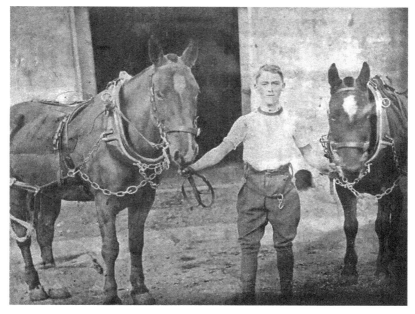

The man in this image has been identified by a family member as James Gormley. A local newspaper dated September 1914 included an article about Chapel Street entitled 'Street of Soldiers', which listed those men who had joined up to fight. It included two Gormley brothers. (Image courtesy of Stuart Anthony Hurlston)

Peter Gormley (1896–1957)
Family origins: Father, not known; Mother, Knutsford, Cheshire
War Record: First World War 1914–18
Military Service: Private 1st, 3rd, 9th, 11th and 15th Battalions, Cheshire Regiment, Service Nos 10408, 4114384
Lived at Nos 13, 20 and 28 Chapel Street

Peter Gormley was born on 10 March 1896 at Altrincham and was baptised at the Church of St Vincent de Paul on 12 April. His parents were Peter and Ellen, neé Corfield. In 1901 Peter, aged five, was an inmate at Knutsford Workhouse along with his mother and brothers James, aged seven, and John, aged six. The 1897 electoral register listed their father Peter at Back Chapel Street, but after this date his whereabouts are unclear. By 1911 Peter and James were lodging with the Oxley family at No. 20 Chapel Street and Peter was employed as an errand boy for a market gardener.

Peter enlisted in the Cheshire Regiment prior to the start of the First World War, in February 1914. He was listed on the Daily Orders for 2 September 1914 as being admitted to hospital at Birkenhead. A month later he was readmitted to hospital for eleven days but his medical condition was not recorded. The local newspaper dated 8 September 1914 included an article entitled 'Street of Soldiers', which listed those men who had joined up to fight and included two Gormley brothers. Peter's service record has not been traced but it is known from his medal rolls that he was sent to France in January 1915, serving with the 1st, 3rd, 9th, 11th and 15th Battalions during the war. He was awarded the Victory and British War Medals. In a list of postings from Heaton Park, he was posted to Reserve Unit, Cheshire Regiment, at Seaton Carew on 24 May 1918, but in the edition of the *Police Gazette* dated 16 July 1918, he was reported as an absentee or deserter. The reasons for his actions are unclear but it may have been due to unforeseen circumstances, poor health or family reasons. Peter had already served four years in the Army and it is possible the experiences he had witnessed during the war had taken their toll. Peter's Medal Rolls Index card indicated that his war medals were forfeited for desertion as a result of a District Court Martial on 24 September 1918, but this statement was later crossed out and replaced with 'medals forfeited'. Later rolls indicate that the charge of desertion was dropped and the medal roll resubmitted. Peter remained in the Army after the war but was eventually discharged on 5 May 1921.

In 1922 Peter married Ellen Curley, née Shaw, the widow of William Curley who had died in 1918. Peter and Ellen are listed on electoral rolls, living at No. 28 Chapel Street from 1923–1930 and at No. 13 Chapel Street in 1931. By 1939 they had moved to No. 28 Lee Avenue, Altrincham, with their two children and Peter's occupation was listed as 'Corporation A.R.P labourer work'. Peter died in March 1957, aged sixty.

Peter's brother James is also listed on the Chapel Street Memorial.

He is listed on the Chapel Street Roll of Honour as Peter Gormley, Cheshire Regiment.

John Green (1895–1916)
Family Origins: Father, Ashton under Lyne, Lancashire; Mother, Ashton under Lyne
War Record: First World War 1914–18
Military Service: Private, 9th Battalion, Cheshire Regiment, Service No. 11820
Lived at No. 51 Chapel Street

John was born in 1895 in Ashton-under-Lyne. His parents were Thomas and Mary, née Murphy. In 1901 John, aged six, was living with his parents and siblings George, aged sixteen, and Emily, aged two, at No. 2 Hibberts Yard, Ashton-under-Lyne. By 1911 the family had

moved to Altrincham and were boarders at No. 51 Chapel Street, where John's occupation was recorded as a small wares hawker and his age as nineteen. He married Rachel Bradley in the third quarter of 1913 in Ashton-under-Lyne and the couple were living in Hyde, Manchester, when John enlisted in the 9th Battalion, Cheshire Regiment. John's Medal Roll Index card indicated that he embarked for France in July 1915. The 9th Battalion were involved in the opening of the Battle of the Somme and tragically John died of wounds on 4 July 1916. His effects of £8 and 10s were passed to his widow Rachel. He is commemorated at the Thiepval Memorial. The Commonwealth War Grave entry stated he was aged twenty-five although his actual age was twenty-one.

He is listed on the Chapel Street Roll of Honour as John Green, Cheshire Regiment.

Michael Groarke (1896–1941)
Family Origins: Father, County Mayo, Ireland; Mother, Manchester
War Service: First World War 1914–1918
Military Service: Private 1st, 2nd and 3rd Battalions, Cheshire Regiment, Service No. 9278
Lived at No. 22 Chapel Street

Michael Groark was born on 8 February 1896 in Altrincham and baptised on 8 March at the Church of St Vincent de Paul. His parents were John and Agnes, née Grant. In 1901 Michael, aged five, was living at No. 22 Chapel Street, a lodging house run by his father, with his parents and siblings William, aged eleven, Julia, aged eight, and Kitty, aged three. By 1911 the family had moved to No. 6 John Street, Altrincham, where John Groark was lodging house keeper. Michael, aged fifteen, was employed as a plate moulder at an engineering works, likely to be the Linotype and Machinery Co., Broadheath, as his name was listed on the factory's Roll of Honour.

Michael enlisted in the 2nd Battalion of the Cheshire Regiment in May 1914 shortly before the outbreak of war. He was transferred to France in October 1914. The International Red Cross recorded him as missing in November 1914 and this status was reported in the local newspaper dated February 1915. However, according to his Medal Roll Index card, Michael had been taken prisoner of war.

After he was repatriated, Michael returned to live at No. 6 John Street, later moving to No. 19 Heyes Street, Altrincham, and then No. 19 Eaton Road, Bowdon. He married Annie Agnes Owens on 27 October 1921. By 1938 he had relocated to Liverpool with his family and was recorded in 1939 as living at No. 16 Ponsonby Street, working as a warehouse labourer. Michael died at sea on 5 June 1941 of heat apoplexy on board the cargo ship *Comedian* where he worked as a fireman and trimmer. He was aged forty-five.

Michael's brother William is listed on the Chapel Street Roll of Honour as one of the soldiers who gave their lives.

He is listed on the Chapel Street Roll of Honour as Michael Groark, Cheshire Regiment.

William Groarke (1889–1915)
Family Origins: Father, County Mayo, Ireland; Mother, Manchester
War Service: First World War 1914–18
Military Service: Private, 3rd Battalion, Cheshire Regiment Militia, Service No. 7086; Private, 8th Battalion, Cheshire Regiment, Service No. 11267
Lived at Nos 22 and 24 Chapel Street

William Groarke was born on 4 July 1889 in Altrincham and baptised on 21 July at the Church of St Vincent de Paul. His parents were John and Agnes, née Grant, who married in 1886. In 1891 William was living at No. 22 Chapel Street, a lodging house run by his father.

As well as his parents, William lived with his sister Mary, aged three, two half-brothers John and Patrick Hines, a cousin, plus nine lodgers. In 1901 the family were living at the same address, although the lodging house had extended to No. 24 Chapel Street and was inhabited by William, aged eleven, his parents, siblings Julia, aged eight, Michael, aged five, Kitty, aged three, a cousin and nine lodgers.

On 15 January 1904 William enlisted in the Cheshire Militia at Hale and served for six years. He must have been keen to join as he gave his age as seventeen years, six months on enlistment, when in fact he was two years younger. In 1911 he worked as a labourer in the building trade and was living with his family and four lodgers at No. 6 John Street, Altrincham, where his father was the lodging house keeper.

William enlisted in the 8th Battalion, Cheshire Regiment, and embarked for the Balkans on 26 June 1915. He died of wounds on the battlefield at Anzac, Gallipoli, on 18 August that same year, while his battalion were preparing defences in anticipation of an attack on Hill 60. The Army Register of Soldiers' Effects indicated that William's father, being his next of kin, received a sum of £2 6s 6d, which remained in his Army account. William is commemorated on the Helles Memorial.

William's brother Michael is also listed on the Chapel Street Roll of Honour.

He is listed on the Chapel Street Roll of Honour as William Groark, Cheshire Regiment.

Dennis Hanley (1889–1916)

Family Origins: Father, Altrincham; Mother, Altrincham; Grandparents Ireland
War Record: First World War 1914–1918
Military Service: Private, 8th Battalion, Cheshire Regiment, Service No. 12477
Corporal, 9th Battalion, Cheshire Regiment, Service No. 12477
Lived at Nos 10, 12, 44 and 46 Chapel Street

Dennis was born on 16 June 1889 in Altrincham and baptised as Dennis May on 28 July at the Church of St Vincent de Paul. He lived on Chapel Street from at least 1891. His parents were Katherine, née May, and James, who married after his birth, on 25 July 1889.

In 1901 Dennis, aged eleven, was living with his parents and brothers James, aged nine, John, aged six, Michael, aged three, and sister Mary Ann, aged eight, at No. 44 Chapel Street. By 1911 he had moved to No. 10 and was working as a labourer at a printing machinery company, which was probably the Linotype and Machinery Co. in Broadheath. An article was published in the local newspaper in 1914 entitled 'A Street of Soldiers', which listed those who had joined up and included a reference to four Hanley brothers serving. Although no first names were given, these would have been Michael, Dennis, James and John.

On the 14 October 1915, aged twenty-six, he married Catherine Hennerley at the Church of St Vincent de Paul. They had two sons: Dennis, born in 1912, and John (Michael), known as Jack, in 1914.

In August 1914 Dennis joined the 8th Battalion, Cheshire Regiment. His attestation papers dated 30 August list him as Dennis Handley rather than Hanley, aged twenty-five years and six months. He gave his address as No. 12 Chapel Street and his occupation as labourer. In July 1915 he was sent to France and, unfortunately, while serving there, his wife died at the age of twenty-three. Her sister Florence Hennerley took over the responsibility of the two children.

In December 1915 Dennis was appointed lance-corporal and then to corporal with the 9th Battalion on 15 April 1916. The 9th Battalion were heavily involved in the Battle of the Somme at La Boiselle and Dennis was killed in action on 4 July, aged twenty-seven. His effects of £1 4s 11d were passed to his sister-in-law Florence Hennerley for benefit of the soldier's children Dennis and John. Florence took responsibility for Dennis's estate on behalf of the

orphaned sons and in 1919 married Thomas Booth on his return from the war. Dennis is commemorated on the Thiepval Memorial.

Dennis's brothers James, John and Michael are named on the Chapel Street Roll of Honour. He is listed on the Chapel Street Roll of Honour as Dennis Hanley, Cheshire Regiment.

James Hanley (b. 1890)

Family Origins: Father, Altrincham; Mother, Altrincham; Grandparents Ireland
War Record: First World War 1914–1918
Military Service: Private, 8th and 9th Battalions, Cheshire Regiment, Service No. 12482
Lived at Nos 10, 44 and 46 Chapel Street

James was born on 24 September 1890 in Altrincham and baptised on 12 October at the Church of St Vincent de Paul. His parents were Katherine, née May, and James, who lived at No. 46 Chapel Street in 1891.

In 1901 James, whose age was listed as nine, moved to No. 44 Chapel Street with his parents and siblings Dennis, aged eleven, James, aged twenty, John, aged six, Michael, aged three, and Mary Ann, aged eight. In 1911 he was working as clerk at a printing machinery company, which was probably the Linotype and Machinery Co. in Broadheath, as a post-war letter, dated 6 January 1919, from the Linotype and Machinery Co., referred to his continued employment after his demobilisation. It is probable that his older brother Dennis may also have worked for the same company. In 1911 he married Gertrude Stead, setting up home at No. 32 Islington Street, Altrincham, where they had two daughters before he enlisted at Hale, Cheshire, in August 1914. He was 5 feet 8 inches tall and was described as being of fresh complexion with blue eyes and brown hair.

An article was published in the local newspaper in 1914 entitled 'A Street of Soldiers', which listed those who had joined up and included a reference to four Hanley brothers serving. Although no first names were given, these would have been Michael, Dennis, James and John.

James was attached to the 8th Battalion, Cheshire Regiment in 1914 and sailed for France in July 1915 as part of the 9th Battalion, Cheshire Regiment. He undoubtedly saw a lot of action as the 9th Battalion was involved in both the Battles of the Somme and Passchendaele. His Army record gives a good indication of his involvement during the duration of the whole war, and the occasions when injury prevented him being at the front.

In a letter dated 6 January 1919 Private J. Hanley was offered employment with the Linotype and Machinery Co. The letter stated that 'he is currently on leave' and forwarded his return warrant. James was demobilised on 13 February 1919 and, true to their word, Linotype re-employed him as they had promised in their 1914 letter.

In 1939 James was recorded as being a foundry clerk living at Moss View, Altrincham, with his wife Gertrude and daughter Winifred.

James's brothers Dennis, John and Michael are named on the Chapel Street Roll of Honour. He is listed on the Chapel Street Roll of Honour as James Hanley, Cheshire Regiment.

John Hanley (b. 1894)

Family Origins: Father, Altrincham; Mother, Altrincham; Grandparents Ireland
War Record: First World War 1914–18
Military Service: Private, 9th Battalion, Cheshire Regiment, Service No.14716; Private, 3rd and 7th Battalion, Royal Irish Rifles, Service No. 4681; Private, Royal Defence Corps, Service No. 87348
Lived at Nos 10 and 44 Chapel Street

John was born on 19 September 1894 in Altrincham and baptised on 14 October at the Church of St Vincent de Paul. His parents were Katherine, née May, and James Hanley, who lived at No. 44 Chapel Street in 1901.

In 1911 John, aged sixteen, was living at No. 10 Chapel Street with his parents and siblings Dennis, aged twenty one, James, aged twenty, Mary Ann, aged eighteen, and Michael, aged thirteen. He was described as working as a general labourer in an iron foundry. In September 1914, aged nineteen, John enlisted with the 9th Battalion, Cheshire Regiment. The local newspaper dated September 1914 included an article entitled 'Street of Soldiers', which listed those men who had joined up to fight and included four Hanley brothers. His attestation papers described him as being 5 feet 5 and a half inches in height with a fresh complexion, light brown hair and grey eyes. Unfortunately, less than two months later he was discharged as 'unlikely to become an efficient soldier'. His determination to serve, however, saw him enlist again in early 1915 with the 7th Battalion, Royal Irish Rifles, and by the end of that year he was in France. Towards the end of the war he served with the Royal Defence Corps, serving on home duties guarding strategic installations and prisoners of war. After his discharge he returned to No. 10 Chapel Street and his parents, and subsequently moved with them to No. 22 Milner Avenue, Altrincham.

In 1939 he was registered as unmarried and was still living with his parents at Milner Avenue and employed as a general labourer at the Water Works. His nephew, named John M. Hanley, the son of his brother Dennis, who was killed in action in the First World War, was also living with them.

John's brothers Dennis, James, and Michael are also named on the Chapel Street Roll of Honour.

He is listed on the Chapel Street Roll of Honour as John Hanley, Royal Irish Rifles.

Richard Hanley (1897–1945)

Family Origins: Father, Altrincham; Mother, Altrincham; Grandparents Ireland
War Record: First World War 1914–1918
Military Service: Private, 8th Battalion, Cheshire Regiment, Service No. 11386;
Lance-Corporal, 8th Battalion, Cheshire Regiment, Service No. 19832
Lived at Nos 10 and 44 Chapel Street

There is no evidence of a man named Richard Hanley linked to Chapel Street and while the memorial details refer to this name, the evidence indicates that there may have been an error in the restoration of the memorial and that it should refer to Michael Hanley, the brother of the other men named Hanley listed as having served in the war.

Michael was born on 8 April 1897 in Altrincham and baptised on 25 April at the Church of St Vincent de Paul. His parents were Katherine, née May, and James Hanley. In 1901 Michael, aged three, was living at No. 10 Chapel Street with his parents and siblings Dennis, aged eleven, James, aged nine, Mary Ann, aged eight, and John, aged six. In 1911, aged thirteen, he was still at school but by 1914 he was working as a labourer.

When he enlisted on 17 August 1914 he was only seventeen but claimed to be nineteen. The local newspaper dated September 1914 included an article entitled 'Street of Soldiers', which listed those men who had joined up to fight and included four Hanley brothers. His enlistment papers name his father James and mother Kate as his next of kin. He joined the 8th Battalion, Cheshire Regiment, and prior to leaving for overseas service, then aged eighteen, he was made lance-corporal and given a new service number. He served at Gallipoli in the Balkans before moving to Mesopotamia in 1916. Unfortunately, he was deprived of the corporal's stripe for misconduct as he fell asleep at his sentinel post and as a result served two months field punishment number one. In his continued service he spent some time in hospital on account of gunshot wounds and malaria. He served from 1914 to 1919 and was demobilised in early 1919, serving with the 3rd Special Battalion, Cheshire Regiment, before rejoining the 8th Battalion before his discharge in September.

He returned to Chapel Street and in 1921 married Nancy Caine, a widow who had been married to Leonard Caine, who had been killed in 1918. Michael took on the role of father to Nancy's children along with Dennis, his own son by Nancy. He returned to his labourer work, later becoming a foreman. The family moved to No. 15 Moss View, Altrincham, where Michael died on 19 April 1945.

He is listed on the Chapel Street Roll of Honour as Richard Hanley, Cheshire Regiment.

Harry Hannon

Family Origins: Not known
War Record: First World War 1914–18
Military Service: Royal Engineers
Associated with Chapel Street

We have been unable to trace any connection between a Harry Hannon in military records and either Altrincham or the Royal Engineers. There is a reference to a Patrick Hannon, aged twenty-one, from Galway, Ireland, lodging at No. 73 New Street in 1901 and also a Patrick Hanna, aged thirty-one, from Ireland boarding at No. 22 Chapel Street in 1911, which may be the same person. The only link to the surname Hannon can be found in the local newspaper dated 7 November 1900, which reported that 'a domestic servant from Bowdon, named Bailey, called at Mrs Hannon's house at 29 Chapel Street, Altrincham, to have a dress tried on. Whilst there, she alleged that a man named Thomas Poole took a half-sovereign she had used for payment. Mrs Hannon followed Poole down the street but he denied taking the coin.' The Mrs Hannon referred to in the case was a Catherine (Kate) Hannon, née Ratchford, who had married Frederick B. Hannah in 1897. It appears that the surname Hannon has taken many different forms and has been spelt as Hammond, Hannon, Hanna and Hannah.

He is listed on the Chapel Street Roll of Honour as Harry Hannon, Royal Engineers.

James Hardy (b. 1873)

Family Origins: Father, Altrincham; Mother, Altrincham
War Record: First World War 1914–18
Military Service: Private, 1st & 2nd Battalions, Cheshire Regiment, Service No. 6783
Associated with Nos 32 and 34 Chapel Street

James Hardy, who enlisted in the 2nd Battalion, Cheshire Regiment, Service No. 6783, in 1902 at Bowdon was the grandson of James Hardy, born around 1811, who lived at No. 32 Chapel Street in 1861 and No. 34 Chapel Street in 1881. James was born in 1873, the son of James and Mary, née Starkey, though his Army attestation in 1902 gives his age as twenty-four years and nine months. His occupation at this time was a labourer.

James, aged eight, was living at No. 2 Wellington Street, Altrincham, in 1881 with his parents and siblings Arthur, aged fourteen, Ada, aged twelve, and Maud, aged one. After James's mother Mary died in 1889, his father married Louisa Horton in 1890 and James was living with his father and stepmother at No. 29 Russell Street, Altrincham, in 1891 and at No. 33 Russell Street in 1901. This is the address that is given for his father as next of kin when he enlisted in 1902. Although James has a clear connection to Chapel Street, there is no evidence of him living in the street.

James was discharged from the 1st Battalion, Cheshire Regiment, in March 1914, having served for all twelve years in the UK. In the first years of his Army career he had fallen foul of Army authorities on account of drunkenness on five occasions, as well as lateness. On discharge his intended place of residence was given as No. 11 Albert Street, Altrincham. This was the

address of Esther Royle, the mother of Gertrude, whom he had married in the first quarter of 1910, and the address at which he and his wife were living in 1911. He was registered to vote at this address from 1918, though not marked an absent voter, and the 1939 register recorded James Hardy, born 2 January 1873, living with his wife Gertrude, at No. 11 Albert Street.

James Hardy was listed on the Chapel Street Roll of Honour as having served with the King's Own Royal Lancashire Regiment. Evidence for only one soldier of that name from that regiment has been located, Service No. 12214. However, evidence for this man is limited to medal records, which show he served in the 2nd and 5th Battalions of this regiment and later transferred to the Labour Corps, Service No. 347715. He went to France in February 1915 and was discharged in mid-December 1917. There is also a record of an admission to a Casualty Clearing Station for synovitis of the knee on 25 Apr 1915, which may explain the transfer to the Labour Corps. There is insufficient evidence to show this soldier lived in Altrincham and it is not clear whether this man and the James Hardy described above are the same soldier.

He is listed on the Chapel Street Roll of Honour as James Hardy, King's Own Royal Lancs Regiment.

William Haughton (1882–1916)

Family Origins: Father, Eccles, Lancashire; Mother, Dublin, Ireland
War Record: First World War 1914–18
Military Service: Private, 8th Battalion, Royal Berkshire Regiment, Service No. 14738, Lance-Corporal, 8th Battalion, Royal Berkshire Regiment, Service No. 14738
Lived at No. 39 Chapel Street

William Ernest Haughton was born 1882 in Newton Heath, Manchester. His parents were Mary and Peter Haughton, who worked as a commercial traveller. In 1881 Peter Houghton, aged thirty-nine, was living with his wife Mary, aged twenty-eight, and daughter Amy, aged two, at No. 29 Barrett Street in Manchester. In 1891, perhaps following some reversal of fortune, the family, including William Ernest, aged nine, and James Leonard, aged five, were living in the Salford Union Workhouse. William's father Peter was listed as a clerk (accountant). By 1901, Mary was a widow and was working as a shopkeeper/provision dealer on her own account and had moved to No. 39 Chapel Street with her sons William, an iron turner, and James.

In the early 1900s the names of both William and his mother made several appearances in the local newspaper. In April 1900 William issued a summons for assault against Edith Barber of Back Chapel Street, who was fined 2s 6d. In July 1901 he and three other youths pleaded guilty to stealing strawberries in Timperley and were each fined 10s. An article in September 1905 entitled 'A Noisy and Disgraceful Street' gave an account of an altercation between Mary Haughton, grocer, and Annie Kelly of Chapel Street. A witness said he heard Mrs Kelly and Mrs Haughton falling out, but as they were 'frequently at it' he did not take much notice. He said, 'There were always rows in Chapel Street, which was the noisiest and most disgraceful street he had seen in all his life.' The summons against Mrs Haughton was dismissed. In October 1906 William Haughton, a mechanic and keeper of a lodging house in Chapel Street, was convicted and fined for being drunk and disorderly.

In 1911 William, working as a turner, was still living at No. 39 Chapel Street with his mother Mary. He enlisted as a private in the Royal Berkshire Regiment in September 1914. He was recorded as being a deserter in Reading on 12 January 1915 in the *Police Gazette* dated January 1915. However, he must have rejoined the regiment quickly as he arrived in France in the first week of August 1915 with the 8th Battalion and spent time in hospital there in October. He was promoted to lance-corporal but was killed in action on 11 March 1916.

His mother Mary was listed as his sole legatee and was issued with a war gratuity of £6 10s. He was buried in St Patrick's Cemetery, Loos, France.

He is listed on the Chapel Street Roll of Honour as William Haughton, Royal Engineers.

John Healey (1878–1921)

Family Origins: Father, County Mayo, Ireland; Mother, County Mayo, Ireland; Grandparents Ireland
War Record: First World War 1914–18
Military Service: Sapper, Royal Engineers, Service No. 11155
Lived at No. 18 Chapel Street

John was born on 26 November 1878 in Altrincham and baptised on 15 December at the church of St Vincent de Paul. His parents were Julia, née Hines, and Michael Healey. The Healey family had had a long-standing connection with Chapel Street, dating back to John's grandparents, also from Ireland, who lived there in the 1860s and 1870s. However, in 1881 John, aged two, was living at No. 18 Oakfield Street with his father Michael, aged twenty-five, his mother Julia, aged twenty-nine, and his sister Mary, aged eight months. In 1884 his father died and in 1886 his mother married John Manion, who worked as house painter. By 1891 the family had moved to No. 18 Chapel Street, which was also the Rose and Shamrock Public House. In 1901, still at Chapel Street, John was working as a brick setter, living with his mother, who was by that time widowed, his sister Mary and cousin Agnes.

In 1909 John married Annie Foy and by 1911 was living at No. 101 Lawrence Road in Broadheath where he was employed as a bricklayer. By 18 August 1914 he had joined the Army and was serving overseas with the Royal Engineers and was awarded the 1914 Star, but unfortunately few details of his military career have been found. In 1918 and 1919 he was listed on the absent voters list for No. 2 Bridgewater Road, Altrincham.

Sadly, John died at the age of forty-one in March 1921 in what were very tragic circumstances. After the war had ended he continued to serve as an Army reservist for a short period with the Royal Engineers at Mons before returning home. Unfortunately his health had suffered and resulted in what was termed at the time as nervous debility, but which today would be identified as post-traumatic stress disorder. He took his own life by cutting his throat in front of his wife and on 11 March 1921 his suicide was recorded in the local newspaper: 'Answering the coroner, Mrs Healey said her husband had never intended to take his own life'; however, the coroner's verdict was 'that John took his life while suffering from "impulsive insanity"'.

He is listed on the Chapel Street Roll of Honour as John Healey, Royal Engineers.

Frank Hennerley (1890–1947)

Family Origins: Father, Altrincham; Mother, Altrincham, both of Irish descent
War Record: First World War 1914–18
Military Service: Private, 8th Cheshire Regiment, Service No. 11533; Private, Labour Corps, Service No. 268039
Lived at Nos 10, 13 and 17 Chapel Street

Francis Joseph Hennelley (*sic*) was born in Altrincham on 30 May 1890 and baptised a month later at the Church of St Vincent de Paul. He was recorded in the following year living at No. 17 Chapel Street with his parents Dennis, a joiner, and mother Mary, née Haley. He was the cousin of the other Hennerley men listed on the Chapel Street Memorial.

The family remained in Chapel Street, living at No. 10 in 1901 and No. 13 in 1911 where Frank, aged twenty, was living with his father, for whom he worked as a marine store dealer,

along with his sisters Catherine, aged nineteen, and Florence, aged fifteen. In September 1911 Frank married Annie Elizabeth Mitchell in Altrincham. In 1914 he was living at No. 2 Police Street, Altrincham, but at the outbreak of war Frank, working as a pedlar, gave his address as No. 12 Lloyd Square, Altrincham, where he and his wife lived with two children, Mary and William.

Frank was among the first to enlist, joining the 8th Battalion, Cheshire Regiment, on 24 August 1914, but was soon classified as 'medically unfit for further service' and discharged a month later, on 28 September 1914. Undeterred, he re-enlisted on 6 July 1915 and served as a private in the Labour Corps. He was again discharged on 5 January 1918, being found unfit on account of deformities of the toes, a hereditary and permanent condition. Frank was awarded the Silver War Badge. It is likely that he did his Army service, probably in great discomfort, on home soil, as no record has survived of the issue of any campaign medals. The medical report described his character as 'V. Good'.

He was discharged to No. 34 Egerton Street, Sale, where he lived until 1922. The following year he was registered to vote back at No. 13 Chapel Street, where his father was also registered until his death in May 1928. In 1939 there was a pedlar named Frederick Hennerley, born in May 1890, living in shared accommodation at No. 26 Islington Street who seems likely to have been Frank. There was no mention of his wife and children on these records.

There is a death of a Francis J. Hennerley, aged fifty-six, registered in Salford in 1947 and the Church of St Vincent de Paul recorded his burial as 2 May of that year and death as 27 April.

He is listed on the Chapel Street Roll of Honour as Frank Hennerley, Cheshire Regiment.

Hugh Hennerley (1877–1937)

Family Origins: Father, Altrincham; Mother, Altrincham, both of Irish descent.
War Record: Anglo-Boer War 1899–1902; First World War 1914–18
Military Service: Private, 2nd Battalion, Cheshire Regiment, Service No. 4194; Private, 4th Battalion, West Yorkshire Regiment, Service No. 6075; Private, Battalion, Cheshire Regiment, Service No. 10426; Private, York and Lancaster Regiment, Service No. 43268
Lived at Nos 33 and 59 Chapel Street

Hugh was born in Altrincham on 23 December 1877 and baptised on 20 January 1878 at the Church of St Vincent de Paul. His parents were John and Margaret (née Fletcher or Flisk). In 1881 the family, including Hugh, aged three, and his siblings James, aged four, and John, aged eleven months, were living at No. 59 Chapel Street. By 1891 he had moved to No. 33 where Hugh's occupation was recorded as newsboy.

In April 1900 Hugh married Mary Cunningham and in 1901 she resided as head of the household at No. 25 Denmark Street, Altrincham. The Anglo-Boer War medal rolls show that Hugh was serving at this time in South Africa with the 2nd Battalion, Cheshire Regiment. A militia reservist, he was awarded the Queen and King's South Africa Medals with three clasps for action.

After the birth of his first child, Margaret, registered in Oldham in 1903, Hugh moved to Leeds. During his time there he had several addresses, including No. 31 Brunel Street, Armley, in 1911. He was employed as a bricklayer and a labourer in an ironworks and spent a period as a volunteer in the West Yorkshire Regiment where his record was marked 'character good, but permanently unfit'.

By 1914 Hugh and his family were back in Altrincham and living at No. 32 Police Street. When war broke out Hugh was quick to enlist and was training with other reservists at Birkenhead before the end of August 1914. The few surviving fragments of his service records show he put some initial disciplinary transgressions behind him and played a full part in

the war. Serving initially with the Cheshire Regiment he entered France on 18 December 1914. He returned home on a hospital ship for a short spell in 1915, having contracted enteric fever. His obituary states that he was gassed while serving with the York and Lancaster Regiment in France in 1916. He was demobilised in February 1919.

Post-war Hugh lived in Paradise Street, Altrincham until the early 1930s, when the family moved to No. 19 Stokoe Avenue, Oldfield Brow. He died there on 4 February 1937 and was buried in Hale Cemetery. Prior to his death he had been employed at the local RAF depot.

Hugh appears on the Chapel Street Memorial with three of his brothers and a cousin. His uncle Dennis was a member of the memorial committee. Subsequent generations of Hennerleys maintained the family's military service traditions and Hugh's son, James, a Military Medallist with the Cheshire Regiment, was killed in North Africa in 1942. Hugh's grandson, the late Peter Hennerley, helped to keep the Chapel Street story in the public eye and was a key figure pushing for blue plaque recognition. Over the years he gave a number of press interviews, published a booklet and released a DVD about Chapel Street and used Hugh's story to illustrate the sacrifices and commitment displayed by the street's residents.

He is listed on the Chapel Street Roll of Honour as Hugh Hennerley, Cheshire Regiment.

James Hennerley (1876–1901)

Family Origins: Father, Altrincham; Mother, Altrincham, both of Irish descent
War Record: Not known
Military Service: Private, 2nd Battalion, King's Own Royal Lancaster Regiment, Service No. 4876; Private, 2nd Battalion, King's Liverpool Regiment, Service No. 5991; Gunner, Royal Horse and Field Artillery, Service No. 9930
Lived at Nos 33 and 59 Chapel Street

James was born in Altrincham on 25 July 1876 and baptised the following day at the Church of St Vincent de Paul. His parents John and Margaret (née Fletcher or Flisk) married in February that year. In 1881 the family, including James, aged four, and his siblings Hugh, aged three, and John, aged eleven months, were living at No. 59 Chapel Street. By 1891 he had moved to No. 33 where his occupation was recorded as labourer.

In 1897 James Hennelly, of Chapel Street, appeared at Altrincham Petty Sessions charged with a breach of the peace and was bound over to keep the peace. A warrant for his apprehension was issued on 21 May 1900 when he failed to appear at the same sessions 'for using bad language to the annoyance of passengers in the public street'.

On the Chapel Street Memorial James was listed as serving with the King's Own Royal Lancaster Regiment. However, we have not been able to trace any military records associated with the First World War and he was not listed on the memorial's separate list of the Chapel Street war dead. The only reference to James during the war was in a local newspaper report on 22 October 1915 of his brother William's death, which also gave details of the other brothers' whereabouts and said of James, 'Private James Hennerley, of the King's (Liverpool) Regiment), died in India some years ago'. His death, which we have traced to back to 1901, indicates that the names of men on the Chapel Street Memorial were not exclusive to the First Word War and also included the Anglo-Boer War and other service.

There was an Army service record for a John Flisk of St Vincent's parish, Altrincham, who attested for the Royal Horse and Field Artillery on 18 May 1900. He was recorded as a gunner. His next of kin was given as John Flisk of No. 33 Chapel Street, Altrincham, the home of James's parents. Flisk's Army record shows that he had previous service as 'Jas Hennelly' with the King's Own Royal Lancaster and King's Liverpool regiments, the latter ending in 1898 when he was discharged with ignominy. This may explain why he used another surname to re-enlist when he joined the Artillery in 1900. Following a period of imprisonment in the

autumn of 1900, he was posted to India in December. He died of dysentery on 28 November 1901 at Barrackpore, North West India. The record of deceased soldier's effects gave his name as John Flisk, alias Hennerley, and his father's name as John Hennerley.

He is listed on the Chapel Street Roll of Honour as James Hennerley, Kings Own Royal Lancs Regiment.

Martin Hennerley (1891–1942)

Family Origins: Father, Altrincham; Mother, Altrincham, both of Irish descent
War Record: First World War 1914–1918
Military Service: Private, 2nd Cheshire Regiment, Service No. 11832
Lived at No. 33 Chapel Street

Martin, the youngest son of John and Margaret (née Fletcher or Flisk), was born in Altrincham on 2 February 1891 and baptised at the Church of St Vincent de Paul. At that time the family was living at No. 33 Chapel Street. Martin was still resident at the same address in 1901, aged nine, with his parents, brothers John, aged twenty, Dennis, aged seventeen, William, aged thirteen, and sisters Mary, aged fifteen, and Kate, aged eleven. His older brothers Hugh and James had left home by this time.

He married Henrietta Ikin in Altrincham on 1 April 1911. The couple were living that year with his brother William and family at Melling Street in Longsight, Manchester, with Martin's employment given as labourer. At the outbreak of the war he was working for the Linotype and Machinery Co. at Broadheath.

His Army service record has not survived, but other sources show he enlisted in the Cheshire Regiment in 1914 and went to France the following summer. According to his obituary notice in the *Altrincham Guardian* he fought in seven countries. The newspaper continues: 'his daughter was six weeks old when he went overseas and she was five and a half years when he returned'. He was demobilised on 4 June 1919.

After the war he was afflicted by the effects of gas and malaria. From 1919 he lived at No. 2 Pownall Street and was there until his death in 1942. The 1939 Register recorded him as an engineer's labourer and his obituary states that he worked at Tilghmans Patent Sandblast Company, Broadheath; a job he had to give up on account of ill health. Martin was buried in Hale Cemetery on 9 July 1942.

He is listed on the Chapel Street Roll of Honour as Martin Hennerley, Cheshire Regiment.

William Hennerley (1887–1915)

Family Origins: Father, Altrincham; Mother, Altrincham, both of Irish descent
War Record: First World War 1914–18
Military Service: Private, 9th Battalion, Cheshire Regiment, Service No. 11364; Private, Lance-Corporal 4th Battalion, South Wales Borderers, Service No. 19832
Lived at No. 33 Chapel Street

William was born in Altrincham on 25 April 1887 and baptised at the Church of St Vincent de Paul on 12 June. He was the son of John and Margaret, née Flisk or Fletcher. The Hennerley family had been long-time residents of Chapel Street by 1891 when William, aged three, lived at No. 33 with his parents, brothers James, aged fourteen, Hugh, aged twelve, John, aged ten, Dennis, aged seven, Martin, aged two months, and sisters Mary, aged six, and Kate, aged one. He was still at the same address in 1901.

William took up golf as a career. He was certainly playing as early as 1904 and was soon proficient enough to earn a living from the game. In 1907, while working as an assistant professional at Timperley, he was described as 'showing some promise'. According to the

report of his death in the *Altrincham Guardian*, 'great interest was taken in his work' as assistant professional at Timperley, and he 'took part in the Open Championship in Scotland, where he played with some of the best exponents of the game in the kingdom'.

His marriage to Mary Agnes (otherwise May) Tinsley took place in 1909. Two years later, with William now professional golfer at Anson Golf Club, Longsight, the couple were living there at Melling Street with daughter Eva, son William John and William's brother Martin and his wife. It did not turn out to be a successful time for William's marriage and a newspaper article from September that year reported that Mary was granted a separation order on the grounds of desertion.

He lived at No. 14 Cobden Street, Chorley, when he enlisted for the Cheshire Regiment shortly after the outbreak of the war. He later transferred to the 4th Battalion, South Wales Borderers, the unit with which he sailed to the Dardanelles, arriving in the theatre of war in July 1915. All that is known of his Army service is that Lance-Corporal William Hennerley died of enteric fever, as did many who served on that front, in No. 21 General Hospital, Alexandria, Egypt, on 5 October 1915. He was buried at Chatby Memorial Cemetery and left a widow and four children.

He is listed on the Chapel Street Roll of Honour as William Hennerley, South Wales Borderers.

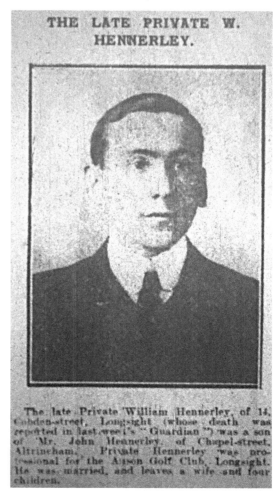

THE LATE PRIVATE W. HENNERLEY.

The late Private William Hennerley, of 14, Cobden-street, Longsight (whose death was reported in last week's "Guardian") was a son of Mr. John Hennerley, of Chapel-street, Altrincham. Private Hennerley was professional for the Anson Golf Club, Longsight. He was married, and leaves a wife and four children.

A local newspaper reported the death of Private William Hennerley in 1915. (*Altrincham, Bowdon and Hale Guardian*)

Michael Hines (1898–1918)

Family Origins: Father, Warrington; Mother, Warrington
War Record: First World War 1914–18
Military Service: Private, 7th Battalion, South Lancashire Regiment, Service No. 36631;
Private, 1st and 7th Battalions, Prince Albert's Somerset Light Infantry, Service No. 44416
Associated with Chapel Street

We have been unable to trace any record of a man named Michael Hines in military records that connect him with Chapel Street or the Cheshire Regiment and there are no references to a man of that name listed in the Cheshire Regiment Roll of Honour. The name is, however, referred to on the Altrincham and District Roll of Honour 1914–18 under the name Michael Hindes. The only possibility that we have been able to find is a Michael Hines whose birth was registered in 1898 at Warrington. He was the son of John and Catherine, née Farrell, and in 1901 was living at No. 3 Cropper's Brow, Cloth Hall Yard, Warrington, with his parents and sister Catherine, aged seven, half-sister Nelly Farrell, aged fifteen, and half-brother Thomas Farrell, aged eleven. Michael's father died in 1907. In 1910 the *Northwich Guardian* of 1 July reported that a Michael Hines, who was living in Chapel Street, Altrincham, was charged at Altrincham Sessions with 'peddling without certificates'. The case against him was dismissed. It is possible that this Michael Hines living in Chapel Street was a different person to the Michel Hines from Warrington as by 1911 he was listed as living at No. 6 Heaton Square, Warrington, with his widowed mother, sister Catherine, a younger sister Mary (born in 1902) and Thomas Farrell.

From the limited evidence available of Michael's military service it is known that he served first with the 7th Battalion, South Lancashire Regiment, and embarked for France on 30 March 1918. It is unclear from his records which regiment he was serving with at that time. At some point he transferred to the Somerset Light Infantry, serving with the 7th Battalion until 2 May 1918, on which date he joined the 1st Battalion. The Register of Soldiers' Effects noted that he was killed in action while serving with this battalion in France on 26 May 1918. His mother Catherine was his sole legatee. Michael was buried in the Lapugnoy Military Cemetery. There is a discrepancy in the spelling of the name for the two areas as he was listed as 'Hindes' on the Altrincham Cenotaph, Altrincham Roll of Honour and Chapel Street Roll of Honour, but Michael Hines was on the Warrington Town War Memorial, which may mean that they were not the same person.

There was a Patrick Hines who lived at No. 18 and No. 22 Chapel Street and it is possible that Michael was a family member, possibly from Ireland on his father's branch of the family and they were linked in some way, but at the time of writing (2018) we cannot find any evidence to support this.

He is listed on the Chapel Street Roll of Honour as Michael Hines, Cheshire Regiment.

Patrick Hines (1879–1943)

Family Origins: Father, Ireland; Mother, Manchester
War Service: Anglo-Boer War 1899–1902; First World War 1914–18
Military Service: Private, 3rd Battalion, Cheshire Regiment, Service No. 3323; Private, 1st Battalion, King's Liverpool Regiment, Service No. 4952; Private, 11th Battalion, King's Liverpool Regiment, Service No. 12629
Lived at No. 18 (Rose & Shamrock Inn) and No. 22 Chapel Street

Patrick was born on 24 April 1879 in Altrincham and baptised as Hugh Patrick on 7 May at the Church of St Vincent de Paul. His parents were John and Agnes (née Grant). In 1881 Patrick was living at No. 18 Chapel Street, which was the Rose & Shamrock Inn, with his parents and older

brother John, aged three. His father John died in 1883 and in 1886 his mother married John Groark. In 1891 Patrick was living at No. 22 Chapel Street, a lodging house run by John, his stepfather. He had a half-sister Mary (born in 1888) and half-brother William (born in 1890). Also living at the address was a half-cousin Nelly Welsh and nine lodgers.

According to a relation, Patrick was known as Paddy and he ran away from home aged fourteen and a half to join the Army. In September 1894 Patrick enlisted in the 3rd Battalion, Cheshire Regiment, giving his age as seventeen and his job as a labourer. He transferred to the King's Liverpool Regiment in September 1895 and served in the Anglo-Boer War, being taken prisoner and released on 29 December 1900 at Helvetia. He was awarded the South Africa Medal and Clasps in 1901. Patrick transferred to the Army Reserve in May 1903 and went on to marry Mary Davis in 1906. In 1911 he was living at Burgess Place, New Street, Altrincham, with his wife and two children – Elizabeth, aged four, and John, aged one. When the First World War began, Patrick re-enlisted in the 11th Battalion, King's Liverpool Regiment, on 4 November 1914 and was drafted to France on 14 July 1915. He was discharged from the Army on 16 September 1916 on the grounds that he was no longer physically fit for military service. A relative has reported that he lost a lung as a result of mustard gas at the Battle of Ypres.

Patrick's death at the age of sixty-four was reported in the local newspaper dated 17 December 1943. It read:

> Mr Hugh Patrick Hines who was in the Siege of Ladysmith and who fought in France and Belgium in the last war was buried at Altrincham cemetery on Saturday. Aged 64, his home was 17 Denmark Street, Altrincham. Mr Hines was born at the Rose and Shamrock Inn, Chapel Street, which was kept by his parents. They afterwards held the licence of the Grapes Inn, Regent Road. He was only in his teens when he joined the King's Liverpool Regiment (now known as the King's Regiment) serving in the West Indies before fighting in the Boer War. He volunteered again immediately hostilities broke out in 1914 and was finally invalided out of the Army. An employee of Altrincham Council for 23 years he worked at the Isolation Hospital and at the Public Baths. He resigned from the Council's employment last year, and from that time to his death had been working at a naval ordnance inspection depot.

Patrick's half-brothers – William and Michael Groarke – are also listed on the Chapel Street Memorial.

He is listed on the Chapel Street Roll of Honour as Patrick Hines, King's Liverpool Regiment.

Joseph Hollingsworth (1893–1914)
Family Origins: Father, not known; Mother, Altrincham
War Record: First World War 1914–18
Military Service: Private, 2nd Battalion, Cheshire Regiment, Service No. 9939
Lived at No. 6 Chapel Street and No. 10 Chapel Yard

Joseph was baptised on 12 September 1893 at St Margaret's Church, Dunham Massey. Although his mother, Mary Ann, was listed as the wife of John Hollingworth on the 1891 census, no father was recorded on Joseph's baptism record. By 1901 Joseph, aged seven, was living at No. 10 Chapel Yard with his mother Mary Anne, who was listed as single and head of the household, and his siblings Mary, aged eleven, and Arthur, aged four. In 1904 the family were living at No. 6 Chapel Street and they were still living there in 1911. On the census Joseph was listed as 'Joe' and he was employed as a general labourer. As well as his mother and brother Arthur, he was also sharing the house with his uncle James, two cousins, Ada and Albert Oxley and two boarders.

Joseph was one of the early casualties of the First World War. He had enlisted with the 2nd Battalion, Cheshire Regiment, in September 1912. By August 1914, the 2nd Battalion were stationed in Jubbulpore, India, and this is where Joseph died on 14 August 1914, aged twenty-one. He was buried in the Jubbulpore Cantonment Cemetery. The Register of Soldiers' Effects gave his father's name as George Warburton, and his effects of £8 6s 6d were authorised to be released to his mother Mary Anne.

He is listed on the Chapel Street Roll of Honour as Joseph Hollingsworth, Cheshire Regiment.

James Hughes (1873–1915)
Family Origins: Father, Ireland; Mother, Ireland
War Record: First World War 1914–18
Military Service: Royal Irish Rifles
Lived at Nos 5 and 48 Chapel Street

The 1891 census lists a James Hughes, aged eighteen, born in Ireland around 1873, working as an agricultural labourer at Castle Hill Farm in Ashley. In October 1899 the local newspaper reported that James Hughes, a farm labourer of No. 48 Chapel Street was the victim of an assault by the landlord of the Foresters Arms in Altrincham and it is possible that this was the same person. By 1901 James, then aged twenty-eight, from County Mayo, was still working as a farm labourer but by this time he was lodging at No. 5 Chapel Street. It is possible that this was the James Hughes that is listed on both the Chapel Street Memorial and the Altrincham and District Roll of Honour.

There are two references to the name James Hughes associated with the Royal Irish Rifles that are listed in the records of 'Soldiers Died in the Great War 1914–1919', one was for Rifleman James Hughes born in Belfast, Service No. 5313, who was killed in action on 7 May 1915, the other was for James Hughes, born in County Down, Service No. 5932, who was killed in action on 9 September 1916.

The death of a Private J. Hughes of Chapel Street was recorded in the Altrincham & Guardian Yearbook Roll of Honour for 1916 and, if this is the correct reference for James Hughes, then it indicates that the death of Private J. Hughes of Chapel Street, Altrincham, must have happened prior to December 1915 to have made it into the book as it was published around December 1915.

He is listed on the Chapel Street Roll of Honour as James Hughes, Royal Irish Rifles.

Peter Hughes
Family Origins: Not known
War Record: First World War 1914–18
Military Service: Cheshire Regiment
Associated with Chapel Street

Peter Hughes is listed on the Chapel Street Memorial as serving with the Cheshire Regiment, but at the time of writing (2018) we have been unable to locate any information that connects anyone of that name with Chapel Street.

He is listed on the Chapel Street Roll of Honour as Peter Hughes, Cheshire Regiment.

Robert Hughes
Family Origins: Not known
War Record: First World War 1914–18
Military Service: Private, Machine Gun Corps, Service No. 29761; Private, King's Own Yorkshire Light Infantry, Service No. 77077
Lived at No. 44 Chapel Street

Family Origins: Not known
War Record: First World War 1914–18
Military Service: Private, 419th Agricultural Company, Service No. 274789; Private, 562nd HSE Company, Service No. 274789
Lived at No. 44 Chapel Street

There are two references to the name Robert Hughes in the absent voters list for Altrincham for 1918, neither of which are linked to the Cheshire Regiment. Both have the address as No. 44 Chapel Street, although only one Robert Hughes was listed on the electoral registers. One of those on the absent voters list was a Private Robert Hughes, Service No. 274789 of the 419th Agricultural Company and the other was a Corporal Robert Hughes, Service No. 29761 of the Machine Gun Corps. The medal award roll listed for a Private, rather than corporal, Hughes, Service No. 29761 noted that he was listed as Class 'Z' Reserve, which indicated that as a trained soldier who was being demobilised he could return to civilian life but had an obligation to return to service if called upon. The Class 'Z' Reserve was abolished on 31 March 1920.

The 1919 absent voters list for Altrincham only refers to Private Robert Hughes, Service No. 274789, 562nd HSE Company.

There are no records relating to any personal information and only one name is recorded on the Chapel Street Memorial; however, it is possible that they were two people and may have been father and son.

He is listed on the Chapel Street Roll of Honour as Robert Hughes, Cheshire Regiment.

William Hughes
Family Origins: Not known
War Record: First World War 1914–18
Military Service: Royal Irish
Lived at No. 15 Chapel Street

William Hughes was listed as a labourer living at No. 15 Chapel Street in the Street Directories from 1914 to 1916, so may have enlisted around 1916 or later. He is listed on the Chapel Street Memorial as serving with the Royal Irish Rifles but it has not been possible to identify this soldier with any certainty in military records.

There are a number of people on the Commonwealth War Graves website named William Hughes, who were killed serving in the Royal Irish Rifles or Royal Irish Fusiliers, but unfortunately none have any proven connection to Altrincham.

He is listed on the Chapel Street Roll of Honour as William Hughes, Royal Irish.

James Hulmes (b. 1885)
Family Origins: Father, Timperley; Mother, Timperley
War Record: First World War 1914–18
Military Service: Private, 3rd Battalion, Cheshire Regiment Militia, Service No. 6829; Private, 14th Battalion Cheshire Regiment, Service Nos 13S, 35865
Lived at Nos 3 and 11 Chapel Street

James Hulme was born around 1885, his Army discharge papers giving his date of birth as 17 August 1885. His parents were Elizabeth, née Gatley, and William Hulme. In 1881 they were living at Woodalls Buildings on Stockport Road, Timperley, with their children John, aged eight, William, aged six, Joseph, aged four, and Florence, aged one. By 1891 they had moved to No. 42 Egerton Street, Sale, with their children John, eighteen, William, sixteen,

Elizabeth, nine, James, six, Samuel, three, and Henry, eight months. Their other children – Joseph, fourteen, and Florence, twelve – were inmates at the Industrial School for Poor Children in Boughton, Chester.

In December 1902 James was working as a labourer and, aged eighteen years and four months, he enlisted with the 3rd Battalion, Cheshire Regiment Militia, at Bowdon. He gave his father William as his next of kin, who was at that time living at No. 3 Chaple (*sic*) Street, Altrincham. In 1911 his brother William was listed as living at No. 11 Chapel Street.

James enlisted for the Cheshire Regiment on 17 January 1916 and joined the 14th Battalion from the reserve at the beginning of March. His attestation papers state that he had previously served in the 3rd Battalion Militia. Unfortunately he was discharged on 14 June that year on the grounds that he was unlikely to make an efficient soldier because of a deformed foot and he carried out all his war service at home. He was awarded the Silver War Badge in May 1917. His address on discharge in 1916 was given as No. 11 Chapel Street and he was still registered there to vote in 1919. His brother William served with the 11th Battalion, Cheshire Regiment, but was killed in action on 30 December 1915. The local newspaper dated 28 January 1916 reported that 'the Chaplain the Reverend William Maddison writes of his burial in a marked grave in soldier's cemetery'. There is a note in James's Army service record dated 23 May requesting that Williams's memorial plaque and scroll should be sent Mr J. Hulme of Chapel Street, Altrincham. Both James and his sister Florence were named on a separate form as his nearest relatives.

He is listed on the Chapel Street Roll of Honour as James Hulmes, Cheshire Regiment.

Harry Johnson (1886–1942)
Family Origins: Father, Hodnet, Shropshire; Mother, Stafford, Staffordshire
War record: First World War 1914–18
Military service: Private, 1st and 2nd Battalions, Cheshire Regiment, Service No. 24179
Lived at Nos 59 and 63 Chapel Street

Harry (Henry) was born on 8 January 1886 at Newton, Staffordshire, and baptised at the Church of St Mary in Stafford on 3 July. He was the son of Henry and Mary Ann Johnson, née Bates. At the time his family were living at No. 22 Railway Street, Stafford, the town in which his father worked as a railway porter. By 1891 Harry and his parents had moved to Latchford, Warrington. They were residing in Dunham Massey, Altrincham, when his brother Samuel Charles was baptised in November 1894.

By 1901 Harry, aged fifteen, was working as a general labourer and had relocated to Agden Bridge, Cheshire, with his mother, Mary Ann, who was by now a widow, brother Samuel Charles, aged seven, and sister Eva, aged four. The family was still living there in 1911.

Harry enlisted as a private with the 1st Battalion, Cheshire Regiment, in December 1914 and went to France in March the following year. He was transferred to the 2nd Battalion, Cheshire Regiment. His obituary in the *Altrincham Guardian* from 24 April 1942 reported that he was disabled in the war. He was discharged on 14 August 1918 and awarded the Silver War Badge. From family sources it is known that he was seriously wounded and his hip was shattered. He had shrapnel embedded in his body and also suffered from mustard gas poisoning. Harry told the family that he was pulled out of a shell hole by a Catholic priest whom he took to be an angel. As a result Harry converted to Catholicism. He met his wife Agnes Welsh at the Church of St Vincent de Paul, Altrincham, where she worked as a cleaner. He married her on 4 January 1919 at the church. Agnes already had a son, Thomas Patrick, born to an unnamed father in 1916.

The precise date when Harry moved to Chapel Street is unclear but he was registered to vote at No. 59 in the autumn of 1919. He appeared on the electoral register at No. 63 Chapel

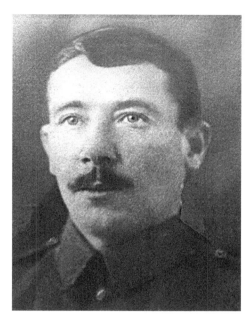

Right: Private Harry Johnson. (Image courtesy of Harry Johnson)

Below: Honourable Discharge Certificate for Private Harry Johnson. (Image courtesy of Harry Johnson)

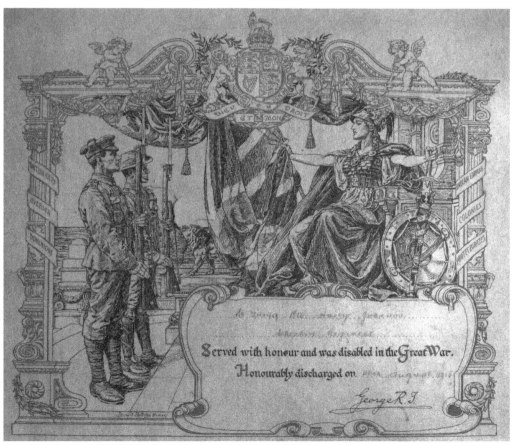

Street between 1921 and 1930. In 1939 Harry and his family were at No. 4 Marsland Road, Timperley and he was working as a stonemason's labourer. He remained at his Marsland Road address until his death in 1942, aged fifty-five.

In an article about his death, a local newspaper reported that he had been taken suddenly ill and had died the next day in Altrincham General Hospital. It described how he had been an enthusiastic bandsman who played the euphonium, cornet and trombone and belonged to a number of local bands, as well as Blackpool seaman's bands. He served in the Home Guard during the Second World War and was working as a gateman at Tilghmans in Broadheath at the time of his death. He had other children including Harry Vincent, who was taken as a prisoner of war in the Second World War, and Thomas Patrick Johnson, who served in Malta. His granddaughter attributed his death to the injuries he had received during his war service. She believed that he had become seriously ill due to the metal in his body and that his lungs, already damaged by mustard gas during the war, reacted catastrophically with the anaesthetics that were used during an operation.

He is listed on the Chapel Street Roll of Honour as Harry Johnson, Cheshire Regiment.

William Johnson (1877–1915)

Family Origins: Father, Cheshire; Mother, Cheshire
War Record: First World War 1914–18
Military Service: Private, 1st Battalion, Lancashire Fusiliers, Service No. 6991; Private, 1st and 3rd Battalion, Lancashire Fusiliers, Service No. 7697
Lived at No. 33 Chapel Street

William was born near Chester in 1877 and baptised at Tarvin, Cheshire, on 14 November 1877. His parents were James and Mary Ellen, née Davies. In 1891 William, aged thirteen, was living at No. 61 Penny's Lane, Witton, Cheshire, with his parents and siblings Hannah Ellen, aged eleven, Elizabeth, aged ten, and John Joseph, aged four. He was described on the census as a general labourer. In 1898, aged eighteen, he enlisted with the 1st Battalion, Lancashire Fusiliers, Service No. 6991 at Bury, Lancashire, and was with them for eight years until December 1906. His military records show that he served in Malta, Crete, Gibraltar and Egypt and, during that period, obtained a qualification as a mounted infantry man. In 1910 he transferred to the Army Reserve until his discharge on 21 December 1910.

He moved to the Altrincham area and was listed as a boarder with George and Margaret Owen at No. 29 Police Street, Altrincham, in 1911. At this time he was employed as a groom. George Owen died in 1912 and on 14 October 1914 William married his widow Margaret at the Church of St Margaret, Dunham Massey. On the 11 December 1914 an article in the local paper reported 'William Johnson, Chapel Street was charged with being absent from the 3rd Battalion Lancashire Fusiliers at Hull on December 9th.'

William entered the Balkan theatre of war on 14 May 1915 and was killed in action in Gallipoli on 15 June 1915. He is commemorated on the Twelve Tree Copse Cemetery Memorial in Gallipoli. The local newspaper reported: 'A letter written by Private William Johnson of the 1st Lancashire Fusiliers to his wife who resides at 33 Chapel Street, Altrincham has been endorsed as follows; this came to me for censoring. I am sorry to have to tell you that Private W Johnson was killed on the 13th June 1915 – H.R. Andrews Lieutenant, 'A' Company, 1st Lancashire Fusiliers.' The article went on to say 'he leaves a wife and six children' and that 'William was a former member of Sale and Eccles Rugby Club and had an enthusiasm for amateur boxing and wrestling.'

He is listed on the Chapel Street Roll of Honour as William Johnson, Cheshire Regiment.

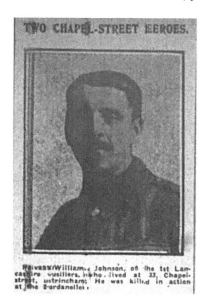

A local newspaper reported the death of Private William Johnson in July 1915. (*Altrincham, Bowdon and Hale Guardian*)

George Jones

Family Origins: Not known
War Record: First World War 1914–18
Military service: Bombardier, Royal Field Artillery, 24th Brigade Division Artillery, Service No. W/1991
Lived at No. 42 Chapel Street

George is listed on the absent voters list for 1918 and 1919, and is recorded as Private George Jones, of 24th Brigade Divisional Artillery, Service No. W/1991. His residence was listed as No. 42 Chapel Street. The medal rolls show that he was a gunner when he embarked for France on 26 December 1915 and that he was bombardier when awarded his service medals.

The electoral registers show that he was living at the same address in 1921 with a Sarah Jones, who may have been his wife, and he remained at this address until after 1931 and was also registered as the owner of land on Urban Road, Altrincham. It has not been possible to identify him in any great detail as the surname Jones is a commonly occurring name and there are too many to identify his parents or place of birth precisely.

He is listed on the Chapel Street Roll of Honour as George Jones, Royal Field Artillery.

Frederick Kelly (b. 1885)

Family Origins: Not known
War Record: First World War 1914–18
Military Service: Royal Engineers
Lived at Nos 11 and 49 Chapel Street

We can only find one reference to the birth of a Frederick Kelly registered in the Altrincham area and that was in 1885. There was a reference to the surname Kelly in the local newspaper entitled 'Street of Soldiers' on September 1914, which referred to the men of Chapel Street who had left to fight in the war, but this may have been referring to John Kelly not Frederick. There are some service records for a Fred Kelly, aged twenty-nine, of 16 Regent Road, Altrincham, a barman who attested for the 14th Battalion Cheshire Regiment serving in the

2/6th Battalion, Service No. 35809 and 4891 in March 1916, and it is possible that this is him as Regent Road lies adjacent to Chapel Street and he may have been well known in the local public houses from his employment. His mother was named as Mary Kelly on his military record and her address was given as No. 11 Byrom Street, Altrincham. Unfortunately Frederick was discharged as medically unfit for service in August 1916.

The electoral registers list a Frederick Kelly living at No. 11 Chapel Street in 1918, 1919 and 1922 and at No. 49 Chapel Street in 1924 and 1929. The surname Kelly was associated with Chapel Street on many occasions in the census between the years 1851 to 1911.

Frederick is listed on the Chapel Street Roll of Honour as Frederick Kelly of the Royal Engineers, but to date (June 2018) we have been unable to confirm anyone with that name from Chapel Street serving with the Royal Engineers.

John Kelly
Family Origins: Not known
War Service: First World War 1914–18
Military Service: Connaught Rangers
Lived at Nos 5, 7, and 51 Chapel Street

In 1901 John, aged twenty-eight, born in Ireland, was living at No. 51 Chapel Street as a lodger and was working as a bricklayer's labourer. In September 1901 a local newspaper reported that a 'John Kelly of Chapel Street was fined for using bad language'.

It has not been possible to link a John Kelly of Chapel Street to military records. A John Kelly gave his sister, Margaret Pollitt, of No. 24 Chapel Street as next of kin when he enlisted for the 1st Battalion, Manchester Regiment, Service No. 3905, in June 1893; however, it has not been possible to confirm that this is the same John Kelly who lived on Chapel Street. John was listed on the 1918 electoral register living at No. 7 Chapel Street but was not recorded as an absent voter, so it is possible that, if this man had served in the forces, he was discharged at an earlier date.

He is listed on the Chapel Street Roll of Honour as John Kelly, Conaught (*sic*) Rangers.

James Kenny
Family origins: Not known
War Record: First World War 1914–18
Military Service: Cheshire Regiment
Associated with Chapel Street

We have been unable to trace any information for the name James Kenny or name variants in military records or a connection with Chapel Street. It is possible that the name may be spelled incorrectly on the memorial. There was a Joseph Kenny, aged twenty-eight, lodging at No. 53 Moss Lane, Altrincham, in 1911, but no evidence has been found that suggests that he served in the Cheshire Regiment or was associated with Chapel Street.

He is listed on the Chapel Street Roll of Honour as James Kenny, Cheshire Regiment.

James King
Family Origins: Not known
War Record: First World War 1914–18
Military Service: Cheshire Regiment
Associated with Chapel Street

James is listed on the memorial as serving with the Cheshire Regiment and also on the Altrincham and District Roll of Honour. However, we have not been able to link a soldier of this name and regiment to Chapel Street.

He is listed on the Chapel Street Roll of Honour as James King, Cheshire Regiment.

John Kirkham (1871–1938)

Family Origins: Father, Warrington; Mother, Warrington
War Record: First World War 1914–18
Military Service: Private, 3rd Garrison Battalion and 22nd Battalion, Cheshire Regiment, Service No. 25393; Private, 11th Battalion, Royal Defence Corp, Service No. 49963
Lived at Nos 20, 45, 49 and 57 Chapel Street

John was born in the third quarter of 1871 at Warrington. He was the youngest son of Peter and Jane, née Johnson. In 1881 John, aged eleven, was living at No. 122 Thomas Street, Newton Heath, Manchester, with his married sister Mary and her husband Richard Haughton. In 1891 John was nineteen years old and living with his brother Peter and family at No. 12 Douro Street, Newton Heath, and working as a general labourer. On the 1911 census John was listed as aged forty and living at No. 57 Chapel Street with his wife Mary, two sons and three daughters. His occupation was 'dealer in rags'. A memo written on the record stated 'These people pass off as married but they are not' and was signed by the registrar Thomas Pritchard.

A report in the local newspaper dated 19 August 1913 indicated John and Mary's relationship may have been a turbulent one. The article was entitled 'Chapel Street Scene: Little Boy's Terrible Story'. The report began 'A night scene which occurred in Chapel Street Altrincham on Saturday had its sequel at Altrincham Police Court on Monday afternoon when John Kirkham, labourer, was charged with unlawfully and maliciously inflicting grievous bodily harm on Mary Kirkham, his wife on August 16.' It continued,

> prisoner's son Joseph Kirkham (nine) was a witness and he had returned home to hear his mother and father shouting at each other. His father had a beer bottle in one hand and a bar of iron in the other hand. Both his father and mother were drunk. His father lifted the iron up and witness thought he was going to hit him because he had been out late. His father sent him to bed and both his father and mother smacked him. He had been in bed about three minutes with his little brother and sister and could hear his father and mother quarrelling and swearing. He did not hear his father threaten or hit his mother. After he had been in bed about a quarter of an hour he heard his mamma shout "Joe" three times. Witness did not get up as he thought that she would hit him and then he heard her coming upstairs. Some distance up the stairs turned, and he heard someone fall down.

The report continued,

> he lay in bed a few more minutes and then his father called him so he got up and went downstairs. He found his mamma lying on the floor of the passage with her head cut open.' After listening to other witness accounts, 'Supt. Sutherland applied for a remand. The woman he said was in the Hospital in a somewhat serious condition. He suggested a remand for eight days during which time prisoner would be detained in custody. Prisoner was remanded for eight days.

On 4 March 1915 John enlisted in the Cheshire Regiment and was attached to the 3rd Garrison Battalion. On joining, he gave his age as thirty-seven years and seven months,

his address as No. 49 Chapel Street and his occupation as engineer's labourer. He stated he was not married but he had been living with Mary Curley for twenty-one years as man and wife and she was 'known as Mrs Kirkham'. On 12 May 1915, John and Mary married at the Church of St Vincent de Paul. The marriage record stated that John was aged forty-four years and Mary was aged forty years and it gave their address as No. 20 Chapel Street. A letter dated 13 May 1915 in his Army records referred to a 'Notice of Marriage' and referred to John as being a private in the 'A' Company of the 22nd Battalion, Cheshire Regiment.

John disobeyed Army regulations on a number of occasions and his actions included being drunk and disorderly, using bad language, creating a disturbance in his billet and leaving barracks without permission. On 8 August 1917 he was transferred to 454th Company, Royal Defence Corp. He was discharged from the Army on 14 May 1919 and his address recorded as No. 45 Chapel Street.

John died in 1938, aged sixty-seven years, and is buried at Hale Cemetery.

He is listed on the Chapel Street Roll of Honour as John Kirkham, Cheshire Regiment.

John Lennard (b. 1870)

Family Origins: Father, Ireland; Mother, Enniskillen, County Fermanagh, Ireland
War Record: First World War 1914–18
Military Service: Private, 3rd Battalion, Cheshire Regiment Militia; Bombardier, 221st Battery, 70th Brigade, Royal Field Artillery, Service No. 97383; Driver, 15th and 74th Divisional Ammunition Column, Royal Field Artillery, Service No. 97383
Lived at No. 58 Chapel Street

John Leonard, recorded as Lennard on the Chapel Street Memorial, was born in Altrincham on 11 July 1870 and baptised at the Church of St Vincent de Paul on 31 July. His parents were Henry Leonard and Catherine, née Maxwell. In 1871 he lived at No. 5 Paradise Street, Altrincham with his parents and siblings James, eleven, Ann, seven, and Mary Jane, two, and a boarder named Mary Maxwell. His age was recorded as nine but must actually have been nine months old. He was still at the same address in 1881, aged ten. By 1891 he had moved with his mother and two sisters to No. 17 Goose Green, Altrincham, and was working as a groom. He married Edith Ellen Ensor at the church of his baptism on 7 September 1895 and had a son, Frederick James, a month later. He was living with his mother in No. 58 Chapel Street in 1901, where he was recorded as single. His son was at Armitage Street School in Manchester in October that year. John was at the same house in Chapel Street in 1911 and working as a window cleaner. He was recorded as married but his wife and child were not living with him.

Having served with the Cheshire Regiment Militia before the war, John enlisted in the Royal Field Artillery at the end of August 1914 and gained swift promotion to bombardier, 221st Battery, on 13 October. His battery was absorbed into 70th Brigade Artillery in January 1915 as a result of Army reorganisation. John requested to revert to the rank of driver in May that year, having received ten days field punishment No. 1 at the end of April for absence from duty. He was posted to France in July 1915 and served there with the 15th and 74th Divisional Ammunition Columns.

Following demobilisation in A1 medical condition in January 1919, he returned to live at No. 31 Victoria Street, Altrincham. He married Martha Hassall in the second quarter of 1927 and was living with her in 1939 at No. 12 Grosvenor Street, Altrincham. He was working as a messenger at an RAF depot.

He is listed on the Chapel Street Roll of Honour as John Lennard, Royal Field Artillery.

Edward Lowe (1899–1918)

Family Origins: Father, Knutsford, Mother, Altrincham; Paternal Grandmother Ireland
War Record: First World War 1914–18
Military Service: Rifleman, 1st and 3rd Battalion, Royal Irish Rifles, Service No. 10990
Lived at No. 57 Chapel Street

Edward was born on 10 January 1899 in Knutsford and baptised on 5 February at the Church of St Vincent de Paul, Knutsford. His parents were Joseph and Catherine, née Morrough. Catherine was a former resident of Chapel Street, having lived there in 1881. In 1901 Edward was living in Market Place, Knutsford, with his parents and maternal grandmother. The family were still living at this address in 1911 and Edward, aged thirteen, had been joined by four younger siblings Kate, aged nine, John, aged seven, Mary, aged three, and Margaret, aged eight months. The Lowe family continued to live in Knutsford for the next few years, but by July 1916 they had moved to Altrincham and were residing at No. 57 Chapel Street. Edward was at this address on the absent voters list in 1918.

Edward enlisted at Altrincham and joined the 3rd Battalion, Royal Irish Rifles, as a Rifleman. The date of his enlistment is unknown but due to his young age, he was unlikely to have embarked for France until after the end of 1916. He served in France with the 1st Battalion, Royal Irish Rifles, and following action on the first day of the German Spring Offensive on 21 March 1918 was presumed dead. According to a war diary relating to his battalion, they were stationed at Grand Seracourt that day and faced heavy bombardment from the German positions. Four days earlier his battalion had celebrated St Patrick's Day with a football match and a battalion sports event.

Edward was just nineteen when he died and is commemorated on the Pozieres Memorial. Credits of £6 6s 9d, including a war gratuity of £6, were paid to his mother Catherine. Sadly she lost both her son and her husband in the war as Edward's father Joseph, of the South Wales Borderers, had died of wounds on 2 Jul 1916. Joseph is also listed on the Chapel Street Roll of Honour.

He is listed on the Chapel Street Roll of Honour as Edward Lowe, Royal Irish Rifles.

Joseph Lowe (1877–1916)

Family Origins: Father, Knutsford; Mother, Ireland
War Service: First World War 1914–18
Military Service: Private, 1st Battalion, South Wales Borderers, Service No. 19157
Lived at No. 57 Chapel Street

Joseph was born on 30 October 1877 in Knutsford and baptised the same day at the Church of St Vincent de Paul, Knutsford. His parents were Joseph and Margaret, née Bourke. In 1881 Joseph, aged three, was living with his parents, older sister Margaret, aged six, and two lodgers at Market Place, Knutsford. In 1891 the family had moved to King Street, Knutsford, and there were two more children – Edward, aged eight, and Mary, aged six.

On 11 September 1897 Joseph married Catherine (Kate) Morrough, who, at the time of the 1881 census, was residing at Chapel Street. By 1901 the couple had moved to No. 11 Old Market Place, Knutsford, and they were still living there in 1911. By this time they had another daughter, Margaret, aged eight months. Joseph's widowed mother was also living with them. Joseph's occupation was listed as a scavenger with the local council. The family then moved to No. 57 Chapel Street.

Joseph enlisted at Altrincham in the 1st Battalion, South Wales Borderers, and was drafted to France on 18 May 1915. According to the war diary relating to his regiment, they were

in Petit Sans in Flanders on 29 June 1916 when eight men were wounded in the village by enemy shells. Presumably Joseph was one of them as he died of wounds shortly after on 2 July 1916. The local newspaper, dated 4 July 1916, reported 'Mrs Lowe, 57 Chapel Street, received a telegram on Saturday, from the Commanding Officer Shrewsbury, informing her that her husband, Private Joseph Lowe, South Wales Borderers had been dangerously wounded at the front.' A war gratuity of £5 and 10s was paid to his widow Catherine, who, two years later, would also lose her son Edward in the war. Joseph was buried at Barlin Cemetery in France and was mentioned in a book entitled *The Knutsford Lads Who Never Came Back* in 2014.

Joseph's son Edward of the Royal Irish Rifles was presumed dead on 21 March 1918. Edward is also listed on the Chapel Street Roll of Honour.

He is listed on the Chapel Street Roll of Honour as Joseph Lowe, South Wales Borderers.

Vincent McGuire (1893–1964)

Family Origins: Father, Altrincham; Mother, Galway, Ireland
War Record: First World War 1914–18
Military Service: Gunner, Royal Artillery; Private, 2nd Battalion, Cheshire Regiment, Service No. 9546; Gunner/Signaller, 28th Battery, 9th Brigade, Royal Field Artillery, Service No. 77441; Section B, Army Reserve
Associated with No. 8 Chapel Street

Vincent was born on 15 March 1893 in Altrincham and baptised on 31 December at the Church of St Vincent de Paul. His surname appears as Maguire on all records found but is McGuire on the memorial. Vincent's parents, John and Mary, née Slattery, were living at No. 6 Albert Street, Altrincham in 1891, but by 1901 they had moved to No. 9 Regent Road with Vincent, aged seven, and his five siblings Barry, aged thirteen, Eileen, aged eleven, Nora, aged nine, Mary, aged five, and Kathleen, aged seven months. Vincent's mother died in 1902 and by 1911 his widowed father and his sister Mary had moved to No. 8 Chapel Street and were boarding with John Hennerley and his wife.

Vincent enlisted in the Royal Artillery in November 1910 and on his service record he stated he was eighteen years and eight months, although he was actually aged just sixteen and eight months. Vincent then briefly served in the 2nd Battalion, Cheshire Regiment, prior to transferring to the Royal Field Artillery in January 1914. By October 1914 he had embarked for France. During the war he also saw service in Mesopotamia and Egypt and was awarded the 1914 Star. According to a family member, Vincent was gassed with mustard gas and suffered from trench foot in France.

He was awarded the Distinguished Conduct Medal on 8 January 1919 while serving with the 28th Battery, 9th Brigade of the Royal Field Artillery. The citation in the *London Gazette* dated 3 September 1919 stated that he had 'shown the greatest coolness and contempt of danger in maintaining communications under heavy fire as Battery Signaller and especially during the recent open fighting when he spared no effort to maintain the line, frequently under heavy fire'.

In February 1919 Vincent transferred to Section B, Army Reserve, and in September of that year he married Margaret Nolan. The couple had three children by the time Vincent was discharged from the Army in November 1922 on completion of his term of service. According to electoral registers, between 1919 and 1930, Vincent and his family lived at a number of different addresses in Altrincham, including New Street, Woodfield Road, Red House, Woodville Road and No. 28 West Avenue in Dunham Massey. In 1939 the family had moved to Dagenham, Essex, and Vincent was employed as a 'charge hand janitor, Motor Engine Assembly'. He died on 25 October 1964.

He is listed on the Chapel Street Roll of Honour as Vincent McGuire, Royal Field Artillery.

John McNicholas

Family Origins: Not known
War Record: First World War 1914–18
Military Service: Royal Irish Rifles
Associated with Chapel Street

John is listed on the Chapel Street Memorial as serving with the Royal Irish Rifles, but it has not been possible to identify this soldier with any certainty or to link the name John McNicholas or a variant to Chapel Street from the available records.

He is listed on the Chapel Street Roll of Honour as John McNicholas, Royal Irish Rifles.

Patrick Mahon

Family Origins: Not known
War Record: First World War 1914–18
Military Service: Connaught Rangers
Associated with Chapel Street

Patrick is listed on the Chapel Street Memorial as serving with the Connaught Rangers, but it has not been possible to identify this soldier with any certainty or to link the name Patrick Mahon or a variant to Chapel Street from the available records. Only one soldier of that name for whom there is a record of service in the Connaught Rangers survived the war and he had Service No. 8537 and came from Dundrum, Dublin, Ireland. There was a Patrick Moran living at No. 49 Chapel Street in 1911 but there is no military record for any man of that name with an Altrincham connection.

He is listed on the Chapel Street Roll of Honour as Patrick Mahon, Connaught Rangers.

Joseph Margiotta (1897–1986)

Family Origins: Father, Picinisco, Italy; Mother, Picinisco, Italy
War Record: First World War 1914–18
Military Service: Trooper, 4th Royal Dragoons, Service No. 17742; Trooper 1st King Edward's Horse, Service No. 2005; Royal Tank Corps, Service No. 538207, Corporal 13th and 19th Hussars, Service Nos 80208 and 53820
Lived at No. 16 Chapel Street

Throughout the surviving records of Gerardo Margiotta there are various spellings of his first name and surname, but only on the Chapel Street Memorial is he referred to as Joseph.

Gerado was born on 31 March 1897 in Manchester, the son of Antonio and Maria Margiotta, who came from Picinisco in Italy and arrived in the UK probably after the birth of his sister Maria, who was born in Italy in 1891. In 1911 his parents, both listed as labourers, were boarding at No. 32 Barker Street, Nantwich, Cheshire, while Gerado, aged fourteen, and his brother Giovanni, aged six, were boarding next door at No. 30 Barker Street.

By 1915 the family had moved to No. 16 Chapel Street, and on 14 April 1917 Gerado enlisted in the Royal Dragoons, his trade on enlistment was given as a storekeeper's labourer. He transferred to the 1st King Edward's Horse in July 1917 and joined the Royal Tank Corps at Dublin on 14 April 1918 and was with this regiment until February 1919. At this point he re-enlisted for three years with the Hussars and served in the 13th and 19th Battalions, including a two-year period in India from November 1919 to November 1921. According to absent voters lists he was a lance-corporal by autumn 1920. Gerado was discharged from the Army in March 1922, a corporal in the Hussars, his character recorded as 'very good'.

In 1923, Gerado married Rosa (Rose) Protana in the Manchester Registration District. His address on discharge was given as No. 16 Chapel Street and he was still registered to vote there with Rose in 1931 as Giarard Vincent Margiotta. His mother, Maria Assunta, was living at this address at the time of her death in March 1938. In 1939 Gerardo and Rose were living at No. 19 Milner Avenue, Altrincham, where Gerado was listed as a crane slinger, and they were still living there when Rose died in 1957. Gerado died on 17 June 1986 and was buried in Hale cemetery.

He is listed on the Chapel Street Roll of Honour as Joseph Margiotta, Army Service Corps.

James Morley (b. 1878)

Family Origins: Father, Ireland; Mother, Ireland
War Record: First World War 1914–18
Military Service: Private, 8th and 2nd Battalions, Cheshire Regiment, Service No. 11945;
Private, 820 Area Employment Company, Labour Corps, Service No. 393563
Lived at Nos 41, 53 Chapel Street and No. 9 Chapel Yard

James was born on 13 September 1878 in Altrincham and baptised on 22 September at the Church of St Vincent de Paul. He was the son of Thomas, a bricklayer's labourer, and Catherine (Kate), née Heneghan. In 1881, James was living at No. 53 Chapel Street with his parents and five siblings Mary, aged ten, Ellen, aged eight, John, aged six, Thomas, aged four, and one-year-old Annie. The family then moved to No. 41 Chapel Street and by 1891 James was employed as an errand boy and had five more siblings – Catherine, Edward, Owen, Martin and Peter. The family were still living at this address in 1901 and James was working as a house painter. He married Sarah Astles in 1904 and by 1911 they had three children, Mary, Thomas and Ellen, and were living at No. 9 Chapel Yard.

James joined the Cheshire Regiment and was on a list of recruits who arrived at Birkenhead in September 1914 and was posted to 'B' Company. He embarked for France on 7 April 1915. The local newspaper dated 28 May 1915 reported that Private J. Morley of Chapel Yard, Altrincham, had been wounded while serving with the 2nd Battalion. An undated Army list recorded that James had suffered a gunshot wound to his right arm and was discharged to a convalescent depot. He was later transferred to the Labour Corps and was listed on the 1919 absent voters list as serving with the 820th Area Employment Company. He was demobilised to Class 'Z' Reserve on 13 March 1919.

After the war James had a short spell living at No. 9 Church Street, Altrincham, but then returned to No. 9 Chapel Yard. He and Sarah had another daughter named Elizabeth (born in 1920). Sarah died in in 1937, aged fifty-five, and in 1939 James was living with his son Thomas and family at No. 3 Peveril Road, Altrincham, and working as a painter and decorator.

James's youngest brother, Peter, was killed in action in 1916. He is listed on the Chapel Street Memorial.

James is listed on the Chapel Street Roll of Honour as James Morley, Cheshire Regiment.

Peter Morley (1890–1916)

Family Origins: Father, Ireland; Mother, Ireland
War Service: First World War 1914–18
Military Service: Private, 5th Battalion, Cheshire Regiment, Service No. 2758; Private, 2nd Battalion, Welsh Regiment, Service No. 53568
Lived at No. 41 Chapel Street

Peter was born in Altrincham on 6 November 1890 and baptised on 7 December at the Church of St Vincent de Paul. He was the youngest child of Thomas and Catherine (Kate), née

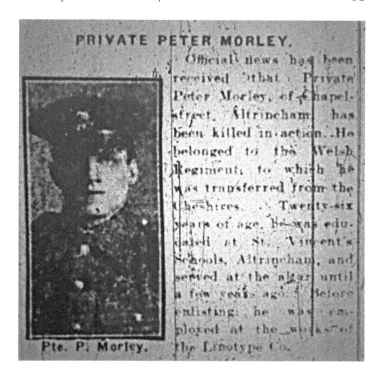

A local newspaper reported the death of Private Peter Morley in October 1916. (*Altrincham, Bowdon and Hale Guardian*)

PRIVATE PETER MORLEY.

Official news has been received that Private Peter Morley, of Chapel-street, Altrincham, has been killed in action. He belonged to the Welsh Regiment, to which he was transferred from the Cheshires. Twenty-six years of age. He was educated at St. Vincent's Schools, Altrincham, and served at the altar until a few years ago. Before enlisting he was employed at the works of the Linotype Co.

Pte. P. Morley.

Heneghan. Both families were long standing residents of Chapel Street, as far back as 1871. In 1891 Peter, aged five months, was living at No. 41 Chapel Street with his parents and siblings Mary, aged twenty, Ellen, aged nineteen, John, aged sixteen, Thomas, aged fourteen, James, aged twelve, Ann, aged ten, Catherine, aged nine, Edward, aged six, Owen, aged four, and Martin, aged two. Peter's father died in 1908 and in 1911 Peter was still living at No. 41 Chapel Street with his widowed mother and was employed as a clerk at Linotype and Machinery Co. in Broadheath, Altrincham. He married Ada Darlington in the third quarter of 1915.

Peter initially enlisted with the 5th Battalion, Cheshire Regiment, and was then transferred to the 2nd Battalion, Welsh Regiment. He was killed in action on 22 September 1916, north of Flers during the Battle of the Somme and is commemorated on the Thiepval Memorial. The local newspaper dated 20 October 1916 reported Peter's death and stated he was educated at St Vincent's School and had served as an altar boy. A war gratuity was paid to his widow Ada.

Peter's elder brother James is also listed on the Chapel Street Roll of Honour.

Peter is listed on the Chapel Street Roll of Honour as Peter Morley, Cheshire Regiment.

James Murray

Family Origins: Not known
War Record: First World War 1914–18
Military Service: Manchester Regiment
Associated with Chapel Street

There were two men named James Murray living in Chapel Street in 1901. One lived at No. 9 Chapel Street, a labourer, aged twenty-two who was born in Ireland; the other lived at No. 5 Chapel Street and was also a labourer, aged twenty-eight, who was born in Birkenhead. Unfortunately we have not been able to trace any record that connects either of these men to the Manchester Regiment. From examination of the military records available, there are eight

men named James Murray from the Manchester Regiment who have been identified from service records, medal rolls or the Medal Roll Index cards. Only two have not been eliminated with Service Nos 7558, 295082 and 303333, but their records are insufficient to establish their place of origin.

He is listed on the Chapel Street Roll of Honour as James Murray, Manchester Regiment.

James Murray (b. 1873)

Family Origins: Father, Ireland; Mother, Ireland
War Record: First World War 1914–18
Military Service: Private, 11th Battalion, Cheshire Regiment, Service No. 36458; Private, King's Liverpool Regiment; Private, 540 Home Service Employment Company, Labour Corps, Service No. 268826; AM3/2/1 (Air Mechanic) 103 Squadron Royal Flying Corps, Service No. 99104
Lived at Nos 13 and 39 Chapel Street

James was born in Altrincham on 8 November 1873 and baptised on 23 November at the Church of St Vincent de Paul. His parents were Patrick and Julia, née Meaney, who both had been long-term residents of Chapel Street since the 1860s. In 1881, James was living at No. 39 Chapel Street with his parents and siblings Martin, aged twenty, Henry, aged eighteen, Thomas, aged fifteen, Mary Ann, aged ten, and Sarah, aged four. By 1891 the family had moved to No. 13 Chapel Street where James was listed as working as a joiner's apprentice. By 1901 both parents and his elder brother Henry had died and James and three of his siblings were living in Hale. In 1911 James, aged thirty-six, his brother Thomas, aged forty-three, and his sister Sarah, aged thirty-three, were listed at No. 64 Victoria Road, Altrincham.

James enlisted as a private in the 11th Battalion, Cheshire Regiment, and served in France from August 1916 to February 1917. He transferred to the King's Liverpool Regiment in April 1917 and the Labour Corps later that month. In August 1917 he transferred to the Royal Flying Corps (later the RAF) as an Air Mechanic 3rd class, later being reclassified as AM2, then AM1. He was demobilised to the RAF Reserve in March 1919 and was discharged on 30 April 1920. His address on discharge was given as No. 22 Greenwood Street in Altrincham and this is confirmed as the electoral register for 1921 lists him living at this address with his brother Thomas.

He is listed on the Chapel Street Roll of Honour as James Murray, Royal Air Force.

John Naughton (b. 1886)

Family Origins: Father, Ireland; Mother, Claremorris, County Mayo, Ireland
War Record: First World War 1914–18
Military Service: Private, Cheshire Militia, Service No. 6369; Gunner, Royal Field Artillery, Service No. 258398
Lived at Nos 14, 17 and 21 Chapel Street

John was born on 3 August 1886 in Altrincham and baptised on 22 August at the Church of St Vincent de Paul. His parents were Thomas and Bridget, née Gill. In 1891 John was living at No. 14 Chapel Street, with his parents and siblings Mary, aged three, and Kate, aged one, and also two lodgers. By 1901 John, aged fifteen, was employed as a labourer and living at No. 21 Chapel Street with his grandparents Luke and Kate Cusack (Bridget's mother and stepfather). The 1901 census indicated that his mother Bridget was an inmate of Wakefield Prison for the offence of 'neglecting six children'.

In November 1901 John enlisted in the Cheshire Militia and lied about his age, stating he was seventeen when in fact he was only fifteen years old. This falsehood eventually came to

light and it led to him being discharged a year later for 'having made a mis-statement as to age on attestation'. However, he was recognised as being of good character.

The local newspaper dated 27 February 1907 reported that John Naughton of Chapel Street was summoned on two charges, one of bad language, the other for assaulting a police officer. He was fined *2s 6d* for bad language and *10s* for assault. In 1911 John was working as a labourer and living at No. 21 Chapel Street with his mother Bridget, who was head of the house, and siblings Catherine, aged twenty-one, Michael, aged nineteen, Margaret, aged seventeen, and William, aged fifteen. A Thomas Naughton, aged fifty-four, possibly John's father, was listed on the 1911 census as an inmate of Macclesfield County Lunatic Asylum.

In 1915, John married Margaret McKenna at the Church of St Vincent de Paul and by 1922 they had three children: John, Frank and William.

The Medal Roll Index cards recorded John's service with the Royal Field Artillery during the First World War and he was registered as serving in this regiment on the 1918 and 1919 absent voters lists with an address of No. 17 Chapel Street. On 14 March 1921 he enlisted in the Royal Artillery but was discharged the following month with his 'services no longer required'. In 1939 John, Margaret and family were living at No. 25 Milner Avenue, Altrincham, and John was working as a general labourer.

John's brother William is also listed on the Chapel Street Roll of Honour.

He is listed on the Chapel Street Roll of Honour as John Naughton, Royal Field Artillery.

William Naughton (b. 1896)

Family Origins: Father, Ireland; Mother, Claremorris, County Mayo, Ireland
War Record: First World War 1914–18
Military Record: Private, 1st and 3rd Garrison Battalions, Cheshire Regiment, Service No. 10289; Private, Denbigh Yeomanry, Service No. 10289; Private, 545th Agricultural Company, Labour Corps, Service No. 501783; Driver, Royal Army Service Corps, 662nd Labour Company, Service No. 41234
Lived at No. 21 Chapel Street

William was born on 5 April 1896 in Altrincham and baptised on 26 April at the Church of St Vincent de Paul. His parents Thomas and Bridget, née Gill, were living at No. 14 Chapel Street in 1891 with Williams's older siblings John, Mary and Kate. The 1901 census indicated that his mother Bridget was an inmate of Wakefield Prison for the offence of 'neglecting six children', but there is no trace of William at this time and it is possible he may have been placed in care. His elder brother John and sister Mary were living at No. 21 Chapel Street with grandparents Luke and Kate Cusack (Bridget's mother and stepfather). By 1911 William, aged fifteen, had moved into No. 21 Chapel Street and was employed as a golf link caddy. Also living there were his mother Bridget, who was head of the house, and siblings John, aged twenty-four, Catherine, aged twenty-one, Michael, aged nineteen, and Margaret, aged seventeen. A Thomas Naughton, aged fifty-four, and possibly his father, was listed on the 1911 census as an inmate of Macclesfield County Lunatic Asylum.

On 8 December 1913 William, aged eighteen, enlisted as a private in the 1st Battalion, Cheshire Regiment, before transferring to the 3rd Garrison Battalion, Cheshire Regiment, in November 1915, the Denbigh Yeomanry in August 1917, the Labour Corps (545th Agricultural Company) in November 1917 and finally the Army Service Corps, 662nd Labour Company in April 1918 where he served as a driver. He broke Army regulations on numerous occasions including leaving parade without permission, not handing his rifle in when proceeding on leave and overstaying his special pass, resulting in him being confined to barracks each time.

William married Mary Jane Cunningham on 7 January 1918 in Liverpool and his service record indicated she replaced his mother Bridget as next of kin, with a home address of No. 34 Pleasant Street, Liverpool. William was on home duties for his entire military service until his discharge as 'surplus to military requirements' on 7 June 1918. A medical report of April 1918 stated that he had 'very poor vision even with glasses', but his conduct was recorded as very good and stated: 'he is honest, sober, reliable and intelligent'. In 1939 William was living with his wife and family at No. 13 Auburn Road, Liverpool, and was employed as a 'skin labourer' at an abattoir.

William's brother John is also listed on the Chapel Street Roll of Honour.

He is listed on the Chapel Street Roll of Honour as William Naughton, Cheshire Regiment.

David Norton (1896–1958)

Family Origins: Father, Ireland; Mother, Warrington
War Record: First World War 1914–18
Military Service: Driver, Royal Army Service Corps, Service No. T1/879
Lived at No. 27 Chapel Street

David was born on 29 March 1896 in Altrincham and baptised on 19 April with his twin brother Peter at the Church of St Vincent de Paul. Aged fifteen in 1911, he lived at No. 27 Chapel Street and worked as an errand boy for an oil merchant. He resided with his mother, a widow, his brothers Robert, aged nineteen, and Peter, aged fifteen, and sisters Mary, aged thirteen, and Martha, aged nine, as well as a nephew, Thomas, aged six months.

The limited evidence available for his Army service shows that he arrived in France as a driver for the Royal Army Service Corps on 19 May 1915. An article in the local newspaper from June 1916 stated that he enlisted at the start of the war. He was discharged to the Army Reserve on 29 May 1919.

After the war, David worked as an engineer's labourer and married Gertrude Berry in December 1919. They were registered voters in Brook Lane, Timperley, between 1924

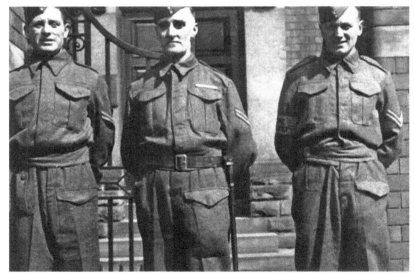

David Norton (centre) served as a Local Defence Volunteer during the Second World War. (Image courtesy of Sue Arcangeli and Ruth Hirst)

and 1931. David joined the post office as a postman in November 1934 and in 1939 he was living at No. 66 Barlow Road, Broadheath. He served in the Home Guard in the Second World War and three of his sons saw active service in that conflict. He was awarded the Imperial Service Medal in August 1955 on retirement from the post office.

David died in 1958, aged sixty-two, and was described in his obituary in the *Altrincham Guardian* as 'an active worker in the public life of the district'. He served on a number of local health and welfare committees, was an active member of the Altrincham and Sale Labour Party and stood as a socialist candidate for Dunham Ward.

He is listed on the Chapel Street Roll of Honour as David Norton, Army Service Corps.

John Norton (b. 1885)

Family Origins: Father, Ireland; Mother, Warrington
War Record: First World War 1914–18
Military Service: Cheshire Militia, Service No. 6837; Sergeant-Major Instructor, 2nd Battalion, King's Own Royal Lancaster Regiment
Lived at No. 27 Chapel Street

John William Norton, known to family members as Jack, was born on 15 December 1885 and baptised on 5 June 1887, the same day as four of his siblings, at the Church of St Edward, Runcorn. His birthplace was given on different censuses as Runcorn and Warrington. He was living at No. 27 Chapel Street in 1891 with his parents, Patrick and Charlotte, his paternal grandmother Mary Naughton, and brothers Michael, aged eleven, Thomas, aged nine, Joseph, aged eight, James, aged twelve months and sister Martha, aged five. He resided at the same address in 1901.

In January 1903, John, a labourer at the Linotype and Machinery Co., Broadheath, enlisted with the Cheshire Militia. After forty-nine days of drill he transferred as a private to the King's Own Royal Lancaster Regiment. In 1911, now a sergeant, he was stationed with the 2nd Battalion at Fort Regent in Jersey. He had married Catherine De Courcy in 1910, the daughter of lodging house keepers from Chapel Street and she was living as housekeeper to his widowed brother Thomas, in Wigan with their son John, aged nine months, in 1911.

When war was declared his regiment was in India. The local newspaper of June 1916 confirmed this, stating that John was 'an old service man, having seen twelve years' service. At the outbreak of war he was with his regiment, the King's Own Royal Lancasters, in India. In January 1915 he arrived at Southampton with the Indian Expeditionary Force, after having a rough voyage, and was drafted to France.' His rank was given as Sergeant-Major Instructor. With limited evidence for his service in the First World War, it has not proved possible to identify his service number with certainty, but there is a medal card for a J. Norton of the right rank in the regiment in which he served, Service Nos 771 and 3701357.

Family sources record him living in Dover after the war, but he has not been located in the 1939 register.

He is listed on the Chapel Street Roll of Honour as John Norton, King's Own Royal Lancaster Regiment.

Joseph Norton (1883–1947)

Family Origins: Father, Ireland; Mother, Warrington
War Record: Anglo-Boer War 1899–1902; First World War 1914–18
Military Service: Private, 3rd Militia Battalion, King's Own Royal Lancaster, Service No. 6207 or 6688; Company Sergeant-Major, 1st, 2nd & 4th Battalions, Grenadier Guards, Service No. 10330
Lived at No. 27 Chapel Street

Patrick Joseph Norton was born on 10 February 1883, in the Runcorn area and baptised there at the church of St Edward on 5 June 1887. He had moved to No. 27 Chapel Street, Altrincham, with his family by 1891 and the family were still living there in 1911. Joseph was not living at home in 1901 as he was serving in South Africa with the 3rd Battalion, King's Own Royal Lancaster Regiment, having arrived there in January 1900. He was awarded the Queen's and King's South Africa medals with two clasps.

He joined the Grenadier Guards in 1902 and rose to the rank of lance-sergeant by 1908, the year in which he married Ellen Brown from Mildenhall, Suffolk. The local newspaper reported that Joseph had been a bearer and bodyguard at the funeral of Edward VII in May 1910. The newspaper described him as 'a splendid type of soldier, standing 6'4" and weighing 17 stone'. In 1911, now promoted to sergeant, Joseph lived with his wife and first son Bertram, aged one, in the married quarters in Westminster.

At the outbreak of war he was an instructor for the new Army, but volunteered for France and went there with the 1st Battalion, Grenadier Guards, on 22 November 1914, the year in which he was promoted to company sergeant-major. He took part with the 2nd Battalion, Grenadier Guards, in the Battle of Flers Courcelette on the Somme on 15 September 1916. The war diary for the battalion records that during an attack near Ginchy, 'the Germans began bombing down the trench very strongly, having three or four men throwing. Our bombers could not stop them and Company Sergeant Major J. Norton who was lying out by the wire with some men rushed them and stopped the attack for the time'.

It was during this same engagement that he rescued the wounded Lieutenant M. H. MacMillan of his battalion (the future Prime Minister Harold MacMillan) from the battlefield. The book *Supermac, The Life of Harold MacMillan* tells the story: 'Under cover of the relative safety of night-time, a search party, led by Company Sergeant Major Norton, who had witnessed MacMillan's fall, set out to find and rescue him. MacMillan's legs were

As a custodian at No. 10 Downing Street, Joseph Norton (left) served under five prime ministers. (Image courtesy of Sue Arcangeli and Ruth Hirst)

quite unable to take his own weight, and stretcher bearers were brought in to carry him home, the noise of their movements bringing shelling all the while from Ginchy village.' The official biography of MacMillan recalled the events and referred to Company Sergeant-Major Norton as a splendid man. Joseph himself was wounded in both thighs by machine gun bullets in this period and evacuated to England, receiving a mention in despatches in January 1917. He returned to France in December 1917.

He was with the 4th Battalion, Grenadier Guards, in 1918 when awarded the Distinguished Conduct Medal. The citation states, 'He showed conspicuous gallantry in March in the fighting around Ervillers. He was commanding the men of Battalion headquarters, which came under very heavy shell fire for some hours, and severe casualties incurred. He superintended the removal of the wounded men under this heavy fire, and greatly helped in their removal. By his gallantry and devotion to duty he set an inspiring example to all ranks, and his conduct throughout the nine days' heavy fighting was magnificent.' The war diary recorded this evacuation of the wounded of all ranks as 'a noticeably fine piece of work'.

Joseph remained in the Army after the war, having received a mention in despatches three times and the Italian Bronze Medal for Valour in addition to the DCM. He retired from the Army in June 1923 and joined the Metropolitan Police and was a custodian at No. 10 Downing Street from 1923 to 1947, serving under five prime ministers. He lived with his family in Windsor, where he died in 1947. His funeral was attended by representatives from No. 10 Downing Street.

He is listed on the Chapel Street Roll of Honour as Joseph Norton, Grenadier Guards.

Michael Norton (1879–1948)

Family Origins: Father, Ireland; Mother, Warrington
War Record: First World War 1914–18
Military Service: Militia, 3rd Volunteer Battalion, Cheshire Regiment;
Acting Sergeant, 3/5th Battalion, Cheshire Regiment, Service No. 3544; Sergeant, 1/4th Battalion, South Lancashire Regiment, Service Nos 266428 and 241060
Lived at Nos 17 and 27 Chapel Street

Michael was born in Wigan on 9 Sep 1879 and baptised on 5 June 1887 at the same time as four of his siblings at the Church of St Edward, Runcorn. He was living in Wigan with his parents Patrick and Charlotte Norton, née Patten, in 1881. The family had moved to No. 27 Chapel Street by 1891 where his grandmother was head of the household. In 1901, aged twenty-one, he lived in the same house with his parents, his brothers John William, aged fourteen, James, aged eleven, Robert, aged nine, George, aged seven, Peter and David, both aged five, sister Mary, aged three, and his wife Mary Norton. Michael had married Mary Bailey on 11 December 1900 and by 1911 the couple and four children had moved to No. 17 Chapel Street.

The local newspaper reported a court case where Michael did his duty as a good citizen in May 1907 when he and a friend came to the aid of a police constable who was being attacked by local men.

Michael had already served in the Volunteer Battalion, Cheshire Regiment, from 1900 to 1906 when he enlisted in the 3rd/5th Cheshire Regiment in March 1915. He was working as a scaffolder for Potts, builders of Broadheath, and living at No. 14 Thomas Street, Altrincham. By November 1915 he had risen to the rank of corporal and was acting sergeant, and a bomb instructor, according to a local newspaper article from June 1916 about his family's war service.

In August 1917 he transferred to the South Lancashire Regiment and was posted to France with the 1/4th Battalion on 20 December, serving there until 11 August 1918 when he returned

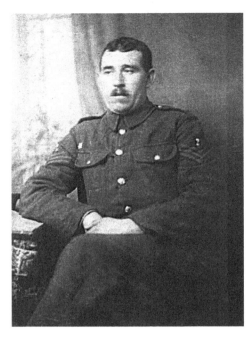

Sergeant Michael Norton. On 23 June 1916 a local newspaper article described the patriotism of Charlotte Norton and her sons and reported that 'Sergeant-Bomb-Instructor M. Norton, who is married, with four children, answered his country's call.' (Image courtesy of Sue Arcangeli and Ruth Hirst)

home to spend time in hospital in Perth with gunshot wounds. He was demobilised at the end of March 1919 and had his rank as sergeant substantiated.

He returned to live in Thomas Street and was still there in 1931. In 1939 he was living with his family in Oakfield Road, Altrincham, and working as a labourer. He died in 1948.

He is listed on the Chapel Street Roll of Honour as Michael Norton Cheshire Regiment.

Peter Norton (1896–1960)

Family Origins: Father, Ireland; Mother, Warrington
War Record: First World War 1914–18
Military Service: Lance-corporal, 3rd & 9th Battalions, Gordon Highlanders, Service No. S/20000; Lance-corporal, 14th & 2/16th Battalions, London Regiment, Service No. 516310
Lived at No. 27 Chapel Street

Peter's early life follows the same pattern as that of his twin brother, David. He lived at No. 27 Chapel Street in 1901 and in 1911, when he was working as a greengrocer's errand boy.

Little evidence has survived of Peter's war service. He was still living at home in June 1916 when an article about the part being played by the Norton brothers in the war appeared in the local paper. He served in France with the 9th Battalion, Gordon Highlanders, a pioneer battalion, from June to July 1918, earning himself the nickname 'Jock', which stayed with him for life. He transferred to the 14th Battalion, London Regiment, in France and remained there until the Armistice. The absent voters lists for No. 27 Chapel Street recorded him as lance-corporal with the 3rd Battalion, Gordon Highlanders, in 1918 and the 2/16th Battalion, London Regiment, in 1919.

Peter returned to No. 27 Chapel Street after the war. In 1920, when the police opposed the renewal of the licence of the Rose & Shamrock Inn, Peter spoke in support of renewal on the grounds that 'he went there to meet his friends'. In 1926 he married Ada Batterson and the couple were still living at No. 27 in 1929. They moved to Albert Square, Bowdon, in 1930

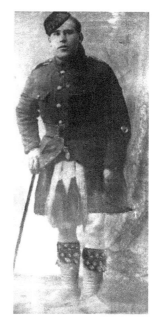

Right: Lance-Corporal Peter Norton in his Gordon Highlanders uniform. (Image courtesy of Sue Arcangeli and Ruth Hirst)

Below: Peter Norton's letter to the Altrincham Urban District Council regarding his mother. (Image courtesy Trafford Council)

THE LATE MRS. NORTON.

The following letter was read to the Council:-

62, Bold Street,
Altrincham.

To the Altrincham Urban District Council.

Gentlemen,

As one of the seven sons of the late Mrs. Norton, I feel that I must extend to the Members of the Council my profound thanks for the manner in which my Mother was remembered by the leading gentlemen of this Town. A more fitting tribute could not have been paid to one who gave her all in the Country's hour of need, and I can assure you their appreciation and sympathy will go down in the annals of this Town and in the minds of those who mourn her, as one of the kindest acts ever meted out to a native of this town. The letter of condolence received from the Council clearly shows the respect that was held for my Mother. I cannot close without thanking Councillors J. Sumner, R.H. Lee, T.C. Handford and Mr. W.S. Stokoe, for their kindness by attending the Cemetery, and to Councillor A. Weston, I owe a great indebtedness.

Trusting this letter will be read to all the Members of the Council, as a token of my gratitude,

I beg to remain,

Yours, etc.,

Peter Norton.

and in 1939 they were living at No. 13 Lee Avenue, Altrincham, when Peter was working as a window cleaner.

In 1926, when his mother Charlotte died, Altrincham Council placed on record their deep sense of appreciation of the valuable services rendered by the sons and their mother, and also forwarded a letter of condolence to the sons. Peter replied to members of the council on behalf of the family, stating, their appreciation and sympathy will go down in the annals of this town and in the minds of those who mourn her, as one of the kindest acts ever meted out to a native of this town'. Peter died in 1960.

He is listed on the Chapel Street Roll of Honour as Peter Norton, Gordon Highlanders.

With six sons having enlisted in the Army and fighting for their country, Charlotte Norton was adamant that her remaining son, Peter, would not enlist and she appealed to say he was needed at home to help her look after his two invalid sisters. Charlotte was successful in obtaining an absolute exemption from military service for Peter. However, it appears this is not what Peter wanted and after several attempts at enlisting, he did eventually join the Gordon Highlanders. This meant that seven brothers enlisted and seven survived the war.
Charlotte was described as 'a well-known and highly respected resident of Altrincham', which this was apparent when she died in 1926 and members of Altrincham Urban District Council paid tribute to her by sending a letter of condolence to the Norton family.

Robert Norton (1892–1955)
Family Origins: Father, Ireland; Mother, Warrington
War Record: First World War 1914–18
Military Service: Driver, 100 Company, 14th Divisional Train, Royal Army Service Corps, Service No. T/1306; Private, 10th Battalion, East Yorkshire Regiment, Service No. 30189; Corporal 2/8th Battalion, Manchester Regiment, Service No. 27703
Lived at No. 27 Chapel Street

Robert was born in Altrincham on 19 May 1892 and baptised on 12 June at the Church of St Vincent de Paul. His parents Patrick and Charlotte Norton were already living at No. 27 Chapel Street. The family still resided there in 1911, when Robert, aged nineteen, was working as a labourer at an iron foundry. A family source has reported that his daughters recalled him telling them that the family was very poor and, at one point, the person who had work on a particular day would be allowed to use the family boots.

Robert enlisted in the Army Service Corps in August 1914 as a driver. He was discharged at Aldershot from the 14th Divisional Train on 2 April 1915 on the grounds that the unit had no further use for his services. At the time of discharge Robert had refused to be re-attested. His surviving service record does not go beyond this discharge but he must have been persuaded otherwise, as he was serving as a corporal in the 8th Battalion, Manchester Regiment, at the time of his son Robert George's birth in October 1917. His medal roll shows that he also served as private in the East Yorkshire Regiment and this in confirmed by the list of absent voters for 1918.

In 1916 Robert married Emily Knowles and in November 1917 his address was No. 14 Thomas Street, Altrincham, the home of his brother Michael. By spring 1919 he had moved to No. 21 where he was still registered in 1931. Emily died in 1929. Four years later Robert married Charlotte Morris and in 1939 they were living at No. 23 John Street, Altrincham. Robert was a storekeeper and stoker at an electricity generating station. He died in July 1955 and was buried in Altrincham Cemetery.

He is listed on the Chapel Street Roll of Honour as Robert Norton, Cheshire Regiment.

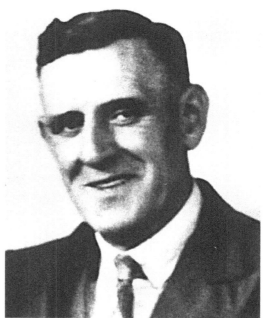

Above: British War Medal belonging to Driver/ Private Robert Norton. (Image courtesy of Sue Arcangeli and Ruth Hirst)

Right: Robert Norton. (Image courtesy of Sue Arcangeli and Ruth Hirst)

Thomas Norton (b. 1881)

Family Origins: Father, Ireland; Mother, Warrington
War Record: First World War 1914–18
Military Service: Gunner, 452 Siege Battery and 2 Siege Battery, Royal Garrison Artillery, Service No. 155890
Lived at Nos 21 and 27 Chapel Street

Thomas was born in Wigan, Lancashire, on 10 April 1881 and baptised on 5 June 1887 at the Church of St Edward, Runcorn. He was the son of Patrick Norton and Charlotte, née Patten. By 1891 he had moved with the family to No. 27 Chapel Street to live with his grandmother, Mary. He married Bridget Mary Carlin in the Wigan area in the first quarter of 1901 and was living with her in Bickershaw Lane, Abram, in that year and working as a railway engine stoker. Bridget died in 1910 and in 1911, Catherine, the wife of his brother John, who was serving overseas, was living in Wigan as housekeeper for Thomas, his five children and her son.

Thomas's service record indicated that he joined the Royal Garrison Artillery as a gunner in Altrincham on 5 June 1916. He had been promoted to engine driver by that time. He was posted to 452 Siege Battery at Farnborough in June 1917 and also served with the 2nd Siege Battery, which was stationed in France throughout the war.

He received a gunshot wound to the head in March 1918 and in April was admitted to the 3rd Northern General Hospital in Sheffield for six weeks. He was discharged on 19 March 1919. A medical board in 1920 found that the wound was well healed and the slight deafness that he had incurred was no longer detectable.

Thomas appeared on the list of absent voters at No. 21 Chapel Street in 1918 and 1919. He was still living at that address in 1926 and a Margaret Norton was also registered there. A family source recalled that he lived for a long time in Brighton, returning north to Moss Side, Manchester, in later life. The date of his death is unknown.

He is listed on the Chapel Street Roll of Honour as Thomas Norton, Royal Garrison Artillery.

John O'Connor (1886–1946)

Family Origins: Father, County Galway, Ireland; Mother, Claremorris, County Mayo, Ireland
War Record: First World War 1914–18
Military Service: Private, Lancashire Fusiliers
Lived at No. 55 Chapel Street

John was born in Altrincham on 29 November 1886 at No. 55 Chapel Street where his family had lived since at least 1881. He was baptised on 22 January 1887 at the Church of St Vincent de Paul. His birth certificate, baptism record and birth registration gave his surname as Connor. He seemed to have been uncertain about his year of birth as his marriage certificate, entry in the 1939 register and his obituary notice indicate that he believed he was born in 1890.

In 1891 John, aged four, lived with his parents, sister Saisillia (Sealia on 1881 census), aged thirteen, and brothers Thomas, aged eleven, and Michael, aged eight, at No. 3 Lord Street, Altrincham. In 1891 John was living with his parents at No. 6 King Street, Altrincham, and working as a newspaper boy. In 1911 his father Thomas died and his mother Maria returned to Chapel Street to live at No 61. John, aged twenty four and working as a bricklayer's labourer, was a lodger at the home of Owen Arnold at No. 15 Heyes Street, Altrincham.

The Chapel Street Memorial, and John's obituary notice, confirm he saw First World War service with the Lancashire Fusiliers. Unfortunately, his service record has not survived and it has not been possible to identify his service number from other sources, as there were several men named John Connor or O'Connor who served in his regiment during the war.

John returned to Altrincham after the war. He was registered to vote at No. 6 Islington Street, Altrincham, in 1919, and 1921 with his brother Michael. He married Margaret Irlam at the Church of St Vincent de Paul on 10 January 1920. John's occupation at this time was

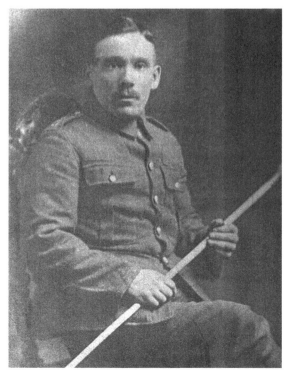

Private John O'Connor in uniform.
(Image courtesy of Sharon Withers)

fettler in an iron foundry and Army pensioner, though no record of his pension has survived. In 1924 the couple were living at No. 6 King Street, Altrincham.

John and Margaret had six children and continued to live in the Altrincham area. Post-war John was employed by the Altrincham Gas Co. and was a member of their social club. In 1939, and at the time of his death, he was living at No. 16 Islington Street. He died in Altrincham General Hospital on 2 August 1946 and is buried in Hale Cemetery.

John's brothers Thomas and Michael are listed on the Chapel Street Roll of Honour.

He is listed on the Chapel Street Roll of Honour as John O'Connor, Lancashire Fusiliers.

Michael O'Connor (1882–1932)

Family Origins: Father, County Galway, Ireland; Mother, Claremorris, County Mayo, Ireland
War Record: Anglo-Boer War 1899–1902; First World War 1914–18
Military Service: Private, 6th Battalion, Manchester Regiment Militia, Service No. 7155; Private, 3rd and 2nd Battalions, Manchester Regiment, Service No. 6322; Private, 826 Area Employment Company, Labour Corps, Service No. 450913
Associated with Nos 7, 55 and 61 Chapel Street

Michael was born in Liverpool on 26 November 1882 and baptised as Michael Connor on 10 December at the Church of St Anthony, Everton. He was the son of Thomas and Maria, née Jennings, both of whom had been living at No. 55 Chapel Street the previous year. In 1891 Michael, aged eight, was living with his parents and siblings at No. 3 Lord Street, Altrincham.

Michael became an experienced soldier. He enlisted for the 6th Battalion, Manchester Regiment Volunteer Militia, on 6 June 1900. His occupation was labourer and his address was given as No. 5 King Street, Altrincham. On 19 July he committed to become a regular soldier with the Manchester Regiment, and was posted to the 3rd Battalion in October. At the time of the 1901 census he was stationed in barracks at Aldershot, Hampshire. Later that year, on 7 October, he went to South Africa with his battalion and saw action in the Anglo-Boer War, earning campaign medals and clasps. He remained in South Africa until November 1906 and transferred to the Army Reserve in July 1908, having completed two four-year terms. On transfer to the reserves he was described as 'a willing and hard-working man', despite the considerable list of low-level infringements of Army discipline, such as drunkenness and use of improper language, on his conduct sheet.

It is likely that Michael returned to Altrincham on completion of his service. There was a Michael O'Connor, aged twenty-seven, a farm labourer with birthplace given as Galway, living at a lodging house at No. 7 Chapel Street in 1911. In September 1911 the local newspaper reported that Michael O'Connor and Patrick de Courcey of Chapel Street were fined and bound over to keep the peace for fighting in Chapel Street.

Michael re-engaged with the Manchester Regiment in July 1912. When the war broke out he was swiftly posted to France on 27 Oct 1914. He saw early action with the 2nd Battalion and was awarded the 1914 Star. In December he was removed from the fighting suffering from frostbitten feet and spent time in hospital in London.

Michael returned to France in May 1915. In January 1916 he lost five days' pay for failing to groom the horses and clean the stables by 7:00 a.m. In November 1917, having completed his term of service, he transferred to the Labour Corps and, on demobilization in February 1919, returned to the Army Reserve.

After the war he lived with his mother at No. 6 Islington Street, Altrincham and was still at that address in 1930. There is no evidence that he married. He died on 22 June 1932.

Michael's brothers Thomas and John are is listed on the Chapel Street Roll of Honour

He is listed on the Chapel Street Roll of Honour as Michael O'Connor, Manchester Regiment.

Thomas O'Connor (1879–1915)

Family Origins: Father, County Galway, Ireland; Mother, Claremorris, County Mayo, Ireland
War Record: Anglo-Boer War 1899–1902; First World War 1914–18
Military Service: Private, 3rd Battalion, Cheshire Regiment Militia; Sergeant, 4th Battalion, King's Liverpool Regiment, Service No. 6146. Also served, with the 1st, 2nd and 3rd Battalions, King's Liverpool Regiment
Lived at Nos 38, 55 and 61 Chapel Street

Thomas was born on the 28 September 1879 at No. 38 Chapel Street, Altrincham, and baptised on 12 October at the Church of St Vincent de Paul. His birth certificate and parish baptism entry record his surname as Connor. His parents were Thomas and Maria, née Jennings, who, by 1881, were living with their children Mary, aged seven, Sealia, aged three, and Thomas, aged two, at No. 55 Chapel Street. In 1891 they had relocated to No. 3 Lord Street, Altrincham, and Thomas had been joined by two more brothers, Michael and John.

Thomas was a career soldier, joining the 2nd Battalion, King's Liverpool Regiment, in August 1898, having previously served with the 3rd Volunteer Battalion, Cheshire Regiment, and also having worked as a groom. He served first in Ireland and was promoted quickly, reaching the rank of sergeant in October 1901, despite a severe reprimand in August for neglect of duty. On 21 October that year he joined the South Africa campaign with the 1st Battalion of his regiment for just over a year and was awarded campaign medals and clasps. This was followed directly by an eight-year period in India, not returning home until October 1910. He was based at Orford Barracks, Warrington, in 1911.

Thomas was discharged in March 1912, having achieved several good conduct badges during his service and with his general character described as 'good'. He had faced a few disciplinary issues during the latter part of his service, including a demotion to the ranks following a court martial the month before his discharge for drunkenness and ill-treating a soldier. He clearly missed the Army and applied to re-join from an address in Ardwick Green, Manchester. He was accepted for the Army Reserve on 3 July 1912. He married Julia Foy at the Church of St Vincent de Paul, Altrincham, on 12 October that year and they had a daughter, Kathleen, in October 1914.

At the outbreak of the First World War Thomas was quickly recalled and his previous experience duly recognised. He was mobilized with the 3rd Battalion, King's Liverpool Regiment, on 5 August 1914, promoted to corporal a month later and acting sergeant early the following year.

On 1 May 1915 Thomas was sent to France with the 4th Battalion. Tragically, he was killed at Neuve Chappelle on 4 July 1915. The battalion war diary stated that the troops were in the front line trenches at the time and subject to shelling. The entry read 'one high explosive shell burst in the front line trench, five men killed (including Sergeant. O'Connor) and three wounded'. In a letter to Mrs O'Connor, the adjutant of the battalion, said, 'O'Connor was one of the best Sergeants in the company, and his death was a great loss to all.' An Army memo, dated August 1915, listed his personal effects, and they included three letters, two photos and a picture.

After the war Julia O'Connor entered into correspondence with the Army authorities regarding the site of Thomas's burial. The War Graves Commission were initially unable to locate it, but she provided information from his battalion adjutant that he had been buried behind the trench near to Hogg's Hole, Neuve Chappelle. His body was located there and laid in its final resting place in the Guards Cemetery (Windy Corner) at Cuinchy. Mrs O'Connor requested that the words 'May his reward be as great as his sacrifice, RIP', be placed on his headstone. The local paper stated that he had lived at Upper Conrad Street, Harpurhey, Manchester, but 'he belonged to Altrincham'.

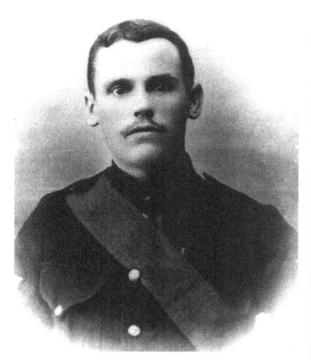

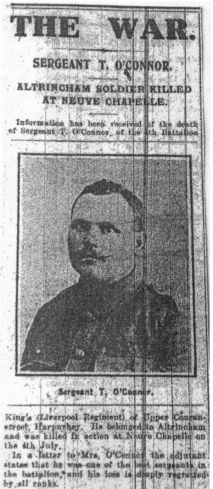

THE WAR.

SERGEANT T. O'CONNOR.

ALTRINCHAM SOLDIER KILLED
AT NEUVE CHAPELLE.

Information has been received of the death
of Sergeant T. O'Connor, of the 4th Battalion

Sergeant T, O'Connor.

King's (Liverpool Regiment), of Upper Couran-
street, Harpurhey. He belonged to Altrincham
and was killed in action at Neuve Chapelle on
the 4th July.
In a letter to Mrs. O'Connor the adjutant
states that he was one of the best sergeants in
the battalion, and his loss is deeply regretted
by all ranks.

Above: Sergeant Thomas O'Connor in uniform.
(Image courtesy of Sharon Withers)

Right: A local newspaper reported the death of Sergeant
Thomas O'Connor in 1915. (*Altrincham, Bowdon and
Hale Guardian*)

Thomas's brothers John and Michael are also listed on the Chapel Street Roll of Honour.

He is listed on the Chapel Street Roll of Honour as Thomas O'Connor, Kings Liverpool Regiment.

Thomas O'Connor (b. 1868)

Family Origins: Father, Ireland; Mother, Ireland
War Record: India, Miranzai Expedition 1891; Anglo-Boer War 1899–1902; First World War 1914–18
Military Service: Private, 1st and 2nd Battalions, Manchester Regiment, Service No. 1987; Private, 3rd Battalion, Cheshire Regiment Militia; Private, 3/5th Battalion Cheshire Regiment, Service No. 20097
Air Mechanic, Royal Air Force, Service No. 163021
Lived at Nos 11, 29 and 46 Chapel Street

Thomas was born on 2 July 1868 in Altrincham, the son of Bernard and Ellen, née Cavaney, and was living in Chapel Street with his parents in 1871. In 1881 Thomas, aged twelve, resided

at No. 11 Chapel Street with his parents and his sisters Mary, aged fourteen, Catherine, aged ten, and Margaret, aged eight.

Thomas had a long association with the Army. He enlisted as a private in the Manchester Regiment at Ashton-under-Lyne in August 1887, aged seventeen, and served in India with the 2nd Battalion from September 1889 to March 1895. During this time he took part in the Miranzai Expedition in May 1891 for which he was awarded the India Star and Samana clasp. He was discharged from this regiment after twelve years in August 1899.

In 1900 he married Edith Barber and in the following year was living with her and four stepchildren at No. 46 Chapel Street. Local newspaper reports give an impression that this was a rather tempestuous relationship. In April 1901 it reported a case held at Altrincham Police Court in which Thomas was charged with assaulting his wife Edith. Entitled 'An Altrincham Reservist goes to gaol', it gave a detailed account of the proceedings. Thomas stated 'he had done twelve years in the Manchester Regiment. He joined the 3rd Cheshire Reserve and was sent to the front, but was not there very long as he lost a finger. He got married to Edith before he was called up so that, in the event that he was killed, she could get the money. While he had been in South Africa he had heard she had been drinking all the time. When she knew he was returning she took a house and got some furniture on trust. She said it was a pity he 'did not have his head cut off in Africa.' The newspaper continued, 'Inspector Smith N.S.P.C.C., said he had had this case under observation for ten months. Mrs Connor came to see him and she complained there was no food in the house. Witness found that was so and he gave her 2 shillings to buy some. She explained there was a cheque from Lloyd's Patriotic Fund due to her husband and he went and saw Mr Goodall, the local secretary. Under the circumstances it was thought right that Mrs Connor should have the £3. Prisoner had a pension and was spending the money in drink.' He then went on to smash four pictures and two new chairs. Thomas stated 'he had been unable to get work since his return; and was unable to use his right hand properly. Thomas was found guilty of assaulting Edith and was sent to prison for a month.

The following year Thomas was again charged with assaulting Edith. It was reported 'Prisoner denied that he struck his wife with his belt. He said she threw a glass at him which cut his forehead and he had to go to the Hospital. Complainant had been drinking with her sister at her mother's. Police Constable Prosser alleged that prisoner had been drinking for the last three days.' Edith didn't appear in court but her brother, George Collins, came forward and said, 'she would like to withdraw the charge as she considered herself to be as much at fault as prisoner was'. Thomas was bound over in the sum of £10 to keep the peace for twelve months.

By 1911 Thomas was employed as a firewood dealer and living with Edith and their six children at No. 29 Chapel Street. He enlisted as a private in the 3/5th Battalion, Cheshire Regiment, in February 1915, but was discharged on medical grounds in April 1916, having a double hernia. Undeterred, in 1918 Thomas enlisted in the RAF as an air mechanic while still living at No. 29 Chapel Street and served until discharged in April 1920.

He is listed on the Chapel Street Roll of Honour as Thomas O'Connor, Royal Air Force.

Frank O'Shea (1887–1954)

Family Origins: Father, Ireland; Mother, Ireland
War Record: First World War 1914–18
Military Service: Driver, 21st Brigade, Royal Field Artillery, Service No. 40267
Lived at No. 4 Chapel Street and also associated with No. 54 Chapel Street

Frank was born on 25 March 1887 in Chester and was christened on 27 March at the Church of St Bridget, Chester. His parents were Margaret, née Quinlan, and John Shea. He was

baptised into the Catholic faith on 26 May 1889 at the Church of St Francis in Chester. In 1891, Frank, aged four, was living at No. 4 Victoria Buildings, Chester, with his widowed father and his brother Thomas, aged five. Although his baptismal record shows him as 'Francis O'Shea', his was christened 'Francis Shea'.

Frank married Mary Ann Collins, the daughter of Ellen and Michael Collins of No. 54 Chapel Street, Altrincham, at the Catholic Church of St Werburgh in Chester on 18 April 1909. She was the sister of Frank and James Collins listed on the memorial. She died in 1911, aged twenty-four, leaving Frank a widower. In 1911 Frank was working as an insurance agent and living with his grandmother, Martha Lloyd, at No. 60 Gloucester Street, Chester. Elsie Shea, aged five, and Francis Joseph Shea, aged one, were also living at this address.

Frank experienced some difficulties in coping on his own with his young family. In June 1914 the *Chester Observer* reported that Frank O'Shea, of the lodging house at No. 4 Chapel Street, had been charged with family desertion. Frank pleaded not guilty. The relieving officer explained that his children had been admitted to the workhouse at Knutsford, based on information that they had been left while they were residing in Altrincham. The children had reportedly been in the Bucklow and Chester workhouses the year before while Frank worked in Bolton. Having left them in a Catholic home, Frank reported that he had returned to find them in the Chester Union. As the children were again chargeable to the fund of the Chester Union, Frank agreed to pay 7s per week for them, and the case was adjourned.

Frank must have joined the Army before or at the very start of the war as on 11 September 1914 he entered the theatre of war in France. He served as a driver in the Royal Field Artillery, 21st Brigade, and received the 1914 Star. He was tried by court martial at Croix du Bac in northern France at the end of January 1915 for absence from barracks and for striking or using violence. He was awarded six months imprisonment, which was commuted to three months field punishment No. 1. Despite this, he gained promotion to acting bombardier following his sentence and, according to absent voters lists, was still serving in autumn 1919.

In 1917 Frank married Elizabeth Beatrice Reeves. He appears to have been registered to vote at two addresses in Altrincham in 1918 and 1919. At No. 11 John Street he was registered under his own Service No. 40267. This was the same address as William Arthur Reeves, who is listed on the memorial and was his wife's brother. At No. 33 Victoria Street he was listed with the Service No. 43267, one digit different from his own.

In 1939 Frank and Elizabeth were living at No. 40 Milner Avenue, Altrincham, with his son Francis Joseph and three other children – Brian, born in 1925, Thomas, born in 1931, and Margaret, born in 1932. He was working as a general labourer at a heavy works.

Frank died on 22 December 1954 aged sixty-seven, leaving effects of £410, 2s 11d. Up until his death, he was still living at No. 40 Milner Avenue. A death acknowledgement in the local paper recorded Mrs O'Shea and family thanking relatives, friends, neighbours, staff and work mates of 2 MU RAF Camp, the RAF Maintenance Unit at Broadheath, Altrincham.

He is listed on the Chapel Street Roll of Honour as Frank O'Shea, Royal Field Artillery.

Frank Owen (b. 1899)

Family Origins: Father, Widnes; Mother, Warrington
War Record: First World War 1914–18
Military Service: Private, South Wales Borderers, Service No. 64573; Private, 9th Battalion Royal Welsh Fusiliers, Service No. 57698 and 4179683
Lived at No. 33 Chapel Street

Francis George Owen was born on 19 November 1899 in Widnes. He was the son of George and Margaret, née Collins. In 1901 he was living with his parents at No. 14

Edwin Street, Widnes. By 1911 the family had moved to No. 29 Police Street, Altrincham, and Frank, aged eleven, was listed as a scholar and newsboy. Here he lived with his parents and siblings Lillian, aged eight, Herbert, aged six, Gertrude, aged four and a lodger, William Johnson. Frank's father died in 1912 and his mother married William Johnson in 1914.

Frank served in the First World War as a private in the South Wales Borderers and the Royal Welsh Fusiliers. The dates of his military service are uncertain but, given his age, he is unlikely to have enlisted until the latter part of the war. He was awarded the Victory and British War medals. In February 1919 Frank re-enlisted as a driver in the Royal Welsh Fusiliers aged nineteen years and three months. He gave his address as No. 33 Chapel Street and his mother Mrs M. Johnson as next of kin. The 1921 to 1923 electoral registers recorded him as an absent voter at this address, because he was serving in Waziristan, India. In 1926 he was living at No. 5 Islington Terrace, Altrincham, and the following year he married Margaret Poole and they had a son Stanley Hubert. By 1930 the family had moved to No. 65 Hillcroft Road, Altrincham, and Frank remained in the Army until 13 February 1931 when he was discharged as corporal.

The Postal Service Appointments Book confirmed that Frank began employment as a postman in Cheadle Hulme in September 1936 and in 1939, he was living with his family at No. 179 Grove Lane, Cheadle. Frank re-enlisted with the Royal Welsh Fusiliers in 1940.

He is listed on the Chapel Street Roll of Honour as Frank Owen, South Wales Borderers.

Albert Oxley (1899–1918)
Family Origins: Father, Altrincham; Mother, Altrincham
War Record: First World War 1914–18
Military Service: Private, 12th Battalion, Manchester Regiment, Service No. 54772
Lived at No. 6 Chapel Street

Albert Oxley was born in the first quarter of 1899 and baptised on 23 February at St Margaret's Church, Dunham Massey. His parents were William and Elizabeth, née Hollingsworth. The Oxley family had a long association with Chapel Street. Albert's great-grandfather, John Oxley ,and his wife, Mary Anne, were living at No. 24 Chapel Street in 1871. In 1901 Albert was living at No. 6 Chapel Street with his parents and sisters Margaret, aged five, and Elizabeth, aged ten months. He was still living at the same address in 1911 in the care of his aunt, Mary Anne Hollingsworth, who was head of the house. Albert's mother Elizabeth had died in 1903, aged thirty two, and his father William, who was a boarder at No. 8 Salisbury Street, St Helens, died in 1914, aged forty-three.

In February 1917, Albert, aged nineteen, enlisted in the 12th Battalion, Manchester Regiment, at Altrincham and was sent to the front in January 1918. Tragically, within a month, he had died of wounds. The local newspaper dated March 1918 reported that 'Miss Hollingworth of 6 Chapel Street has been advised her nephew Private Albert Oxley, Manchester, only son of the late William E. Oxley, Chapel Street was killed in action on 20 February 1918. He was nineteen years of age and received his education at St Margaret's Day Schools, Altrincham. He enlisted on February 20th 1917 and went to the front in January last. Previous to joining the Colours he was employed at the Altrincham Hippodrome where he was a great favourite.'

Albert was buried at Rocquigny-Equancourt Road Cemetery, Manancourt, France. The soldier's record of effects indicated that the residue of his Army account passed to his aunt, Mary Hollingsworth. Albert was listed on the Chapel Street Roll of Honour as having served in the Cheshire Regiment; however, no evidence has been found to confirm this.

He is listed on the Chapel Street Roll of Honour as Albert Oxley, Cheshire Regiment.

Alfred Oxley (1877–1915)

Family Origins: Father, uncertain; Mother, Altrincham
War Record; Anglo-Boer War 1899–1902: First World War 1914–18
Military Service: Private, 3rd Battalion, Cheshire Regiment Militia; Private, 1st Battalion, Royal Lancaster Regiment, Service Nos 4614, 54772; Private, 2nd Battalion, Royal Lancaster Regiment, Service No. 17298
Lived at Nos 2, 7, 20, 22 and 24 Chapel Street

Alfred was born around 1877 and, although three different locations for his birth – Altrincham, Manchester and Chester – were listed on different censuses, Alfred put Altrincham as his place of birth on his Army enlistment record. However, a birth record for an Alfred Ellison Oxley born on 23 January 1877 registered in Prestwich, Manchester, has been traced. Hannah Oxley of No. 13 Berkeley Street, Cheetham, Manchester, was recorded as his mother, but no father's name was given. In 1873 Hannah Oxley of No. 24 Chapel Street was named on the birth record of Alfred's older brother William Edward and a father's name was given as James Royle. Both Alfred and William were brought up from an early age by their maternal grandparents John and Mary Ann Oxley, who resided at No. 24 Chapel Street. In 1881 Alfred, aged five, was living at No. 8 Albert Street with his grandparents, William, aged eight, and an uncle, Walter Oxley. John died in 1881 and by 1891, the family consisting of Alfred, his widowed grandmother Mary Ann, William and another uncle, Robert Oxley, had moved to No. 2 Chapel Street.

In November 1894, Alfred enlisted in the 1st Battalion, Royal Lancaster Regiment, at Manchester. He was aged nineteen years and ten months and gave his occupation as a labourer. He stated on his attestation form that he was serving in the Cheshire Militia and had previously served in the Cheshire Regiment. His brother William of No. 9 Chapel Street was listed as next of kin. Between 1895 and 1900 Alfred served in Malta, Hong Kong and

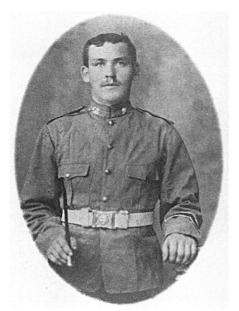
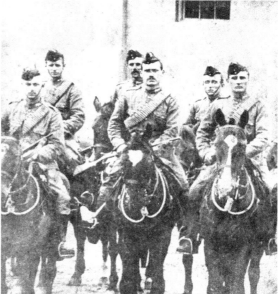

Above left: Private Alfred Oxley in uniform. (Image courtesy of Kathleen Winkley)

Above right: Alfred Oxley (centre) on horseback. (Image courtesy of Kathleen Winkley)

Singapore, but on 25 October 1900 he was discharged from the Army after being found to be medically unfit for further service.

When Alfred returned home, he gained employment as a railway porter and moved into lodgings at No. 7 Chapel Street. He married Mary Frances De Courcy in the second quarter of 1901 and by 1911 he was head of household at Nos 20, 22 and 24 Chapel Street, a lodging house. Also living there was his wife Mary Frances, their sons Alfred, Joseph, Jack and William, daughter Mary, and niece Alice, plus two lodgers, Peter and James Gormley.

When the First World War broke out, Alfred re-enlisted in January 1915 with the Royal Lancaster Regiment. He served in the 2nd Battalion and was transferred to France in February 1915, but sadly died of wounds on 8 May 1915. A report in the local newspaper dated October 1915, entitled 'A family's ill luck', stated that Private Alfred Oxley had been reported as missing in France and his wife was unaware of his whereabouts until she received a letter from Private Samuel Shaw of the same regiment as Alfred. Samuel wrote, 'I have been making enquiries all week about your husband and I found out from a man Samuel Brown who was with him on the 8 May that he was killed by the explosion of a shell.' Alfred is commemorated on the Menin Gate Memorial.

He is listed on the Chapel Street Roll of Honour as Alfred Oxley, Kings Own Royal Lancaster Regiment.

Arthur Oxley (b. 1900)

Family Origins: Father, Altrincham; Mother, Staffordshire/Derbyshire
War Record: First World War 1914-18
Military Service: South Lancashire Regiment
Lived at No. 36 Chapel Street

Arthur Oxley was born on 5 March 1900 in Altrincham and his baptism took place on 25 April at St George's Parish Church. His parents were Robert and Mary, née Munton. In 1901, Arthur was living at No. 36 Chapel Street with his parents, his sister Mary, aged three, and two step-brothers, William Munton, aged seventeen, and Montague Munton, aged fifteen. Arthur also had a younger brother Robert, who was born in 1903. By 1911 the family had moved to No. 1 Albert Street, Altrincham. Arthur was still living at this address with his widowed mother Mary in 1923. He married Edith Dunn that same year. In 1939 he was living at No. 26 Hillcroft Road, Dunham Massey, and was employed as a crane driver in an iron foundry.

The Chapel Street Roll of Honour listed Arthur as serving in the South Lancashire Regiment, but so far, no military records have been traced that link this name and regiment to Altrincham. Only one soldier named Arthur Oxley has been located from the medal rolls and Army service records as serving in the South Lancashire Regiment, but this soldier was killed in action in April 1918 and his birthplace was Warrington. It is possible that the Arthur Oxley from Chapel Street was the Lance-Corporal A. Oxley of Chapel Street, a deserter, whom James Gormley, a relation by marriage, was accused of sheltering in 1923, as reported in the local newspaper of 9 March 1923. James Gormley pleaded not guilty and the case was eventually dismissed.

He is listed on the Chapel Street Roll of Honour as Arthur Oxley, South Lancashire Regiment.

Walter Oxley (b. 1867)

Family Origins: Father, Conisborough, Yorkshire; Mother, Altrincham
War Record: Anglo-Boer War 1899–1902; First World War 1914–18
Military Service: Private, 3rd Battalion, South Lancashire Regiment, Service No. 6523; Private, 3rd Battalion, Cheshire Regiment, Service No. 6523; Private, 4th Battalion, King's Own Royal

Lancaster Regiment; Private, Cheshire Regiment Special Reserve, Service No. 7519; Private, Labourer, Aircraft Hand, Royal Air Force, Service No. 269483
Lived at Nos 2, 22 and 26 Chapel Street

Walter was born in the fourth quarter of 1867 in Altrincham. His parents were John and Mary Ann, née Lloyd. In 1871 Walter, aged four, was living at No. 26 Chapel Street with his parents and siblings Ann, aged nineteen, William, aged seventeen, Charles, aged fifteen, Harriet, aged thirteen, George, aged twelve, and Robert, aged eight. By 1881 Walter had relocated to No. 8 Albert Street, Altrincham, with his parents and two nephews, William and Alfred Oxley. Walter married Mary Corfield on 7 April 1894 at the Church of St Vincent de Paul, Altrincham, and they went on to have a daughter, Anne, born in 1897.

In May 1897 Walter enlisted at Warrington in the 3rd Battalion, South Lancashire Regiment. He served with this battalion and the 3rd Battalion Cheshire Regiment in South Africa until the end of November 1901. He was awarded the South Africa Medal and clasps for Orange Free State and Cape Colony. His attestation papers for the Army Reserve from 1902 onwards stated that he had also served with the 4th Battalion, King's Own Royal Lancaster Regiment, but the dates of this service have not been located.

While Walter was overseas, Mary and Annie, aged four, were residing at No. 40 Chapel Street with Mary's parents James and Bridget Corfield. Walter returned home and re-enlisted with the 3rd Battalion, Cheshire Special Reserve, in January 1902. He remained with the reserves until June 1910, during which time he was employed as a labourer working for E. Owen of Altrincham and for John Fox, builder. The addresses given on his Army service records during that period were No. 2 Chapel Street and No. 7 Denmark Street, Altrincham.

Walter's wife Mary sadly died in the fourth quarter of 1908, aged thirty-three. By 1911 Walter, employed as a labourer, was boarding at No. 22 Chapel Street, the lodging house run by his cousin Alfred and wife, Mary Frances. Walter's daughter Annie was listed as an 'inmate' at St Clare's Roman Catholic Orphanage for Girls run by the Sisters of Charity of Our Lady Mother of Mercy in Pantasaph, Holywell, Flintshire, in 1911.

Over the years there were a number of 'colourful' incidents in Walter's life. According to the *Cheshire Observer* of January 1895, he was wounded by James Corfield, probably his father-in-law, for which James was sentenced to three months imprisonment. The local newspaper in March 1905 reported that Walter and his brother Robert were charged at the Police Court with assaulting a police officer while in the execution of his duty. Robert, the main protagonist, was imprisoned for two months hard labour and Walter was fined 10s or, in default, seven days imprisonment. On his attestation for the Cheshire Militia in 1906 Walter admitted to serving seven days in prison for drunkenness.

In July 1918, at the age of fifty, Walter enlisted in the RAF as a private and labourer at 9 Aircraft Repair Depot, Edmonton, London. He was transferred to the RAF Reserve in February 1919 in the rank of private, aircraft hand, and was rated as having 'moderate proficiency', with his character described as 'very good'. His daughter Annie, of St Clare's Convent, Pantasaph, was listed as next of kin on his service record. He was discharged from the RAF in April 1920 and after the war lived at No. 16 Hamon Road, Altrincham.

He is listed on the Chapel Street Roll of Honour as Walter Oxley, Royal Air Force.

Thomas Peers (1884–1917)

Family Origins: Father, Newton by Daresbury, Cheshire; Mother, Ashton on Mersey
War Record: First World War 1914–18
Military Service: Private, 20th Labour Battalion, Cheshire Regiment, Service No. 41763; Private, 61st Company, Labour Corps, Service No. 36264
Lived at No. 43 Chapel Street

Tom Peers was born in 1884 and baptised in Ashton on Mersey on 29 January. His parents were Caleb Peers and Mary, née Robinson. In 1891 Tom, aged six (listed on the census as Sam), was living at Green Lane in Ashton on Mersey with his parents, brothers William, aged sixteen, James, aged fourteen, Caleb, aged twelve, and sisters Annie, aged thirteen, Mary, aged eleven, Margaret, aged nine, Edith, aged four, and Alice, aged three.

Tom's father, a shopkeeper, died in the summer of 1895 and five years later his mother married Edward Jones, a farmers' son from Ashton on Mersey. In 1901 Tom was living with his stepfather, mother and four sisters in Green Lane, Ashton on Mersey. He was educated at St Martin's School and belonged to the Primitive Methodist Sunday school in Ashton on Mersey.

Tom married Mary Elizabeth Jackson on 3 December 1905 at St Anne's Church, Sale. On his marriage certificate he gave his occupation as coachman and his address as No. 3 Greenhill, Ashton on Mersey. By 1911 Tom, now a general farm labourer, and Mary were living in Norley Lane in Norley, Cheshire, with their three surviving children: Mary, aged four, William, aged two, and Caleb, aged three months. The couple would go on to have two more children – Alice, born 1913 and James, born 1916. By March 1914 the family had relocated to No. 43 Chapel Street and the local paper reported that a Tom Peers of Chapel Street, Altrincham, was fined 2s 6d for driving a vehicle without exhibiting a red light to the rear.

Tom enlisted in the 20th Labour Battalion, Cheshire Regiment, in July 1916 and in April 1917 transferred with the rest of his battalion to the newly formed 61st Company, Labour Corps. The local paper reported in January 1917 that he was granted leave to return home following the death of his son James.

Tom Peers died of wounds on 15 August 1917 in France during the third Battle of Ypres, (30 July–10 November 1917) and was buried at Lijssenthoek Military Cemetery. The local newspaper reported his death on 31 August 1917 and referred to the many letters he had sent home to his wife and brothers and sisters in 'which he expressed his despondency from the fact of not coming across anyone he knew personally well out of the thousands of men he saw'. Although his letters from the front expressed regret 'about a week before his death he had the satisfaction of working with his cousin from Norley'.

His effects were sent to his widow Mary Elizabeth in December 1917 and she received a war gratuity of £4 1s the following year. His medals were not issued to her until January 1936.

He is listed on the Chapel Street Roll of Honour as Thomas Peers, Cheshire Regiment.

Arthur Prosser

Family Origins: Not known
War Record: First World War 1914–18
Military Service: Cheshire Regiment
Associated with Chapel Street

Arthur is listed on the Chapel Street Memorial as serving with the Cheshire Regiment but it has not been possible to identify this soldier with any certainty or to link the name Arthur Prosser or a variant to Chapel Street. There are service records for two Arthur Prossers, but neither show any link to the area or to the Cheshire Regiment. There are no census returns for Arthur Prosser in Altrincham, although an Albert Prosser was living in Chapel Street, Leigh, Lancashire, at the time of the 1911 census.

He is listed on the Chapel Street Roll of Honour as Arthur Prosser, Cheshire Regiment.

Michael Quinn
Family Origins: Not known
War Record: First World War 1914–18
Military Service: Royal Irish Rifles
Associated with Chapel Street

Michael is listed on the memorial as serving with the Royal Irish Rifles, but it has not been possible to identify this soldier with any certainty, or to find any Michael Quinn who served in the Royal Irish Rifles or similarly named regiments who has any connection with Altrincham.

There was a marriage of a Michael Quinn to Bridget Morgan registered in the third quarter of 1887 at Altrincham. A son, Edward, was born on 14 April 1889 and baptised at the Church of St Vincent de Paul. His father is named as Michael Edward Quinn. There was also a Michael Quinn at No. 126 Grove Lane, Altrincham, on the 1939 register. An agricultural labourer, he was living with his wife Mary and children, although as he was born on 10 November 1901, he was probably too young to have served between 1914 and 1918.

Two men with the surname Quinn have been found with a Chapel Street connection: James Quinn, navvy, born in 1875 in Mayo, Ireland, was living as a boarder with Mary Brennan and her family at No. 42 Chapel Street at the time of the 1901 census; and Thomas Quinn of Chapel Street, who, according to a report in the local newspaper, was fined 5 shillings in 1906 at Altrincham Petty Sessions for peddling without a certificate.

He is listed on the Chapel Street Roll of Honour as Michael Quinn, Royal Irish Rifles.

Patrick Quinn
Family Origins: Not known
War Record: First World War 1914–18
Military Service: Royal Irish Rifles
Associated with Chapel Street

Patrick is listed on the memorial as serving with the Royal Irish Rifles, but it has not been possible to identify this soldier with any certainty. Although there were a number of men named Patrick Quinn who served in the Royal Irish Rifles, Royal Irish Fusiliers or Royal Irish Regiment, it has not been possible to trace a Patrick Quinn serving in these regiments who has any connection with Altrincham. The 1901 census indicated there was a Patrick Quinn, born in Ireland in 1874 and living and working as a cattleman on a farm in Rostherne, but no link to Chapel Street or Altrincham has so far been established.

Two men with the surname Quinn have been found with a Chapel Street connection: James Quinn, navvy, born in 1875 in Mayo, Ireland, was living as a boarder with Mary Brennan and her family at No. 42 Chapel Street at the time of the 1901 census; and Thomas Quinn of Chapel Street, who, according to a report in the local newspaper, was fined 5s in 1906 at Altrincham Petty Sessions for peddling without a certificate.

He is listed on the Chapel Street Roll of Honour as Patrick Quinn, Royal Irish Rifles.

James Ratchford (1868–1925)
Family Origins: Father, Ireland; Mother, Ireland
War Record: First World War 1914–18
Military Service: Private, 8th Battalion, Cheshire Regiment, Service No. 10455; Private, 3rd Garrison Battalion, Royal Welch Fusiliers, Service No. 71258
Lived at Nos 44 and 56 Chapel Street

The birth of James William (Willie) Ratchford was registered in the Chorlton District in the first quarter of 1868. In 1871, aged four, he was living with his parents Martin and Bridget, née Jennings, and his brothers Owen, aged five, and Michael, aged nineteen months. By 1881 the family had relocated to Moss Lane, Altrincham, with additional children: Kate, aged ten, John, aged eight, Martin, aged six, Mary Ellen, aged five, Annie, aged two, and Cecilia, aged one.

Following the death of his father in May 1882, James, in common with his siblings, moved away from Altrincham. A James Ratchford, a labourer aged eighteen, joined the 4th Battalion, Manchester Regiment Militia, Service No. 2019, on 14 Jun 1887 at Ashton-under-Lyne. His birthplace was recorded as Salford, though there was no James Ratchford born there on the right date for the given age. The Chapel Street James was recorded as having been born in Salford on the 1901 census. A note at the bottom of the attestation form indicated that he had lived at No. 6 Bangall Street, off Oldham Road, for the previous five years and eleven months, and was of good character. While it is by no means certain that this man was the son of Martin and Bridget, his age is consistent and the date of moving into lodgings was around ten months before his father's death.

James was living with his sister Kate at No. 55 Nicholas Street, Rochdale Road, Manchester, in October 1890 when his brother John enlisted for the Lancashire Fusiliers. He has not been located in 1891, possibly because he was serving overseas or on board a ship. The *Northwich Guardian* in November 1916 reported that he was on a steamer off Nova Scotia in November 1892 when it went ran onto a sandbank. He swam with a lifeline a good distance and saved many lives.

He married Elizabeth Ann Tyrell on 23 April 1897 at the Church of St William, Simpson Street, Angel Meadow, Manchester. In 1901 the couple were lodging at No. 94 St Simon Street in Salford with his sister Mary Ellen, her children and her husband, John Thomson, as well as Elizabeth's mother, Mary Tyrell. By 1907 he had returned to Chapel Street and in 1911 was living at No. 56 with his wife and her brother, Thomas Tyrell, and working as a bricklayer's labourer.

The Chapel Street Memorial listed James as serving with the Cheshire Regiment. The only soldier of that name who served with this regiment was Private James Ratchford, who enlisted on 19 August 1914, served with the 8th Battalion and went with that unit to enter the Balkans theatre of war on 7 July 1915. He later transferred to the 3rd Garrison Battalion, Royal Welch Fusiliers, which was stationed at Litherland, Liverpool. While serving in Liverpool Private Jim Ratchford, Cheshire Regiment, of 56 Chapel Street was rewarded by the Shipwreck and Humane Society with £1 and a vote of thanks for a gallant rescue of the foreman of the *Shiloth Shed*, who had fallen into Clarence Dock on 17 October 1916. James saved the man and a policeman who had exhausted himself trying to rescue the foreman. The report also indicated that James was a well-known boxer and club swinger. He was discharged from the Army on 1 October 1917, his age given as forty-four but, in reality, nearer to fifty. He was awarded the Silver War Badge.

He returned to No. 56 Chapel Street and was still registered to vote there in 1924. James William Ratchford died in 1925, aged fifty-six, and was buried at Hale Cemetery on 6 January 1925.

He is listed on the Chapel Street Roll of Honour as James Ratchford, Cheshire Regiment.

John Ratchford (b. 1873)

Family Origins: Father, Ireland; Mother, Ireland
War Record: Anglo-Boer War 1889–1902; First World War 1914–18
Military Service: Private, 3rd and 10th Battalions, Lancashire Fusiliers, Service No. 3446; Private, 1st Battalion, King's Liverpool Regiment, Service No. 3451; Private, 3rd & 4th Battalions, King's Liverpool Regiment, Service No. 10773
Associated with No. 44 Chapel Street

John Ratchford was born in Altrincham on 28 March 1873 and baptised as John Rochford on 20 April at the Church of St Vincent de Paul. Like his brother Michael, his birth was registered under the surname Rachford. There is no direct evidence that John lived in Chapel Street but his parents, Martin and Bridget, née Jennings, were living at No. 44 at the time of the 1871 census, about two years before he was born. By 1881 the family had moved to Moss Lane, Altrincham.

Following the dispersal of his family after his father's death in May 1882, on 8 October 1890 John, a wire worker aged eighteen, joined the Lancashire Fusiliers at Bury, stating on his attestation form that he had already served with the 3rd and 10th Battalions of that regiment. He gave his brother James and sister Kate of No. 55 Nicholas Street, Rochdale Road, Manchester, as his next of kin. He transferred to the King's Liverpool Regiment at the beginning of December that year and served with the regiment in Bermuda, Nova Scotia, Barbados, and his first period in South Africa from November 1897 to July 1898, when he was transferred to the Army Reserve. He was recalled to the King's Liverpool Regiment and served with the 1st Battalion in South Africa from January 1900 until August 1902. He was awarded the Queen's and King's South Africa medals and clasps for engagements at Belfast, the Relief of Ladysmith and Lang's Nek.

Between his periods of service in South Africa he had married Catherine Jackson in the Manchester Registration District in 1899, and in the following year they had a daughter, also Catherine, before his wife died in 1906. In 1911, aged thirty-six and working as a labourer in a chemical works, he lived with his daughter along with his sister Mary Ellen Thomson, her husband and their daughter at No. 41 Kenyon Street, Blackley, Manchester.

When hostilities broke out he returned to the King's Liverpool Regiment on 29 September 1914, and was posted to the 3rd Battalion in November, before transferring to the 4th Battalion when he entered France on 1 May 1915. On a few occasions punishment was imposed upon him for transgressing Army rules, including fourteen days of field punishment No. 1 on account of his behaviour in the barrack room and for not obeying an order, and twenty one days of the same in March 1918 for drunkenness when on active service. He was transferred to the Army Reserve on 6 June 1919. There is a letter in John's Army service record that states that his daughter was living with her aunt, Cecilia Bagnall, who, as her guardian, was receiving John's allotment for a dependent relative.

John returned to Altrincham after the war and was registered as a voter at No. 5 Paradise Street in 1923 and at No. 27 Bank Hall Lane, Hale, between 1927 and 1931.

He is listed on the Chapel Street Roll of Honour as John Ratchford, Kings Liverpool Regiment.

Michael Ratchford

There are two possible options for this name associated with Chapel Street, which are below.

Michael Ratchford (b. 1869)
Family Origins: Father, Ireland; Mother, Ireland
War Record: First World War 1914–18
Military service: Sapper, Royal Engineers, Service No. 79702; Private, 5th Battalion, King's Own Yorkshire Light Infantry, Service No. 3117
Lived at No. 44 Chapel Street

Michael Ratchford was born in Altrincham on 4 October 1869 and baptised as Michael Rochford thirteen days later at the Church of St Vincent de Paul. His birth was registered as Michael Rachford. His parents were Martin, a bricklayer's labourer from Ireland, and Bridget, née Jennings, also from Ireland. In 1871 Michael, aged nineteen months, was living with them and his brothers Owen, aged five, and James, aged four, at No. 44 Chapel Street. By 1881 the

family had moved to Moss Lane, Altrincham, and included additional children: Kate, aged ten, John, aged eight, Martin, aged six, Mary Ellen, aged five, Annie, aged two, and Cecilia, aged one.

Michael's father Martin died in May 1882 and the family became separated. His sisters Mary Ellen and Cecilia were resident at St Joseph's Industrial School in Rusholme in 1891. Michael's whereabouts in 1891, 1901 and 1911 are uncertain but it is possible that he went to Ireland. There was a Michael Rochford, aged forty, from County Mayo living with his wife Catherine and family at No. 28 Egerton Street, Sale, in 1911 who may be the same Michael Rochford, aged thirty-two, who lived with Catherine in Cuildoo, County Mayo, in 1901.

If the allocation of regiment to Michael Ratchford on the Chapel Street Memorial is correct, there is evidence for only one soldier of the name Ratchford or variants who served in the Royal Engineers. Medal card and medal roll entries survive for a Sapper Martin Rochford, Service No. 79702, who later served as a private in the 5th Battalion, King's Own Yorkshire Light Infantry, Service No. 3117. He entered France on 14 April 1915 and was transferred to Class 'Z' Reserve on 18 March 1919. There is no evidence to connect him to Chapel Street.

A Michael Rochford was registered as a voter at No. 41 Egerton Street, Sale, in 1920 and 1930.

Michael's brothers James, John and William Ratchford are listed on the Chapel Street Roll of Honour.

Michael Ratchford (1870–1929)
Family Origins: Father, County Mayo, Ireland; Mother, Loughrea, County Galway
War Record: None located
Military Service: None located
Lived at Nos 14, 26, 29 and associated with 13 Chapel Street

Martin Ratchford was born on 21 July 1870 and baptised ten days later with the surname Rachford at the Church of St Vincent de Paul, Altrincham. He was the son of Michael and Bridget, née Brown. The family had lived in Chapel Street since at least 1871 when they resided at No. 13. In 1881 Bridget was at No. 26 Chapel Street without her husband but with Maria, aged thirteen, Michael, aged ten, Lizzie, aged eight, Kate, aged six, and Agnes, aged one. By 1891 Michael's father had returned and the family were at No. 29 Chapel Street with the addition of two extra children – Julia, aged nine, and Ada, aged five. Michael was aged twenty and working as a bricklayer's labourer.

Michael married Catherine Callaghan on 19 October 1895 at the church of his baptism and by 1900 they were living at No. 14 Chapel Street and in 1911 were still there with their two children – Kate, aged three, and Thomas, aged two. Michael continued to work as a bricklayer's labourer and the family continued to live at this address until at least 1922.

Michael was not listed as an absent voter in either 1918 or 1919 and there is no evidence of any military service associated with him. It is interesting to note that his name was crossed out as next of kin on the attestation form of his son Thomas in 1917 and replaced by Kate Ratchford. Sources currently available do not record any man named Michael Ratchford as having served with the Royal Engineers, as listed on the memorial, but there was a Michael Rochford in that regiment, described above.

Michael died 17 July 1929, aged fifty-eight, and was buried at Hale cemetery. His son Thomas was named on the memorial.

He is listed on the Chapel Street Roll of Honour as Michael Ratchford, Royal Engineers.

Thomas Ratchford (1899–1983)

Family Origins: Father, Altrincham; Mother, Altrincham. Paternal Grandparents, Ireland
War Record: First World War 1914–18
Military Service: Private, 57th Training Reserve Battalion and 52nd Graduated Training Reserve Battalion, South Wales Borderers, Service No. 1775; Private, 1/4th Battalion, King's Shropshire Light Infantry, Service No. 31618
Lived at No. 14 Chapel Street

Thomas Ratchford was born in Altrincham on 26 January 1899 and baptised on 8 February at the Church of St Vincent de Paul. He was the son of Michael and Catherine, née Callaghan, who were living in Chapel Street at the time of his baptism and recorded in 1901 at No. 14. The family was still living at this address in 1911 and consisted of his parents, Thomas, aged twelve, and at school, Agnes, aged eight, and Ada, aged six. An older sister, Kate, who was listed as aged three in 1901, has not been located.

Thomas was working as an engine cleaner for Great Central Railway at Altrincham when he enlisted in the Army on 22 January 1917, aged eighteen. He was placed in the Army Reserve and mobilised at Chester on 8 June and allocated to the 57th Training Reserve Battalion before being posted to the 52nd Graduated Training Reserve Battalion, South Wales Borderers, in November 1917. He had an early encounter with Army discipline when awarded a ninety-six hours detention in July for hesitating to obey an order and making an improper remark to an NCO. On 3 February 1918 he entered France and was posted to the King's Shropshire Light Infantry. His service there did not last long. He was wounded in the field on 26 March; three days after his battalion had fought in the Battle of St Quentin. He returned to England four days later and was admitted to a military hospital at Chatham.

On 5 July 1918 he was posted to Prescot before moving to the regimental depot at Shrewsbury on 24 July, having been admitted the day before to St James's Military Hospital in Liverpool where it was recommended that he attend a Medical Board. The outcome of this was that he was discharged from the Army with a good military character on 8 October 1918. The reason given was that chronic papular dermatitis, from which he had suffered since childhood, rendered him physically unfit for continuing his service, despite his protestations that it was no worse than when he had enlisted. He was awarded the Silver War Badge.

He returned home to No. 14 Chapel Street and was registered as a voter there between 1919 and 1923, the year in which he married May Berry. They moved to No. 6 Haddon Grove, Timperley, and then to No. 50 Stamford Avenue, Altrincham, where he still resided in 1931. He was recorded on the 1939 register living with his wife at No. 3 Montrose Avenue, Stretford, and employed as a railway locomotive fireman, qualified for driving. He died in the fourth quarter of 1983 in the Eastbourne area, aged eighty-four. He was buried on 3 February 1984 at Hale Cemetery.

He is listed on the Chapel Street Roll of Honour as Thomas Ratchford, Royal Shropshire Light Infantry.

William Ratchford (b. 1884)

Family Origins: Father, Not known; Mother, Ireland
War Record: First World War 1914–18
Military Service: Private, 8th, 10th & 13th Battalions, Cheshire Regiment, Service No. 11235
Lived at Nos 3–5, 52, 53 and 57 Chapel Street

William Ratchford was born in Altrincham on 2 October 1884 and baptised on 9 November at the Church of St Vincent de Paul. He was the son of Bridget Ratchford, née Jennings, but no father was recorded on his baptism entry, his mother having been widowed over two years

before his birth. William's family had been resident in Moss Lane, Altrincham, in 1881 but it is not known whether they were still there at the time of his birth. It has not proved possible to locate him on the 1891 and 1901 censuses.

In 1911 he was living at No. 53 Chapel Street as a boarder at the lodging house of Margaret Collins. He was aged twenty-eight, single and working as a hawker of small wares. Slater's Street Directory recorded him as a labourer, living at No. 57 in 1909 and at No. 52 in 1911.

There is evidence for only one William Ratchford, who served in the Cheshire Regiment, as indicated on the memorial. That man was Private William Ratchford, Service No. 11235, and this is confirmed by the words, 'Private No. 11235', written against his name in his entry in the 1939 register. He was, at various stages of the war, allocated to the 8th, 13th and 10th Battalions, Cheshire Regiment. He entered the Balkan theatre of war on 26 June 1915 with the 8th Battalion and later served with the two other battalions, which were in action in France. He was discharged on 12 April 1919.

After the war he returned to Altrincham and from 1924 to 1926 and in 1930 he was registered to vote at Nos 3 –5 Chapel Street, a lodging house, and at No. 3 Paradise Street from 1929 to 1931. He was still single and working as a general labourer when he was included on the 1939 register at No. 4 Lord Street, Altrincham.

He is listed on the Chapel Street Roll of Honour as William Ratchford, Cheshire Regiment.

Arthur Reeves (1898–1963)
Family Origins: Father, Altrincham; Mother, Altrincham
War Record: First World War 1914–18
Military Service: Private, 4th Battalion, Cheshire Regiment, Service No. 243831
Associated with Nos 48 and 52 Chapel Street

The only soldier named Arthur Reeves that can be linked to Chapel Street was William Arthur Reeves. William Arthur was born on 10 June 1898 in Altrincham and baptised at the Church of St John on 17 August. His parents were Arthur and Mary, née Wyatt, and they lived at No. 9 Paradise Street, Altrincham, at the time of his birth. On the 1901 census he was recorded as Arthur and was living as a boarder at No. 1 Thomas Street, Altrincham, with his parents and sister Beatrice, aged four. After Arthur's father died in 1903 his mother Mary began a relationship with Ralph Ryan and they went on to have three children. Arthur's surname was listed as 'Ryan' on the 1911 census when he was living at No. 8 Baker Street, Timperley, with his mother Mary, her partner Ralph, sister Beatrice, aged fourteen, and half-brothers Charles, aged nine, Ralph, aged two months, and half-sister Ellen, aged four. On Ralph's Army record, Mary was described as his 'unmarried wife' and when Ralph was killed in action in 1915, Mary wrote to the Army to make a claim on behalf of Arthur on the pension of Ralph Ryan, stating he had supported Arthur since he was four years old. Mary was listed as householder at No. 52 Chapel Street in Slater's Directory of 1915 and 1916 but all Army correspondence was addressed to her at No. 48 Chapel Street.

The dates of Arthur's military service are unknown, but, given his age, he was unlikely to have enlisted until the latter part of the war. His name appeared on the 1918 and 1919 absent voters' list for No. 11 John Street, Altrincham, and his service was recorded as a private in the 4th Battalion, Cheshire Regiment. No medal card has been located for him so it is likely that he did not serve overseas. No evidence has come to light to suggest he served in the South Lancashire Regiment as is stated on the Chapel Street Memorial. In 1920 Arthur was living with his mother at No. 11 John Street and he married Laura Hill in the second quarter of 1921, the marriage being registered in Bucklow, Cheshire. Arthur was admitted to the National Union of Railwaymen in 1925 as a carriage cleaner and in 1939

was recorded in the same occupation and living with his wife, Laura, at No. 39 Oak Road, Hale. He died on 4 October 1963 at Cranford Lodge Hospital, Knutsford, and left £211 14s to his widow.

He is listed on the Chapel Street Roll of Honour as Arthur Reeves, South Lancashire Regiment.

James Riley M.M. (1883–1966)

Family Origins: Father, Longton, Staffordshire; Mother, Leeds
War Record: First World War 1914–18
Military Service: Private, 8th and 2nd Battalion, Cheshire Regiment, Service No. 8/11222
Lived at No. 26 Chapel Street

James Riley was born on 18 December 1883 at Little Ireland, Southport, and his birth was registered in Ormskirk in January 1884. His parents were Thomas Riley, a pedlar from Longton, Staffordshire, and Mary Ann, née Charles, from Leeds. They had married in Great Boughton in Chester in 1863. James, aged seven, was living with his parents in Little Ireland, North Meols, Southport, in 1891, along with his siblings Peter, aged twenty-seven, Elizabeth, aged nineteen, Bridget, aged sixteen, John, aged ten, and Annie, aged three. In 1881 the family lived at Model Lodging House at No. 2 Cross Street, Northwich.

James resided as a boarder at the home of Dennis Hefferan at No. 26 Chapel Street, aged eighteen and worked as an errand lad in 1901. The census recorded his place of birth in error as Stockport, Lancashire, rather than Southport, Lancashire. In 1901 there was at No. 13 Chapel Street a Mary Ann Riley, hawker, born in Leeds. This may well have been James's mother but her age was recorded as sixty-six, around ten years older than his mother's correct age as she was recorded as aged thirty-six in 1881, forty-five in 1891 and was eighty-two when she died in 1927. There was also a John Riley, thirty-four, born in Southport living at No. 11 but it is not certain whether this man was a relation. He was too old to be James's brother John, who was living in Southport at this time and in 1911.

It has not proved possible to locate James in 1911 but the local newspaper reported on 2 July 1912 that James Riley of Chapel Street was fined 2s 6d at Altrincham Sessions for using bad language. In 1911 his mother Mary Ann Riley, a widow from Leeds, age recorded as sixty-eight, was living at No. 23 Oak Grove, Urmston, with her daughter Annie and daughter's husband Patrick Brady. James's brother John, who worked as docker, lived in Liverpool, and gave Oak Grove, Urmston, as the address for his mother, Mary Ann Riley, as his next of kin when he enlisted in 1915.

At some point before the First World War James lived in Barry Island, Glamorgan, as his Military Medal entry in the *London Gazette* in April 1918 gave this as his home town and his medal was reported in local newspapers in Barry. He joined the 8th Battalion, Cheshire Regiment, and the close proximity of his service number to that of others in the street suggests that he joined around the same time as many other men from Chapel Street, sometime in August 1914. He embarked for Egypt on 26 June 1915.

He later transferred to the 2nd Battalion, Cheshire Regiment, and was awarded the Military Medal for his part with this battalion in the Salonika campaign. The war diary for this battalion confirms that the medal was awarded to him on 14 February 1918 for gallantry and devotion to duty during the second of two raids, which took place on 20 January 1918, on Butkova Dzuma in Macedonia, commanded by Captain Ronald King-Smith (attached from the 3rd Wiltshire Regiment). This raid was a success, though one man was killed. King-Smith, who was wounded, won the DSO. Around forty Bulgars were killed and no prisoners were taken.

James himself was taken prisoner of war in Salonika soon after these events, probably during the raid on Kumli on 15 April 1918 when soldiers of the 2nd Battalion Cheshire Regiment were captured by the Bulgarians. His name is on a Red Cross list of British prisoners of war that arrived at Dover on 1 December 1918. He was demobilised in April 1919.

On the 1939 Register James Riley was listed as a bricklayer's labourer living alone at No. 2 Richmond Avenue. He gave his date of birth as 12 November 1882, which is different to his birth certificate. He died on 15 September 1966 and was buried in Urmston Cemetery woth his mother, Mary Anne Riley.

He is listed on the Chapel Street Roll of Honour as James Riley, M.M. Cheshire Regiment.

Thomas Riley
Family Origins: Not known
War Record: First World War 1914–18
Military Service: Royal Irish Rifles
Associated with Chapel Street

Thomas is listed on the memorial as serving with the Royal Irish Rifles but it has not been possible to link a soldier of this name and regiment to Chapel Street.

On 24 October 1900, a local newspaper reported that a Thomas Riley was charged with being drunk on Chapel Street and was subsequently fined 2s and 6d, although the article does not make it clear whether he was a resident of the street. For this reason, it is only a possibility that they are the same Thomas Riley.

He is listed on the Chapel Street Roll of Honour as Thomas Riley, Royal Irish Rifles.

John Rowan (*c.* 1880–1960)
Family Origins: Ireland
War Record: First World War 1914–18
Military Service: Corporal (Acting Lance Sergeant), 13th and 9th Battalions, Manchester Regiment, Service No. 6047
Lived at the Rose & Shamrock, No. 18 Chapel Street

John was born in Kilasser, County Mayo, Ireland. It has not been possible to identify his birth and baptism or the names of his parents but on the 1939 register, his date of birth was recorded as 1 November 1880; however, judging by the age given in his obituary, he was born around two years earlier. It is not known when he moved to England, but on 28 April 1906 he married Ada Foy at Sale. Following their marriage the couple lived at No. 27 New Street, Altrincham and John was employed as a labourer. By 1910 he was beerhouse keeper at the Rose & Shamrock, and at the 1911 census was living there with his wife Ada and their children John, aged four, and Eileen, aged two. The couple went on to have two more children: Anthony, born in 1911, and Mary, born in 1914.

In September 1914 John enlisted as a private with the 13th Battalion, Manchester Regiment. His occupation was recorded as joiner on his attestation form. He was appointed lance-corporal in November 1914 and corporal in August 1915, while his battalion was based in Eastbourne and Seaford, both in Sussex. The battalion embarked for France in September 1915 and, within a month, had arrived in Salonika, where it remained until June 1918. On 4 December 1915 John was admitted to hospital in Salonika, but records do not indicate the nature of his medical condition.

Sadly John's youngest daughter, Mary, aged two, died in October 1916. Her death certificate recorded that she died of septic osteomyelitis and general peritonitis at Pendlebury Children's Hospital, Salford. John did not return home until the following May when he was granted

leave. By then the family had left the Rose & Shamrock and were living at No. 18 Bentley's Buildings, Altrincham. John returned to Salonkia in June 1917. His battalion returned to France in 1918 and was absorbed into the 1/9th Battalion of the Manchester Regiment. John was appointed as acting lance-sergeant in February 1919 before returning to England three weeks later.

After the war John and Ada remained in the Altrincham area and were still living at No. 18 Bentley's Buildings in 1931. John was one of the men on the committee who organised the Chapel Street Memorial. In the 1939 register John and Ada were living at No. 4 Bradbury Avenue in Oldfield Brow and John was employed as a labourer. John died on 22 March 1960 and his age was recorded as eighty-two. His obituary, which appeared in the local newspaper in April 1960, reported that he had also been landlord of the Old Pear Tree public house as well as the Rose & Shamrock. It also mentioned that he was actively associated with the old Altrincham Hospital Carnival, Altrincham Football Club and the Irish National Foresters.

He is listed on the Chapel Street Roll of Honour as John Rowan, Manchester Regiment.

Peter Ryan (b. 1867)

Family Origins: Father, Ireland; Mother, Ireland
War Record: Anglo-Boer War 1899–1902
Military Service: Private, 3rd Battalion, Cheshire Regiment Militia, Private, King's Liverpool Regiment, Service No. 2144; Private, 3rd Battalion, Cheshire Regiment, Service No. 5461; Private, Cheshire Regiment Militia, Service No. 6520;
Private, 3rd Battalion, Cheshire Regiment Special Reserve, Service No. 7657
Lived at Nos 13 and 59 Chapel Street

Peter was born on 25 August 1867 and baptised on 22 September at the Cathedral Church of St John the Evangelist, Salford. His parents were Peter and Bridget, née Geoghegan. In 1871 Peter, aged five, was living in Back Police Street, Altrincham, with his parents and five siblings John, aged fifteen, James, aged thirteen, Mary Ellen, aged eleven, Catherine, aged seven, and Ralph, aged three. In 1881 he was living with his mother and seven siblings at No. 59 Chapel Street and was employed as a general labourer.

He enlisted with the King's Liverpool Regiment in September 1887, aged eighteen, having previously trained in the 3rd Battalion, Cheshire Regiment Militia. In October 1899 he joined the 3rd Battalion, Cheshire Regiment, Service No. 5461. Although he was on the Military Deserters' List for desertion at Chester in May 1900, Peter went on to serve in South Africa with this battalion under Service No. 6520, and was awarded the Queen's South Africa Medal and three clasps. A war gratuity of £5 was paid to him in July 1902.

An article in the *Northwich Guardian* in November 1902 entitled 'Alleged Trespass in Pursuit of Game' reported a case at Altrincham Petty Sessions involving a man named George Capper, who was summoned for trespassing in search of game on private land with a greyhound. Peter and Ralph Ryan were also summoned for aiding and abetting. In reply 'the defendants submitted that they were simply out for a walk, Capper having invited the Ryans who had recently returned from South Africa out for a stroll'. The result of the case was that 'Capper was fined 40 shillings and the summonses against the Ryans were dismissed.'

From 1902 to January 1908 he served in the Cheshire Militia, giving his address on re-enlistment forms as No. 13 Chapel Street, and then No. 12 King Street, Altrincham. He joined the Cheshire Regiment Special Reserve in August 1908 until January 1911 and in his service record stated that his next of kin was his father Peter, address unknown, and his two brothers Ralph and Richard. His mother Bridget had died in 1898. During this period he was employed as a gardener and a building labourer working for J. Drinkwater of Altrincham.

Peter was discharged from the Army in January 1911 and that year was living at No. 44 Egerton Street, Sale, with Elizabeth Longworth. No record has been traced of any service in the First World War. In 1939 he was living with Elizabeth at No. 141 Bury Road, Rochdale. Peter's brothers Ralph, killed in action in 1915, and Richard, are listed on the Chapel Street Roll of Honour.

He is listed on the Chapel Street Roll of Honour as Peter Ryan, Liverpool Regiment.

Ralph Ryan (1869–1915)

Family origins: Father, Ireland; Mother, Ireland
War Service: Anglo-Boer War 1899–1902; First World War 1914–18
Military Service: Private, 3rd Battalion, Liverpool Regiment Militia, Service No. 1927; Private, 1st and 2nd Battalions, King's Own Royal Lancaster Regiment, Service No. 3966; Private, 1st and 3rd Battalions, Kings Own Royal Lancaster Regiment, Service No. 3508
Lived at the back of No. 49 and at Nos 52 and 59 Chapel Street

Ralph was born on 24 June 1869 in Salford and was baptised on 8 August at the Church of St Peter, Greengate, Salford. He was the son of Peter and Bridget, née Geoghegan who were living at No. 8 Collier Street, Salford, at the time of his baptism. In 1871 Ralph, aged three, was living at the back of Police Street, Altrincham, with his parents and siblings John, aged fifteen, James, aged thirteen, Mary Ellen, aged eleven, Catherine, aged seven, and Peter, aged five. In 1881 he was living with his mother Bridget and seven siblings at No. 59 Chapel Street. By 1891 Ralph had moved in with his widowed sister Mary Kelly and her two children at the back of No. 49 Chapel Street and was employed as an agricultural labourer.

Ralph enlisted in the 3rd Battalion, Liverpool Regiment Militia, at Warrington in June 1890 and was then appointed to the King's Own Royal Lancaster Regiment, serving with the 1st and 2nd Battalions. Between February 1894 and August 1902 he served in India, Malta, Hong Kong, Singapore and two years in South Africa for which he was awarded the Queen's and King's South Africa medals and a clasp for Transvaal.

In 1911 Ralph was living at No. 8 Baker Street, Timperley, with Mary Reeves, née Wyatt, their two children, Ellen and Ralph, and Mary's three children, Beatrice, Arthur and Charles from her marriage to Arthur Reeves, who had died in 1903. Ralph was working for Messrs. James Hamilton & Son (Builders) of Hale when he re-enlisted in the 1st Battalion, King's Own Lancaster Regiment, on 19 August 1914. He gave his age as forty, although his actual age was forty-five. His Army service record indicated that he was living at No. 52 Chapel Street and his next of kin was Mary Reeves, who was referred to on all records as his 'unmarried wife'. He was posted to France in December 1914. A letter was received by Mary Reeves on 17 May 1915 from Ralph in which he stated 'We have been having a rough time. They are lucky fellows that get home from here'.

A report in the *Manchester Evening News* dated 26 June 1915 stated 'news has been received by Mrs Ryan of No. 48 Chapel Street, Altrincham, that her husband Private Ralph Ryan of the Kings Own Royal Lancaster Regiment has been killed in action. Private Ryan who was forty-six years of age was an old campaigner and saw service during the Chinese Riots and in the South African War'. On hearing Ralph had been killed, Mary applied to the Army for financial support for her and her children, which did not prove straightforward. To further add to the confusion, the matron at No. 12 General Hospital in Rouen wrote to Mary on 10 August 1915, to inform her that her husband had only been wounded and transferred to a hospital in England on 9 July, although she was unable to confirm the exact location. In the meantime on 17 August, in order to ascertain pension entitlements, the Army wrote to Mary asking her to explain her claim on 3508 Private Ryan and why Arthur Reeves was named as the father on the birth certificate she had provided. Mary in reply explained

that Arthur Reeves had died many years before and her son had been dependent on Ralph since he was four years old, adding that she had lived with Ralph for over ten years. Mary, on receiving the notification from the matron in France that Ralph was still alive, naturally queried this further with the Army and on 20 August 1915, the Army contacted the matron to enquire whether the information she had given Mary Reeves was actually correct, as there were five soldiers in the battalion with the surname Ryan and they had a report that Ralph Ryan, Service No. 3508, had already been killed in action. In a reply dated 25 August 1915, the matron at Rouen wrote, 'I regret that the Pt. Ryan transferred to England 9-7-15 was not No. 3508 Private Ralph Ryan of whom there is no record at all in our books. Two Ryans actually left for England on that date but one was Pt. T. Ryan and the other L/Cpl G. Ryan. I can only conclude that when Mrs Reeves wrote she did not give the No. and initial, as is so often omitted when enquiries are made.' The Army then wrote to Mary on 30 August 1915 to say they regretted to have to inform her, having received confirmation from the matron in Rouen, that Ralph was not one of the soldiers transferred to England. They also requested she forward further evidence in her claim for financial assistance. Mary later had to complete a statement of all Ralph's living relatives including the names of his children and siblings. Ralph had been killed in action on 14 May 1915 while serving with the 1st Battalion of his regiment and is commemorated on the Ypres (Menin Gate) Memorial. In 1922, his medals were sent to his brother Peter at No 123 Bury Road, Rochdale.

Ralph's brothers Peter and Richard are also listed on the memorial.

He is listed on the Chapel Street Roll of Honour as Ralph Ryan, King's Own Royal Lancaster Regiment.

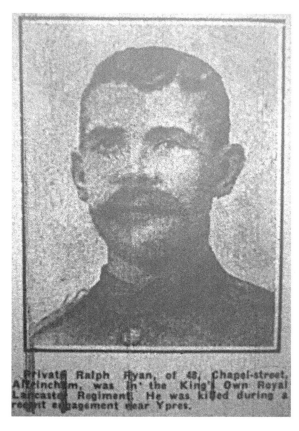

A local newspaper reported the death of Private Ralph Ryan in July 1915.
(*Altrincham, Bowdon and Hale Guardian*)

Richard Ryan (b. 1871)
Family Origins: Father, Ireland; Mother, Ireland
War Record: Anglo-Boer War 1899–1902; First World War 1914
Military Service: Private, 2nd Battalion Manchester Regiment, Service No. 2643
Lived at Nos 59 and 63 Chapel Street

Richard's birth was registered in the fourth quarter of 1871 at Altrincham. He was the son of Peter and Bridget, née Geoghegan. In 1881 Richard was living at No. 59 Chapel Street with his mother and seven siblings Mary Ellen, aged twenty, Kate, aged sixteen, Peter, aged thirteen, Ralph, aged eleven, Sarah, aged seven, William, aged four, John Thomas, aged one, and his nephew John, aged one month. In 1891 Richard was lodging at No. 63 Chapel Street and employed as a rat catcher. He enlisted in the 2nd Battalion Manchester Regiment in 1893 and served in India and South Africa.

The 1911 census indicated that Richard was employed as a bricklayer's labourer and was living at No. 25 Paradise Street, Altrincham, with his wife Florence, their children and various in-laws. In August 1914 he rejoined the Manchester Regiment and stated on his service record that his next of kin was his wife Florence, née Wilkinson, of No. 3 Cow Lane, Timperley, whom he had married at Knutsford in 1904. However, on a later form regarding next of kin, Florence was actually referred to as his 'unmarried wife'. Richard was posted to France in December 1914. He was admitted to the military hospital in Rouen in December 1915, suffering from debility, and then transferred to the military hospital at West Bridgford, Nottingham. He returned to his battalion a month later, but in June 1916 was discharged from the Army as being no longer physically fit for service. Richard applied for an Army pension and was asked to provide his marriage certificate and the birth certificate of his eldest child Thomas, born in 1904. Richard had to admit that he was not married to Florence Wilkinson and that Thomas was not his son, although he had reared him since he began living with his mother. Richard requested that this information be kept as 'close as possible as they were believed to be married'. They were married soon after in the third quarter of 1916 in the district of Bucklow. In 1939 Richard was living at No. 24 Thomas Street, Altrincham, with Florence.

Richard's brothers Ralph, killed in 1915, and Peter, are also listed on the Chapel Street Roll of Honour.

He is listed on the Chapel Street Roll of Honour as Richard Ryan, Manchester Regiment.

John Scanlon (b. 1897)
Family Origins: Father, Ireland; Mother, Altrincham
War Record: First World War 1914–18
Military Service: Driver, 29th Division Artillery, 5th Reserve Brigade and 315th Brigade Royal Field Artillery, Service No. 78279
Lived at No. 55 Chapel Street

John Scanlon was born on 7 February 1897 in Altrincham and baptised at the Church of St Vincent de Paul on 7 March 1897. His parents were Annie, née Brennan, and Michael Scanlon. In 1901, aged four, he was living at No. 55 Chapel Street with his parents and sisters Mary Ellen, aged six, and Helen, aged one. In 1908 his father Michael died at the age of forty-nine and was buried at Bowdon on 7 January 1909. The 1911 census records John, aged fourteen, living with his widowed mother, brothers James, aged eight, Thomas, aged five, and sister Catherine, aged eleven, at the same address as in 1901. Before the war John was employed as a labourer on a farm and worked for a Mr Priestley of Sinderland Lane, Dunham Massey.

John enlisted in January 1915, aged twenty-three, as a driver in the Royal Field Artillery, at No. 2 Depot. His Army discharge documents show that he was posted to 29th Division Artillery later in January that year and by July was in France. He served for two periods in France and Belgium with the artillery of 5th Reserve Brigade until August 1916 and 315th Brigade from December 1916 until December 1918 and was transferred to the Army Reserves in April 1919. On discharge it was recorded in his disability statement that 'upper dentures broken since 2 April 1918 and pieces have been lost. Cause of breakage – eating biscuits'. He was recorded on the absent voters list for 1919 at No. 55 Chapel Street, Service No. 78279 Driver R.F.A.

In 1924 John married Elizabeth Heath and they went on to have seven children including John, whose birth was registered in 1926, and Elizabeth in 1932 and five other Scanlon children with their mother's maiden name of Heath registered in Bucklow, Cheshire, between 1924 and 1940. In 1939 he lived at No. 38 Milner Avenue, Broadheath, Altrincham, and worked as a general labourer. The following year he was fined £5 for making false representation to obtain employment assistance.

He is listed on the Chapel Street Roll of Honour as John Scanlon, Royal Field Artillery.

Frederick Scarle (b. 1898)
Family Origins: Father, Altrincham; Mother, Altrincham
War Record: First World War 1914–18
Military Service: Private, 20th Battalion, Army Cyclists Corps, Service No. 3776; Lance-corporal, No. 3 Traffic, Military Foot Police, Service No. P/14441
Lived at Chapel Yard and Nos 8, 32 and 45 Chapel Street

Frederick was born in Chapel Yard, Altrincham, on 6 January 1898 and baptised as Frederick Scahill on 23 February 1898 at the Church of St Vincent de Paul in Altrincham. His parents were John Scahill and Mary, née Stones. John was the son of Patrick and Bridget Scahill, who lived at No. 11 Chapel Street in 1871, No. 37 Chapel Street in 1881 and No. 31 Chapel Street in 1891. Frederick had two sisters, Annie and Mary.

By 1901 Frederick's father John was no longer living with his family. Frederick and the rest of his family were living with Frederick's maternal uncle John Henry Stones at No. 32 Chapel Street. The whereabouts of his father are unknown. By 1911 the family had moved to No. 45 Chapel Street where Frederick's mother was the head of the household. Frederick, aged thirteen, was at school and was living with his sister Mary Ellen, aged eleven. There are two more children listed: Nora, aged four, and the three-month-old Kathleen. The census registrar had noted on the entry that 'Nora and Kathleen are illegitimate. Her husband is absent and she is living with Thomas Corfield.' Thomas Corfield was listed as a lodger.

Frederick joined the Army Cyclists Corps and disembarked in France on 18 November 1915. On 12 December 1917 he transferred to the Military Foot Police, who were responsible for dealing with the large amounts of military traffic and maintaining law and order. Only soldiers with an exemplary record served in this force and transfer to it carried with it immediate promotion to lance-corporal. Frederick was listed at No. 8 Chapel Street on the absent voters lists for 1918 and 1919 as serving as lance-corporal in No. 3 Traffic. He served in France until 11 November 1918.

In 1920 Frederick married Gladys Cardin in the Bucklow Registration District and the couple had three daughters – Madeline, Mary and Veronica. The couple were living at No. 8 Chapel Street between 1921 and 1926 but by 1939 had relocated to No. 10 Stokoe Avenue, Altrincham, when Frederick was employed as a slater's labourer. Frederick's uncles James, Thomas and Michael Scarle, as well as his cousin James Scarle, are also listed on the Chapel Street Roll of Honour.

He is listed on the Chapel Street Roll of Honour as Frederick Scarle, Cheshire Regiment.

James Scarle (b. 1872)

Family Origins: Mother, Ireland; Father, Ireland
War record: First World War 1914–18
Military Service: Private, Royal Lancaster Regiment, Service No. 3878; Private, 3rd and 8th Battalions, Cheshire Regiment, Service No. 10442
Lived at Nos 31 and 37 Chapel Street

James was born in Altrincham on 31 December 1873, the second son of Patrick Scarle and Bridget, née Goode/Gould. He was baptised at the Church of St Vincent de Paul on 12 January 1874. James had an elder brother, John, and three younger brothers, Thomas, Patrick and Michael. He also had two sisters, Mary and Annie.

Before James's birth the family were living at No. 11 Chapel Street. By the time of the 1881 census they had moved to No. 37 Chapel Street and were recorded under the name of Skehall. In 1891 the widowed Bridget Scahill was living at No. 31 Chapel Street and James, aged eighteen, was listed as a general labourer. Bridget died in 1892, aged forty-six. It has not been possible to identify James in the 1901 census but in 1911 he was living at No. 6 Chapel Yard with the widowed Ellen Lloyd and her three children. He is recorded as a boarder but the enumerator added to the record, 'This couple are living together.' At this time James was employed as a bricklayer's labourer. A local newspaper dated 28 July 1914 reported that James Scahill of Chapel Street was charged with assaulting Margaret Hughes, the daughter of Ellen Lloyd. He was bound over for six months in the sum of £5. In 1910 James had been accused of doing malicious damage to three of Ellen's pictures and two door locks following a dispute in which Ellen had locked him out.

In January 1893 at the age of nineteen James Scahill enlisted at Altrincham for the Royal Lancaster Regiment. The following day he was discharged from the Army on the grounds that he was not likely to make an efficient soldier due to a 'skin eruption'.

During the First World War James enlisted in the Cheshire Regiment. On 27 October 1914 a local newspaper reported that he was charged at Altrincham Police Station with being absent from the 8th Battalion, Cheshire Regiment, based in Swindon from 19 October 1914. He was returned to the regiment and on 29 October 1914 he was transferred to the 3rd Battalion, Cheshire Regiment. The battalion records show that he continued to absent himself from the regiment until 27 January 1915 when the battalion was sent to France. Between 28 January 1915 and 13 October 1917 he served in France with the Cheshire Regiment. His service in France continued with the Labour Corps from 14 October 1917 to 15 July 1918 and finally between 16 July 1918 and 11 November 1918 with the 8th Battalion, London Regiment. The absent voters lists of 1918 and 1919 indicate that he continued to serve until at least 1919 with the Cheshire Regiment.

James Scahill married Ellen Lloyd in the second quarter of 1919 in the Bucklow District. James' brothers Thomas and Michael Scarle also appear on the memorial, as well as his nephews James and Frederick Scarle.

He is listed on the Chapel Street Roll of Honour as James Scarle, Cheshire Regiment.

James Scarle (1894–1959)

Family Origins: Father, Altrincham; Mother, Altrincham
War Record: First World War 1914–18
Military Service: Private, Manchester Regiment, Service No. 13769
Lived at No, 12 Chapel Street

James was born on 31 July 1894 in Altrincham and baptised on 12 August 1894 at the Church of St Vincent de Paul. His parents were Thomas Scahill and Annie, née Franklin, who had

married in 1893. In 1901 they were living at No. 12 Chapel Street. Thomas and Annie went on to have six more children: Thomas, Winifred, Christina, Isabella, Ellen and Annie.

In 1911 James was living with his parents and siblings at No. 17 Police Street, Altrincham, a short walk from Chapel Street. James, aged sixteen, was employed as an errand boy. When he enlisted in 1914 he described himself a bootmaker.

James enlisted as a private in the Manchester Regiment on 6 November 1914. His records describe him as 5 feet 3 inches tall with brown eyes and dark hair. On 11 November 1914, just five days later, he was discharged from the Army for 'being unlikely to make an efficient soldier'. His character was described as good. His parents of No. 23 Oakfield Road, Altrincham, are listed as his next of kin. James was not listed as an absent voter in 1918 and 1919.

The Chapel Street Memorial states that James served in the Royal Irish Rifles, his father's regiment. While there is a record for a James Scahill serving with this regiment between 23 November 1914 and 29 October 1917, there is no evidence that this is the James who is recorded on the Chapel Street Memorial. These military records have not been found.

In 1920 James married Bertha Bamber in the Barton upon Irwell Registration District. The couple had at least three children – Lillian, James and Thomas. In 1939 they are living at No. 1 Seabrook Crescent in Urmston. James' occupation is recorded as oil transformer tank testing (heavy worker).

A James Patrick Scahill of No. 5 Whitegate Park, Flixton, died on 12 March 1959.

James' father Thomas Scarle/Scahill and his uncles James and Michael are on the Chapel Street Roll of Honour, as well his cousin Frederick.

He is listed on the Chapel Street Roll of Honour as James Scarle, Royal Irish Rifles.

Michael Scarle (1883–1950)

Family Origins: Mother, Ireland; Father, Ireland
War Record: First World War 1914–18
Military Service: Sergeant, 3rd Battalion, Scottish Rifles, Service No. 22013; Sergeant, Military Provost Staff Corps, Military No. R/2502
Lived at No. 31 Chapel Street

Michael was born on 12 June 1883 in Altrincham and baptised on 8 July at the Church of St Vincent de Paul. He was the youngest son of Patrick Scahill and Bridget, née Goode/Gould. In 1891 Michael, aged nine, was living with his mother and siblings James, aged eighteen, Thomas, aged sixteen, Mary, aged thirteen, and Annie, aged six, at No. 31 Chapel Street. His mother died the next year, when Michael would have been around ten years old. In 1901 Michael enlisted in the Scottish Rifles and was at Chatham Barracks. It is possible that he served in the Boer War but his records have not been found.

In 1909 Michael, now known as Michael Joseph, married Sarah Wright at the Church of St Vincent de Paul. In July 1909 Michael gained employment as an assistant postman in Altrincham. In 1911 the family were living at No. 16 Egerton Terrace, Altrincham, with their son Bernard, aged ten months, and Michael was employed as a crane driver at the Linotype and Machinery Co. in Broadheath.

Michael rejoined the Scottish Rifles following the start of the First World War. His records have not survived but from his medal card and medal rolls he was an acting colour sergeant with the Scottish Rifles. He was later transferred to the Military Provost Staff where his rank was sergeant.

In 1928 he is listed in Kelly's Directory as a publican, living at the Slipper public house in Stafford. In the 1936 directory he is the publican at the Cottage-by-the-Brook public house, also in Stafford. Michael and Sarah had five children: Bernard, Agnes, Wilfred, Veronica and

Stella. In the 1939 register, Michael Joseph gives his occupation as licensed victualler and his address as No. 59 Peel Terrace in Stafford.

Michael Joseph died at the Cottage-by-the-Brook Hotel in Stafford on 18 August 1950. He left an estate valued at £3,423.

His brothers James and Thomas Scarle, as well as his nephews Frederick and James Scarle, are also listed on the memorial.

He is listed on the Chapel Street Roll of Honour as Michael Scarle, Scottish Borderers.

Thomas Scarle (1875–1928)
Family Origins: Mother, Ireland; Father, Ireland
War Record: First World War 1914–18
Military Service: Private, Royal Irish Rifles, Military No. 3909, Private, Royal Irish Regiment, Service No. 5761
Lived at Nos 12, 31 and 37 Chapel Street

Thomas was born on 11 April 1875 at No. 37 Chapel Street, the third son of Patrick Scarle and Bridget, née Goode/Gould. He had four brothers, John, James, Patrick and Michael, and two sisters, Mary and Annie. In 1881 the family was still living at No. 37 Chapel Street but had moved to No. 31 by 1891. Thomas married Ann Franklin on 26 August 1893 at the Church of St Vincent de Paul and in 1901 they were living at No. 12 Chapel Street with their son and three daughters. Thomas was employed as a bricklayers' labourer. In 1911 the family had moved the short distance to Police Street, Altrincham, and by then had another son and daughter.

Little information has been found about Thomas's military career. The information on his medal card and the Medal Roll Index suggests that he did not serve until after 1915 as he did not receive the 1915 Star. He served in the Royal Irish Rifles and later in the Royal Irish Regiment and was discharged to the Army Reserve on 2 May 1919.

After the war Thomas went back to being a bricklayers' labourer and he remained in this occupation until his death. In the 1918 and 1919 absent voters lists his address is given as No. 23 Oakfield Road, Altrincham, and he remained at this residence until his death from phthisis (tuberculosis) on 30 September 1928, aged fifty-three years.

Thomas' brothers James and Michael Scarle, as well as his son James and nephew Frederick are also listed on the memorial.

He is listed on the Chapel Street Roll of Honour as Thomas Scarle, Royal Irish Rifles.

John Shaughnessy (b. 1873)
Family Origins: Mother, County Tipperary, Ireland; Father, County Tipperary, Ireland
War Record: First World War 1914–18
Military Service: Pioneer, Labour Battalion, Royal Engineers, Service No. 120331
Lived at No. 35 Chapel Street

John was born in Fethard, Tipperary, Ireland in 1873 and was baptised on 24 August 1873. There was only one baptism for a John Shaughnessy listed in Tipperary for the 1870s and that was for John Shaughnessy, the son of William and Margaret, née Goggin, in 1873.

John married Mary Brennan, of Chapel Street, at the Church of St Vincent de Paul, Altrincham, on 4 September 1904; his father was listed as William Shaughnessy. In 1911, aged thirty-two, he was living at No. 1 Back Moss Lane, Altrincham, with his wife Mary, aged twenty-seven and their children John, aged six, William, aged four, Thomas, aged two, and Francis, aged four months. Anne Brennan, John's mother-in-law, aged sixty-two, and John Brennan, his brother-in-law, aged twenty-five, were also living with them. John gave his age as six years younger than his actual age.

Although John is listed on the memorial as John Shaughnessy, Cheshire Regiment, no evidence has been found that indicates that he did serve with this regiment. John enlisted as a pioneer in the Labourer Battalion, Royal Engineers, in London on 17 September 1915. He gave his home address as No. 35 Chapel Street and his occupation as a labourer. On this occasion he gave his age as forty-two, which matched the date of his baptism. His service records show no active service and there are no medal awards for him. By the time his battalion sailed to France, John was a patient in Netley Hospital, Hampshire, where he remained for some time. A letter from his wife to the Army stated 'that my husband John Shaughnessy is in hospital and has been 14 weeks and is still there when I heard from him this morning. He took ill the same week that he should have gone with the battalion.' On 24 March 1916 John was discharged as not being likely to make an efficient soldier. He was listed living at No. 35 Chapel Street with his wife Mary on the electoral register for 1921 and 1929. In total John and Mary had ten children, the youngest born in 1928.

He is listed on the Chapel Street Roll of Honour as John Shaughnessy, Cheshire Regiment.

Alfred Shaw

Family Origins: Not known
War Record: First World War 1914–18
Military Service: Private, 9th and 10th Battalion, Lancashire Fusiliers, Service No. 5124; Private, Labour Corps, Service No. 439478
Lived at Nos 3–5 and 4 Chapel Street

Alfred was listed on the absent voters lists living at No. 4 Chapel Street for 1918 and 1919 and later on electoral registers for 3–5 Chapel Street in 1924 and 1926. He is listed on the Chapel Street Memorial as serving with the South Lancashire Regiment but we have not been able to link him to this regiment. There is only a link with the Lancashire Fusiliers. His Army records indicate that he served in the 9th and 10th Battalions of the Lancashire Fusiliers and the Labour Corps, and disembarked in France on 15 July 1915.

Private A. Shaw of the 10th Lancashire Fusiliers, Service No. 5124, appears on the Hospital Admission and Discharge Register for the 51st Field Ambulance for an injury to his head and left elbow. He was admitted and transferred on 5 July 1916. He then appears on a list of sick and wounded NCOs and men of the Expeditionary Force. He was severely wounded and admitted to No. 2 London General Hospital, Chelsea, on 8 July 1916 and was later transferred to the Labour Corps, before finally being discharged on 8 December 1918. While his service number with the Labour Corps is recorded as 459478 on the absent voters list, his entry on the Medal Rolls Index indicates that it was 439478.

He is listed on the Chapel Street Roll of Honour as Alfred Shaw, South Lancashire Regiment.

James Sheehan

Family Origins: Not found
War Record: First World War 1914–18
Military Service: Royal Irish Rifles
Lived at Nos 3–5, 7 and 54 Chapel Street

The earliest reference to the name James Sheehan we can locate living in the Altrincham area is that for a James Sheehan, aged seventeen, the son of a William Sheehan, an agricultural labourer from Kilkenny, Ireland, and Mary Sheehan from County Galway, who were living at No. 19 Goose Green in 1861 until 1871. It is unlikely that this James Sheehan is the same person who is listed on the Chapel Street Roll of Honour serving in the First World War as he would have been too old; however, there may be a connection to this family. In

1915 there was a marriage between a James Sheehan and Alice Johnson, which took place between April and June 1915 in the Bucklow registration district. The street directory for 1916 lists an Alice Sheehan living alone at No. 45 Chapel Street. James was not listed and may have been away on active service. The electoral registers from 1918 and 1919 list James at No. 7 Chapel Street and in 1920 he was at the lodging house at No. 3–5 Chapel Street. In 1921 he is listed with his wife at No. 54 Chapel Street. It has not been possible to find any military record for James Sheehan of the Royal Irish Rifles; he may have served with the Royal Irish Regiment, but it has not been possible to link the soldiers of that name in the regiment with James Sheehan of Chapel Street.

He is listed on the Chapel Street Roll of Honour Memorial as James Sheehan, Royal Irish Rifles.

John Smith (b. 1872)
Family Origins: Not known
War Record: First World War 1914–18
Military Service: Private, 14th Battalion, Cheshire Regiment, Service No. 26528; Private, 2nd Garrison Battalion, Cheshire Regiment, Service No. 61685; Private, 3rd and 4th Garrison Battalions, Royal Welsh Fusiliers, Service No. 47173
Lived at No. 11 Chapel Street

John was born in Montrose, Ireland, although his date of birth is unclear. He enlisted with the 3rd Garrison Battalion of the Royal Welsh Fusiliers in August 1914 where he gave his age as thirty-eight, which would indicate that he was born in 1876. However, in 1901 he had given his age on the census as eighteen, which would mean that he was born in 1883. The Protection Certificate issued when he left the Army in 1919 stated he was born in 1872.

In 1901 John was living as a lodger at No. 11 Chapel Street and working as a labourer. He married Alice (surname unknown) sometime after 1901 and had a daughter Mary, who was born in 1911. In May 1915 he enlisted with the 14th Battalion, Cheshire Regiment, where he gave his address as Chapel Street. His military record listed his wife Alice Smith as his next of kin and her address as Warrington, but stated that although he was married, they had separated. His daughter Mary was listed as living at Holly Mount in Tottington, near Bury, which was a Catholic children's home for families who were suffering hardship and would otherwise have been brought up in the workhouse.

Throughout his military career John suffered from rheumatism and dental problems and in September 1915 he was recommended for a medical discharge from the Cheshire Regiment on account of his chronic rheumatism, which had affected his knee. However, in May 1916 he was transferred to the 4th Garrison Battalion of the Royal Welsh Fusiliers. In August, having served in France, he was invalided home. His military records show that he served at home until February 1917, when he was transferred to the Cheshire Regiment and served in Egypt and then Salonika. In March 1919 he was transferred to the Class 'Z' Reserve and received a weekly pension of 11s on account of his chronic rheumatism.

John's was listed on the absent voters list for Chapel Street in 1919.

He is listed on the Chapel Street Roll of Honour as John Smith, Cheshire Regiment.

Harry Starrs (1898–1925)
Family Origins: Father, Altrincham; Mother, Altrincham; Maternal grandparents of Irish descent
War Record: First World War 1914–18
Military Service: Private, 2/5th, 12th and 4th Battalion, Kings Liverpool Regiment, Service No. 50895
Lived at No. 37 Chapel Street

Harry was born on 20 July 1898 in Altrincham and baptised at the Church of St Vincent de Paul on 21 August. His parents were John and Margaret, née Connor. His maternal grandparents were from Ireland. Harry's father, John, died on 29 March 1901 aged just twenty-eight, when Harry was two. The 1901 census, taken a few days after his father's death, showed Harry living at No. 37 Chapel Street with his mother and his sister Mary, aged five. In 1911 the family were still at the same address and Harry's widowed mother was head of the house. Harry, aged twelve, was listed as a scholar and news boy. He also had three more siblings: Ellen, aged seven, William, aged five, and James, aged two.

He was listed on the medal roll for the King's Liverpool Regiment, which recorded that he had served in three battalions within the regiment: the 2/5th, 12th and 4th. He was listed on the absent voters list of 1918 and 1919 as still living at No. 37 Chapel Street. Following his discharge from the Army, Harry returned to Altrincham where, in the third quarter of 1922, he married Jessie Ardern. Harry died on 2 January 1925 at the age of twenty-six. A local newspaper featured an article about his death and reported that 'the wife and mother of the late Henry Starrs thank all friends and neighbours for their kindness and help during their sad bereavement.'

He is listed on the Chapel Street Roll of Honour as Harry Starrs, Kings Liverpool Regiment.

Joseph Stocks (b. 1879)

Family Origins: Father, Derbyshire; Mother, Derbyshire
War Record: First World War 1914–18
Military Service: Private, 3rd Battalion, Derbyshire Regiment, Service No. 5866; Private, 9th Battalion, Cheshire Regiment, Service No. 10443; Private, Labour Corps, Service No. 604623
Lived at No. 4 Chapel Street

Joseph was born in 1879 in Whittington Moor, Derbyshire, to Joseph and Alice Stocks. The 1881 census shows that he was living at No. 1 Henry Street, Whittington, Chesterfield with his brothers Samuel, aged nineteen, George, aged sixteen, and Ben, aged ten. Joseph's father and his two oldest brothers were coal miners.

On 12 August 1897, at the age of nineteen, he attested at Derby for the 3rd Battalion of the Derbyshire Regiment with whom he served for six years. After completing his service he settled for a time in Birkenhead and in 1911 was living as a lodger with his 'wife' Annie at No. 186 Chester Street. There was a marriage of a Joseph Stocks, aged thirty-five, to Annie Jones, aged thirty-two, on 7 September 1914 at the Church of St Margaret, Dunham Massey. Their residence at the time of marriage was listed as No. 4 Chapel Street and Joseph's profession was listed as 'soldier'.

As a private in the 9th Battalion, Cheshire Regiment, Joseph was punished for absence from duty on more than one occasion. He went to France on 6 March 1915 and was finally discharged from the Labour Corps on 5 March 1919.

On the absent voters list for 1918 and 1919 Joseph was listed as a private with the 9th Cheshire's Service No. 10443 at No. 18 Islington Street. In 1939 he was still living at this address. He was described as married and a 'pensioner, blind', and his date of birth was given as 12 June 1879. His wife Mary Ann gave her date of birth as 26 January 1881.

He is listed on the Chapel Street Roll of Honour as Joseph Stocks, Cheshire Regiment.

James Tatton (b. 1891)

Family Origins: not known
War Record: First World War 1914–18
Military Service: Private, 1st and 3rd Battalion, South Lancashire Regiment (Special Reserves), Service No. 9354; Private, 1st Battalion, Prince of Wales Volunteers, Service No. 70656
Lived at No. 7 Chapel Street

James was born in Altrincham on 2 July 1891 and baptised on 12 July at the Church of St Vincent de Paul. His parents were John William Tatton and Susannah, née Lloyd. In 1901, James, aged ten, was living at No. 7 Chapel Street, a lodging house, with his parents Susannah, aged fifty-seven, and John, aged fifty. John was a hatter while Susannah was a hawker. She died just two years later.

When James was fourteen, a local newspaper ran a story about him entitled 'Altrincham Boys Steal a Horse'. The article described how James and two other boys were charged with stealing a horse worth £30. A witness described how, at ten o'clock one evening, he had seen two boys holding a horse and trying to get it into a field. After recognising that the animal belonged to a Mr McDermott, the witness told the boys this, who replied that it belonged to a Mr Warburton. The witness then informed Mr McDermott but by the time he went to the stable, the horse had been returned. When one of the boys, Thomas Coleman, was questioned by the police, he told them that 'Tatton said, "Should we go look for a horse" so we went to the stable and took it, with the intention of taking it to Macclesfield.' Their plan, according to Thomas, was to start 'tacking', which was to go looking for rags and bones.

The chairman said that he would have looked on the incident as a boyish prank if he could, but that the boys had deliberately broken into the stable with the intention of taking the horse away. Two of the boys were sent to a reformatory school for three years and their parents were ordered to pay 1s per week towards their maintenance.

In 1909, after working as a farm labourer, James joined the South Lancashire Regiment (Special Reserves). In 1911, aged nineteen, he served in India after sailing from Southampton to Karachi in November. His service in Ambala, Quetta and Karachi would indicate that he served throughout the war in India, retaining his rank of private until he was discharged in February 1919. His sister Mary, who was living in Cape Town, South Africa, was listed as his next of kin on his Army papers.

James chose to re-enlist immediately under the Special India Army Orders 39 for three years and was attached to the Prince of Wales Volunteers. During his time in service, there are varying reports of James's behaviour. In 1914 he was described as 'hardworking and willing' and in 1918 as 'a smart and reliable soldier' who was 'hard working and trustworthy'. However, in 1910 he was punished for 'making use of insubordinate language' and in 1916 for 'hesitating to obey orders'. In July 1920 James was declared a deserter.

He is listed on the Chapel Street Roll of Honour as James Tatton, South Lancashire Regiment.

John Taylor (b. 1892)

Family Origins: Father, County Galway, Ireland; Mother, Altrincham
War Record: First World War 1914–18
Military Service: Gunner, 57th Brigade, Royal Field Artillery, Service No. 54616; Gunner, 81st Battery, Royal Field Artillery; Gunner, 51st Reserve Battery, Royal Field Artillery
Lived at No. 50 Chapel Street

John was born on 22 September 1892 in Altrincham and baptised at the Church of St Vincent de Paul on 23 October. He was the third son of Patrick and Rose, née Rooney. His father Patrick had previously lived at No. 54 Chapel Street as a boarder in 1881. In 1901 John, aged eight, was living at No. 50 Chapel Street with his parents and siblings William, aged fourteen, Winifred, aged thirteen, James, aged eleven, Rose, aged six, Peter, aged four, and Thomas, aged two.

John was working as a labourer when he enlisted in the Royal Field Artillery at Manchester in February 1909. Between 1910 and 1914 he served in India with the 81st Battery, Royal Field Artillery, and on 6 November 1914 his regiment was transferred to France. John continued

to serve until 1918. On 17 December 1918 he was transferred to 51st Reserve Battery, Royal Field Artillery, at Charlton Park, Greenwich. He was granted Christmas leave with pay and a ration allowance for twelve days from 19 to 30 December 1918. He was transferred to Army Reserve 'B' on 4 March 1919. John was discharged from the Army on 31 January 1921, having completed twelve years' service in the rank of gunner.

On leaving the Army John moved back to his mother's address at No. 68 Bold Street, Altrincham.

John's brothers Peter, Thomas and William are listed on the Chapel Street Roll of Honour.

He is listed on the Chapel Street Roll of Honour as John Taylor, Royal Field Artillery.

Peter Taylor (b. 1896)

Family Origins: Father, County Galway, Ireland; Mother, Altrincham
War Record: First World War 1914–18
Military Service: Royal Field Artillery
Lived at No. 50 Chapel Street

Peter James was born on 29 May 1896 in Altrincham and baptised at the Church of St Vincent de Paul on 5 July. His parents were Patrick and Rose, née Rooney. Peter's father had previously lived at No. 54 Chapel Street as a boarder in 1881. In 1901 Peter, aged four, was living at No. 50 Chapel Street with his parents and siblings William, aged fourteen, Winifred, aged thirteen, James, aged eleven, John, aged eight, Rose, aged six, and Thomas, aged two. The family were still living there in 1911 and Peter was employed as an assistant in a hairdresser's shop.

The Chapel Street Roll of Honour stated that Peter served in the Royal Field Artillery and although there are five men of that name who served in that regiment, it has not been possible to link any of them to Altrincham. Merchant Navy Seamen records show that Peter James Taylor joined the Merchant Navy between 1918 and 1921.

Peter married Constance May Maddams at the Church of St Vincent de Paul on 26 February 1921. According to the electoral registers between 1924 and 1931 the couple lived at No. 68 Bold Street and No. 31 Russell Street in Altrincham. The couple had at least three children and in 1939 the family were living at No. 70 Bold Street. Peter was employed as a builder's labourer.

Peter's brothers William, John and Thomas are also listed on the Chapel Street Roll of Honour.

He is listed on the Chapel Street Roll of Honour as Peter Taylor, Royal Field Artillery.

Thomas Taylor (b. 1898)

Family Origins: Father, County Galway, Ireland; Mother, Altrincham
War Record: First World War 1914–18
Military Service: Sapper, Royal Engineers, Service No. 229380; Private, Kings Shropshire Light Infantry, Service No. 32573; Sapper, Royal Engineers Service No. WR/202861
Lived at No. 50 Chapel Street

Thomas was born in August 1898 in Altrincham and baptised at the Church of St Vincent de Paul on 9 October. His parents were Patrick and Rose, née Rooney. Thomas's father had previously lived at No. 54 Chapel Street as a boarder in 1881. In 1901 Thomas, aged two, was living at No. 50 Chapel Street with his parents and siblings William, aged fourteen, Winifred, aged thirteen, James, aged eleven, John, aged eight, Rose, aged six, and Peter, aged two. In 1911 he was still living at No. 50 Chapel Street with his parents and his two brothers William and Peter. Their father Patrick died in 1911 aged fifty-six and the family

continued to live in Chapel Street until 1913. In 1914 his mother Rose was recorded as living at No. 68 Bold Street.

Although the Chapel Street Roll of Honour stated that Thomas served in the Royal Field Artillery, no evidence has been found to confirm this. His Medal Roll Index card linked him to both the King's Shropshire Light Infantry and the Royal Engineers. The 1918 and 1919 absent voters lists stated that he was living at No. 68 Bold Street, the same address as his mother, and serving as a sapper in the Royal Engineers. In 1939 Thomas was still living at this address and employed as a gas mains labourer. He shared the house with his widowed sister Winifred Gallimore, whose husband Ballington Gallimore had died in 1929. Their brother Peter and his family were living next door at No. 70 Bold Street.

Thomas's brothers William, John and Peter are listed on the Chapel Street Roll of Honour.

He is listed on the Chapel Street Roll of Honour as Thomas Taylor, Royal Field Artillery.

William Taylor (b. 1886)

Family Origins: Father, County Galway, Ireland; Mother, Altrincham
War Record: First World War 1914–18
Military Record: Private, 3rd Battalion, Cheshire Militia, Service No. 6585; Driver, Army Service Corps, Service No. T/20230
Lived at No. 50 Chapel Street

William was born on 23 April 1886 in Altrincham and baptised as 'James' at the Church of St Vincent de Paul on 23 May. In all other records he is referred to as William. His parents were Patrick and Rose, née Rooney. William's father had previously lived at No. 54 Chapel Street as a boarder in 1881. In 1891 William, aged five, was living at No. 50 Chapel Street with his parents and siblings Mary, aged seven, Winifred, aged three, and James, aged one. The 1901 census recorded William's occupation as 'boils water for men's meals' at the Linotype and Machinery Co., Broadheath. The family were still living at No. 50 Chapel Street and William had four more siblings: John, Rose, Peter and Thomas.

In March 1902 William enlisted as a private in the Cheshire Militia at Altrincham. On his attestation form, he stated he was employed as a labourer by Mr Hutton of Altrincham and gave his age as seventeen years and one month, although he was actually only fifteen years old. He briefly served with the 3rd Battalion, Cheshire Regiment, until 1 January 1903 when he joined the Army Service Corps, Horse Transport. His Army service record reported that 'he has done forty-nine days of drill and has a very good character in the militia.' He was on Home Service until 15 August 1914. The 1911 census recorded William as still living at No. 50 Chapel Street with his parents and two brothers, Peter and Thomas. Their father Patrick died in 1911, aged fifty-six, and the family continued to live at the same address until 1912.

William transferred to the Army Reserve on 31 December 1910 and was mobilised at Dublin on 5 August 1914. From 16 August 1914 to 19 December 1915 he served as a driver with the Army Service Corps overseas, returning home on 20 December 1915. He was discharged on 31 December 1915 after completing his first period of engagement. A Certificate of Sobriety was issued stating that he was 'thoroughly trustworthy and has not been under the influence of liquor in the last eight years'. His discharge papers described him as a 'good groom and driver. Accustomed, to the care and management of horses'. William re-joined the Army Service Corps on 26 April 1916 as a driver and was posted to 668 Company Reserve Depot at Blackheath, London. He then served with the British Expeditionary Force in Salonika from 19 August 1916 to 19 January 1919. He was appointed paid acting corporal in October 1916 but reverted to driver on 7 March 1918. On 7 May 1918 he faced a court martial for 'conduct to the prejudice of good order and

military discipline' and was sentenced to fourteen days detention for stating to the Military Police at Valletta, Malta, that he came from Ghain Tuffiena Camp, knowing this statement to be false.

During his time overseas, William suffered a number of health problems and was treated in hospital for nasal polyps, sinusitis and pneumonia. He was admitted to No. 50 General Hospital on 18 December 1918 with influenza before being invalided out of Salonika with bronchopneumonia a month later. On 20 June 1919 he was transferred to Section 'B' Army Reserve on demobilisation at Woolwich Dock and was discharged. He gave his address on discharge as No. 68 Bold Street, Altrincham, which was his mother's address. He appears on the electoral register in 1920 at No. 68 Bold Street with his mother and his brothers John and Thomas.

William married Blanche Ann Brennen on 12 November 1921 and the couple lived at No. 5 Denmark Street, Altrincham. They were still living at the same address in 1939 and William was employed as a builder's labourer. William's brothers John, Peter and Thomas are also listed on the Chapel Street Roll of Honour.

He is listed on the Chapel Street Roll of Honour as William Taylor, Army Service Corps.

John Thomson (b. 1895)

Family Origins: Father, Salford, Mother, Altrincham
War Record: First World War 1914–18
Military Service: Private (Acting Corporal), 1st Battalion, Cheshire Regiment, Service No. 10206
Lived at No. 56 Chapel Street

John was born on 18 August 1895 in Salford. His mother Mary Ellen Ratchford was born in Altrincham and John's father James was a carter in Salford. In 1901 John, aged six, was living with his mother, aged twenty-five, father, aged twenty-six, and sister Selina, aged two, at No. 94 Simon Street, Salford. Mary Ellen's brother James Ratchford and his wife Elizabeth were also living at this address. In 1911 John, aged seventeen, was working as a paint mixer and was living with his aunt Abigail Ratcliffe at No. 16 Kirk Braddan Street, Salford.

In October 1913, John enlisted with the Cheshire Regiment. He served with the 1st Battalion and entered France on 16 August 1914. John was taken prisoner at La Bassée on 22 October 1914 and was then held at Munster, Germany, for twelve months, alongside around 800 other British soldiers. A local newspaper reported that he 'endured many hardships' including a lack of food and brutal treatment from the German officers. As there was a large cavalry depot at Munster, he was also made to groom and exercise the horses. In October 1915 he was sent to work in an iron foundry in Dortmund but was sent to Minden after eight months due to his poor health, where he was attended to by a German doctor. On hearing that all NCOs were to be sent to Holland, he made two stripes from the string of a pair of puttees and sowed them on his tunic sleeves so that he could pass as a corporal. He arrived at The Hague on 30 April 1918 and was repatriated in November of that year.

John returned to the Cheshire Regiment but on 14 November 1919 he deserted from the Army at Colchester, where he had been an acting corporal. He was court martialled on 13 February 1920 and given eighty-four days detention with twenty-eight days remitted. As a result he forfeited all of his medals, including the 1914 Star, and was discharged from the Army on 6 April 1921.

John appears on the absent voters list in 1918 under the address of No. 56 Chapel Street. His uncles James, John and William Ratchford are also named on the Chapel Street Roll of Honour.

He is listed on the Chapel Street Roll of Honour as John Thomson, Cheshire Regiment.

Thomas Turton (b. 1874)

Family Origins: Not known
War Record: First World War 1914–18
Military Service: Pioneer, Inland Waterways and Docks, Royal Engineers, Service No. WR/342110
Lived at No. 4 Chapel Street

Thomas was born in Wigan in August 1874. He enlisted in January 1918, aged forty-one, and gave his address as Dolman's Lane, Warrington, and his occupation as a labourer. His Army record stated that he had 'defective vision', a 'poor physique' and 'defective teeth'. His physical description described him as 5 feet tall.

In April 1918 he married Beatrice Lee and was discharged from the Army in December 1918 as being surplus to military requirements and transferred to the Army Reserve. His discharge papers gave his age as forty-four and his previous employment as a miner at Douglas Bank Colliery, Wigan. Under 'distinguishing marks' he was described as having 'slight coal marks on both arms'. Coal mining was a scheduled, or reserved, occupation during the First World War and would explain his late enlistment. Thomas is listed at No. 4 Chapel Street in the absent voters lists until spring 1919.

He is listed on the Chapel Street Roll of Honour as Thomas Turton, Royal Engineers.

Felix Tyrell (1890–1954)

Family Origins: Father, Altrincham; Mother, Altrincham
War Record: First World War 1914–18
Military Service: Private, 2nd Battalion, Loyal North Lancashire Regiment, Service No. 9840; Corporal, 133rd Battery, Royal Field Artillery, Service No. 67210
Associated with No. 58 Chapel Street

Felix was born in Altrincham on 10 June 1890 and baptised at the church of St Vincent de Paul on 20 July. He was named Felix after his father. His paternal grandparents Simon and Mary were listed under the surname Tell in Chapel Street in 1851, and his mother, Sarah, née Fletcher or Flisk, lived with his elder siblings at No. 58 Chapel Street in 1881. However, no direct evidence has yet come to light that Felix lived in Chapel Street.

When Felix was eight months old the family were residing at No. 4 Paradise Street in Altrincham in 1891. His circumstances changed significantly when his mother died the following year. It appears that his father Felix may have struggled to care for his youngest children after her death as the Manchester Courier reported on a case brought against him by the NSPCC in August 1898. The NSPCC alleged that Mr Tyrrell systematically neglected two of his children, aged eight and six. These children, one of whom would have been Felix Jr, had been found covered with vermin and rambling about the streets at midnight. Felix Snr was found guilty and sentenced to two months hard labour. Felix senior died in 1901 and by the time of the 1901 census his sister Elizabeth, aged twenty-three, had Felix, aged nine, and three more brothers living with her at No. 4 Charter Road, Altrincham.

Felix enlisted with the Loyal North Lancashire Regiment in Conway on 12 July 1909 and gave his occupation as labourer. In 1911 he was stationed with the 2nd Battalion of that regiment in Ghorpuri Banacks, Poona, India. On 31 August 1911 he transferred to the Royal Field Artillery as a driver. He arrived in France on 22 December 1914 and served there from 1914 to 1916 when his unit moved to Salonika, where it remained until 1917. In 1915 the local newspaper printed part of a letter that Felix had written to his aunt, Rose Ann Carroll, in which he mentioned spending a day with his elder brother Peter in France. He describes the town as being 'almost a mass of ruins.' Having at some point been promoted to corporal, he

was discharged from the Army on 11 July 1921, on completion of his terms of engagement. His character on discharge was noted as 'very good'.

The absent voters lists for 1918–20 for his sister Elizabeth's home at No. 7 Goose Green, Altrincham stated that he was serving with the Artillery Reserve Brigade. His middle name was recorded as 'Leo'. In 1921 Felix married Emily Barber and the couple lived at no. 23 Mayor's Road and No. 31 Moss Lane in Altrincham during the 1920s and early 1930s. In October 1922 Felix joined the postal service and worked as a postman in Altrincham. In 1939 Felix and Emily were living at No. 21 Woodheys Drive in Sale, Cheshire. He gave his occupation as 'Mutuality Club Collector'.

In 1940 the local paper reported that Felix was fined for showing a light from his house at 11:15 p.m., contrary to wartime rules. Felix was described by the magistrates as having an exceedingly aggressive and offensive manner. He had alleged that the wardens were 'snoopers, dodging around while other people fought for them'. He alleged that the prosecution was the result of political prejudice on account of his trade union activities.

Felix was still living at Woodheys Drive in Sale when he died on 14 April 1954.

Felix's brothers Peter, James, Simon, John and William are also listed on the Chapel Street Roll of Honour.

He is listed on the Chapel Street Roll of Honour as Felix Tyrell, Royal Field Artillery.

James Tyrell (b. 1882)

Family Origins: Father, Altrincham; Mother, Altrincham
War Record: First World War 1914–18
Military Service: Driver, 50th Brigade Royal Field Artillery; Driver, 17th Battery, 41st Brigade, Royal Field Artillery, Service No. 15455
Associated with No. 58 Chapel Street

James Tyrell, whose birth was registered with the spelling Tyrrell, was born in Altrincham on 19 December 1882 and baptised at the Church of St Vincent de Paul on 31 January 1883. His parents were Felix and Sarah Tyrell, née Fletcher or Flisk. No direct evidence has been found that proves that James lived in Chapel Street but, in 1881, the year before James' birth, his mother was living at No. 58 Chapel Street. By 1891 James, aged eight, was living at No. 4 Paradise Street in Altrincham with his parents, brothers and sisters.

On 27 February 1901 James, described as a carter, enlisted with the Royal Field Artillery (RFA) and by April that year he was listed as a driver at Deepcut Barracks in Frimley, Surrey, with 50th Brigade RFA. His artillery attestation shows that he served in India between 1901 and 1903. James was also in India in 1911 when he was recorded as a driver for the 69th Battery, RFA, based in Jubbulpore, India.

James entered France on 16 August 1914 with the 17th Battery, RFA, which, a few days later, took part in the Battle of Mons, the first major engagement for the British Expeditionary Force. He was awarded the 1914 Star.

On 20 March 1915 James married Bridget Alice Murray at the church where he had been baptised. In the same month of that year a local newspaper ran a story with the subtitle 'A Family Squabble', reporting a case of assault brought by Elizabeth Vaughan (James' sister) against James Tyrell, of the RFA. The case against James was dismissed but Elizabeth and Rose McDermott, accused of assaulting Elizabeth, were bound over to keep the peace for a year. In April 1915 the same newspaper reported that James had been wounded about the head as a result of an explosion of a shell at La Bassée and had been invalided home for a short time.

James continued his Army service until 7 January 1921 when, being medically unfit for duty, he transferred to the 3rd Reserve Brigade. He returned to Altrincham to No. 56 Denmark Street where he had been registered as an absent voter in 1918 and 1919. He appeared on

electoral registers at that address between 1921 and 1926. He was still at this address with his wife Bridget in 1939 and was employed as a grocery warehouse man.

James's brothers Peter, Simon, John, William and Felix are also listed on the Chapel Street Roll of Honour.

He is listed on the Chapel Street Roll of Honour as James Tyrell, Royal Field Artillery.

John Tyrell (b. 1887)

Family Origins: Father, Altrincham; Mother, Altrincham
War Record: First World War 1914–18
Military Service: Private, King's Liverpool Regiment, Service No. 66603; Private, Labour Corps, Service No. 43237
Associated with No. 58 Chapel Street

John was born on 26 April 1887 in Altrincham and baptised on 29 May at the Church of St Vincent de Paul, Altrincham. When his birth was registered, he was listed as John Henry Tyrrell. His parents were Felix Tyrell and Sarah, née Fletcher. In 1891 he was living with them, his brothers and sisters at No. 4 Paradise Street in Altrincham. In 1901 he resided at No. 4 Charter Road, Altrincham, where his elder sister Elizabeth, aged twenty-three, was head of the household. His brothers Simon, aged fourteen, William, aged eleven, and Felix, aged nine, were at the same address. John has not been found on the 1911 census and it has not proved possible to find any evidence that John actually lived in Chapel Street, although several members of his family, including his grandparents, mother and brother Peter, lived in the street at different times and it is very feasible that John lived there at times other than the decennial censuses.

The Chapel Street Roll of Honour associated John with the Cheshire Regiment. An article about the Army service of the five Tyrell brothers in a local newspaper in April 1915 noted that he was in the Bantam Regiment and 'in training at Chester, and expects to be sent out to the Front at any time'. The 15th, 16th and 17th Battalions of the Cheshire Regiment, known as the Bantams, were set up for the enlistment of men less than 5 feet 3 inches tall, although no evidence has been found that he joined any of these battalions. The absent voters lists of 1918 and 1919 recorded Private John Tyrrell, living at No. 21 Dale Square, Altrincham, as a soldier in the Labour Battalion of the Liverpool Regiment with the Service No. 43237. His medal roll shows that he served in the King's Liverpool Regiment with the Service No. 66603 and at some point transferred to the Labour Corps, with the Service No. 43237. It is not clear whether he served abroad.

John had married Ethel Vernon in the Bucklow Registration District at the beginning of 1914. After the war he returned to live with her in Dale Street where the couple were registered as voters at No. 21 in 1925. The 1939 register shows John's wife Ethel living at No. 20 Barlow Road in Broadheath, together with three of their children. John was absent from the register.

John's brothers Peter, James, Simon, William and Felix are also listed on the Chapel Street Roll of Honour.

He is listed on the Chapel Street Roll of Honour as John Tyrell, Cheshire Regiment.

Peter Tyrell (1874–1927)

Family Origins: Father, Altrincham, Mother, Altrincham; Grandparents of Irish descent
War Service: Anglo-Boer War 1899–1902, First World War 1914–18
Military Service: Private, 4th Battalion, Royal Lancaster Regiment, Service No. 5015; Corporal, 4th Battalion, Royal Lancaster Regiment, Service No. 8280.
Private 3rd Cheshire Regiment Service No. 10420, Private, Labour Corps, Service No. 701172
Lived at Nos 33 and 63 Chapel Street

Peter Tyrell was born in Altrincham on 28 September 1874 and baptised at the Church of St Vincent de Paul on 18 October 1874. He was the eldest son of Felix and Sarah, née Fletcher. His grandparents, both from Ireland, were residents of Chapel Street in 1851. In 1881 he was staying with his aunts Kate and Rose Tyrell at No. 54 Blanchard Street, Manchester, while his mother was living at No. 58 Chapel Street. In 1891 Peter, aged sixteen, was living at No. 4 Paradise Street, Altrincham, with his parents and siblings Kate aged fifteen, Elizabeth, aged thirteen, James, aged eight, Mary, aged seven, Simon, aged five, John, aged four, William, aged two, and Felix, aged eight months. Peter was employed as an errand boy.

On 22 April 1899 Peter, of No. 33 Chapel Street, married Elizabeth Watson at the church where he was baptised. By 1901 they had a son Albert, aged two, and were listed as visitors at No. 9 Police Street, Altrincham, and Peter's occupation was given as a bricklayer's labourer. By 1911 his growing family had moved to No. 63 Chapel Street.

In 1902 the *Altrincham Guardian* reported that Peter Tyrell of Chapel Street was prosecuted by the NSPCC at Altrincham Petty Sessions for 'Committing an aggravated assault on an infant aged fifteen months', the daughter of Mary Clarke, as well as 'Doing wilful damage to the window of a house in Chapel Street'. He was found guilty of the assault on the baby and committed for two months with hard labour.

When the First World War broke out Peter was an experienced soldier. He had joined the 4th (Militia) Battalion, Royal Lancaster Regiment, in August 1896, had served with that unit in South Africa and had been awarded the King's South Africa Medal. He had re-enlisted in June 1903 and was promoted to corporal in 1905, transferred to the Army Reserve in 1908 and was discharged on completion of his term of service in June 1911.

In August 1914 Peter was swift to enlist and had arrived at the 3rd Cheshire Regiment's Birkenhead base with other men of the Special Reserve on 24 August. Daily orders of the regiment show that he had some initial problems in accepting Army discipline and received a number of penalties for absenting himself between September and December 1914. He was moved to the Army detention barracks in Perth on 18 December 1914. This strategy seems to have been effective as on 6 March 1915 he landed in France with either the 1st or 2nd Battalion and was included in a list of the wounded from these units in the *Stretford Advertiser* on 28 May 1915. Peter was transferred to the Labour Corps, probably as a result of wounds, and was discharged on 17 December 1919. The absent voters lists from 1918 to 1919 gave his address as No. 32 Police Street, Altrincham.

After his discharge from the Army, Peter was listed in the electoral registers of 1924 and 1925 as living at No. 31 Moss Lane, Hale. He died on 21 October 1927, aged fifty-five, and was buried five days later.

Peter's brothers James, Simon, John, William and Felix are also listed on the Chapel Street Roll of Honour.

He is listed on the Chapel Street Roll of Honour as Peter Tyrell, Cheshire Regiment.

Simon Tyrell (b. 1886)

Family Origins: Father, Altrincham; Mother, Altrincham
War Record: First World War 1914–18
Military Service: Gunner, Royal Field Artillery, Service No. 243924
Lived at No. 63 Chapel Street

Simon Tyrell was born in Altrincham on 18 January 1886 and baptised at the Church of St Vincent de Paul on 21 February. In 1891, aged five, he resided with his parents Felix and Sarah, née Fletcher or Flisk, with his five brothers and three sisters at No. 4 Paradise Street in Altrincham.

By the 1901 census Simon's parents had both died, his father on 1 April that year, aged forty-five, and his mother in 1892, aged thirty-eight. Simon, aged fourteen, and working as an errand boy, was living in the care of his sister Elizabeth with his younger brothers John, William and Felix at No. 4 Charter Road, Altrincham. By 1911 he had moved in with his brother Peter and his wife Elizabeth and their four children at No. 63 Chapel Street. Simon's occupation was recorded as fishmonger.

All that has been located of Simon's war service comes from his Medal Roll Index card and the medal roll, which records that he served as a gunner in the Royal Field Artillery with the Service No. 243924.

On 28 July 1917 Simon married Mary Lee at St Joseph's Church, Leigh, Lancashire. Three children named Tyrrell were born in Leigh to a mother with the maiden name of Lee between 1921–24 and it would be reasonable to assume that the family were living in Leigh in that period. By 1930 Simon and Mary Tyrrell had returned to Altrincham and were registered to vote at No. 17 Moss Lane. He was listed in a 1933 directory at that address where his occupation was given as fishmonger's assistant. In 1939 Simon and his wife were living at No. 11 Borough Road, Altrincham, and he was working as a labourer, RAF Maintenance.

Simon's brothers Peter, James, John, William and Felix are also listed on the Chapel Street Roll of Honour.

He is listed on the Chapel Street Roll of Honour as Simon Tyrell, Royal Field Artillery.

William Tyrell (b. 1889)

Family Origins: Father, Altrincham; Mother, Altrincham
War Record: First World War 1914–18
Military Service: Private, Cheshire Regiment, Service No. 9059
Driver 89th Battery, 11th Brigade, Royal Field Artillery, Service No. 75871
Associated with Chapel Street

William Tyrell was born in Altrincham on 10 March 1889 and baptised at the Church of St Vincent de Paul on 28 April. In 1891, aged two, he resided with his parents Felix and Sarah, née Fletcher or Flisk, with his five brothers and three sisters at No. 4 Paradise Street in Altrincham. In 1901 he was living under the care of his sister Elizabeth with three of his brothers at No. 4 Charter Road, Altrincham. Although his family had long association with the street, information available at the time of writing has not provided evidence of him living in Chapel Street.

He worked as a labourer before attesting at Chester for the Cheshire Regiment on 9 February 1909. His service has not been located on the 1911 census but he transferred to the Royal Field Artillery on 1 Nov 1913. He arrived in France on 7 Nov 1914 and was awarded the 1914 Star. He remained with 11th Brigade RFA in France from 1914 to 1919. An article in the *Altrincham, Bowdon and Hale Guardian* in 1915 entitled 'Five brothers don the King's uniform' stated that he was serving with 89th Battery, RFA His attestation for the RFA noted that he received a shell wound on 10 Oct 1917. He transferred to the reserve on 4 Aug 1919 and was discharged on 8 February 1921 when his character was described as very good. His address on discharge on his RFA attestation record was No. 98 Stamford Park Road, Altrincham.

William married Ellen Brooks in the spring of 1923 in the Bucklow registration district. In 1939 they were living at No. 35 Islington Street, Altrincham, and William was working as a brick setter's labourer. Later that year, aged fifty, he re-enlisted in the 8th Cheshire Regiment on 11 December 1939.

William's brothers Peter, James, Simon, John and Felix are also listed on the Chapel Street Roll of Honour.

He is listed on the Chapel Street Roll of Honour as William Tyrell, Royal Field Artillery.

James Wickley

Family Origins: Not known
War Record: First World War 1914–18
Military Service: Cheshire Regiment
Associated with Chapel Street

James is listed on the Chapel Street Memorial as serving with the Cheshire Regiment but it has not been possible to identify this soldier with any certainty, or to link the name James Wickley with Chapel Street. However, there was a man named Thomas Westley who enlisted, aged nineteen, in November 1906 as a private in the 3rd Battalion, Cheshire Regiment, Service No. 7628. His address was given as No. 30 Chapel Street, Altrincham, and his occupation as bricklayer's labourer. His father was named as Thomas Westley, also of No. 30 Chapel Street, and brother as Albert. It is a possibility that Thomas's name was inaccurately recalled when the memorial was restored in 1988 as there is some similarity with the name Wickley.

Thomas transferred to become a regular soldier in January 1907 and in 1911 was recorded serving as a soldier (telegraphist) with the 2nd Battalion, Cheshire Regiment, in Jubbulpore, India, aged twenty-four. He was recorded on the absent voters lists in 1918 and 1919 at No. 30 Chapel Street as a private in the same battalion, Service No. 8373. His medal records show that he went to France in January 1915 and was promoted to corporal in the Cheshire Regiment. His Medal Roll Index card confirms that he served in the Indian Telegraph Department, Service No. 490.

He is listed on the Chapel Street Roll of Honour as James Wickley, Cheshire Regiment.

Samuel Wood (b. 1878)

Family Origins: Father, Ashton on Mersey; Mother, Cuddington, Cheshire
War Record: India 1898–1903; First World War 1914–18
Military Service: Private, 3rd Volunteer Battalion, Cheshire Regiment; Private, Loyal North Lancashire Regiment, Service No. 5124; Corporal, 1st, 2nd, 9th Battalion and 2nd Garrison Battalion, Cheshire Regiment Service No. 12059
Lived at Nos 7, 9 and 34 Chapel Street

Samuel Jepson Wood was born in the first quarter of 1878 at Onston, near Northwich, Cheshire. He was the son of John Thomas Jepson and Agnes Wood, who were married in December 1880 at Crowton, near Northwich, Cheshire. In 1881 Samuel was living with his grandparents George and Mary Wood in Onston Lane, Northwich. He has not been traced on the 1891 census.

In October 1895 Samuel, aged eighteen and ten months, enlisted in the Loyal North Lancashire Regiment and shortly afterwards was transferred to the Cheshire Regiment. He had previously served with the 3rd Volunteer Battalion, Cheshire Regiment. Samuel's parents, who lived at Church Lane, Ashton on Mersey, were listed as next of kin on his Army service record. Between 1895 and 1896 he was on Home Service and then spent two years in Ireland. On 24 February 1898 he was transferred to India serving with the 1st Battalion, Cheshire Regiment. In March 1899 Samuel was appointed lance-corporal and in 1902 was promoted to corporal. He returned home from India in November 1903 and transferred to the Army Reserve. In October 1911 he was discharged on completion of service.

In 1911 Samuel was a boarder at No. 9 Chapel Street and employed as a general labourer. In September 1914 at the age of thirty-six and living at No. 7 Chapel Street, he re-enlisted as corporal in the 9th Battalion Cheshire Regiment. He was on Home Service until March 1916 during which time he was appointed acting sergeant and posted to 2nd Garrison Battalion, Cheshire Regiment. In December 1915 he was hospitalised with influenza at Palm Grove,

Birkenhead. Between March 1916 and February 1919 Samuel served in Egypt and Salonika. In April 1916 he was deprived of the rank of acting sergeant for misconduct and reverted to corporal. However, in March 1918 he was appointed acting lance sergeant. On 1 March 1920 he was demobilised from the Army and said to be of good character, despite a number of disciplinary problems. These included damaging property in his billet, being improperly dressed on guard duty and a charge of drunkenness in August 1918, which led to him being found guilty by court martial and reduced to the ranks. On 23 August 1918 he returned to duty as a private. According to his service record, his Victory and British War medals were to be forwarded to No. 34 Chapel Street.

After the war Samuel lived at No. 5 Moor Nook, Sale, followed by No. 1 Bank Street in Sale. He married Annie Curran in 1925 and they resided at No. 11 Bank Street.

He is listed on the Chapel Street Roll of Honour as Samuel Wood, Cheshire Regiment.

Frank Wyatt (b. 1891)

Family Origins: Father, Altrincham; Mother, Knutsford
War Record: First World War 1914–18
Military Service: Private; 18th Battalion, Cheshire Regiment, Service No. 10293; Private, 8th Battalion, Devon Regiment, Service No. 34061; Private, Manchester Regiment, Service No. 10293
Lived at No. 56 Back Chapel Lane and No. 46 Chapel Street

Frank was born on 5 October 1891 in Altrincham and baptised on 6 December at the Church of St Vincent de Paul. His parents were Frank Wyatt and Annie, née Glavey, who were residents of No. 56 Back Chapel Street. In 1901 Frank, aged ten, was living at No. 4 Pownall Street with his parents and siblings Joseph, aged twelve, Thomas, aged seven, and Annie, aged three. By 1911 he was living as a boarder at No. 1 Armitage Place in Altrincham and employed as a jobbing gardener.

Frank served with the Cheshire, Manchester and Devon regiments. His address on the 1918 and 1919 absent voters list was given as No. 46 Chapel Street where his widowed father and brother, Thomas, lived.

Frank married Sarah Law at St Joseph's Church in Sale in 1923. A son Bernard was born a year later in 1924. In 1939 he was employed as a plasterer's labourer and lived at No. 85

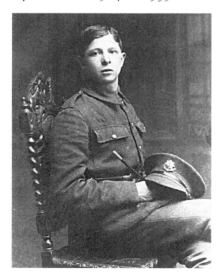

Private Frank Wyatt in uniform. (Image courtesy of Jane Southern)

Jackson Street in Stretford with Sarah and Bernard. Frank's brothers Joseph and Thomas are also listed on the Chapel Street Roll of Honour.

He is listed on the Chapel Street Roll of Honour as Frank Wyatt, Devon Regiment.

Joseph Wyatt (1890–1937)

Family Origins: Father, Altrincham; Mother, Knutsford
War Record: First World War 1914–18
Military Service: Corporal, 10th Battalion, Cheshire Regiment, Service No. 32605
Lived at No. 56 Back Chapel Lane

Joseph was born on 4 May 1890 in Altrincham and baptised on 21 May at the Church of St Vincent de Paul. His parents were Frank and Annie, née Glavey. In 1891, Joseph, aged eleven months, was living at No. 56 Back Chapel Street with his parents and sister Mary, aged three. By 1901 the family had moved to No. 4 Pownall Street with the addition of three more siblings: brothers Frank, aged ten, Thomas, aged seven, and sister Annie, aged three. Joseph was employed as an 'Evening News boy'. In 1912 he married Florence Naylor and they had a son, Joseph, born in 1913. That same year Joseph, aged twenty-three, joined the National Union of Railwaymen and was employed as a cleaner.

Joseph enlisted in the Cheshire Regiment in November 1915. A family member recalls that Joseph served in the 10th Battalion and was badly injured and lost fingers on his left hand from a gunshot wound and also suffered a wound to the head. He was evacuated back to England and was nursed at the military hospital in Edmonton, London. The *Manchester Evening News* on 8th October 1916 reported, 'Corporal Joseph Wyatt, Cheshires, 26, of 2 Russel Street, Altrincham is lying in a military hospital, Edmonton, London suffering from a gunshot wound in the left hand received in action on August 25.' He was discharged from the Army in January 1917 as a result of his wounds and returned to live in Altrincham. Unfortunately his wife Florence died in 1917 and he moved back to Edmonton where, a year later, he married Sarah Agnes Chapman, the Queen Alexandra nurse who had nursed him at the military hospital. Sarah was a widow with three young daughters.

Joseph returned to Altrincham with Sarah, their three daughters, his son Joseph from his marriage to Florence and Sarah's three daughters from her previous marriage. In 1931 the

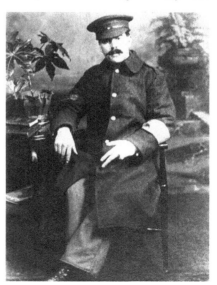

Corporal Joseph Wyatt in uniform, with missing fingers.
(Image courtesy of Jane Southern)

family were living at No. 11 Ash Avenue, Altrincham. Joseph died in 1937, aged forty-seven, and it is understood from a family member that he was buried in an unmarked pauper's grave in Hale cemetery.

Joseph's brothers Frank and Thomas are also listed on the Chapel Street Roll of Honour.

He is listed on the Chapel Street Memorial as Joseph Wyatt, Cheshire Regiment.

Thomas Wyatt (1893–1921)
Family Origins: Father, Altrincham; Mother, Knutsford
War Record: First World War 1914–18
Military Service: Royal Field Artillery
Lived at No. 56 Back Chapel Lane and No. 46 Chapel Street

Thomas was born on 9 December 1893 in Altrincham and baptised on 11 March 1894 at the Church of St Vincent de Paul. His parents were Frank and Annie, née Glavey. In 1901 Thomas, aged seven, was living at No. 4 Pownall Street with his brothers Joseph, aged twelve, Frank, aged ten, and sister Anne, aged three. By 1911 Thomas was living at No. 46 Chapel Street with his widowed father.

There were several men by the name of Thomas Wyatt in the Royal Field Artillery. As Thomas is listed on the 1918 and 1919 electoral registers and not on the absent voters lists, it is likely he left the Army before the end of the war. This could be due to ill health as he died on 6 April 1921, aged twenty-seven, at Altrincham General Hospital. He was still living at No. 46 Chapel Street until this time. His death certificate indicates he died from malignant endocarditis and cardiac failure. It also states he was an Army pensioner. A sad postscript was noted in the Altrincham Urban District Council Fire Brigade Committee dated 18 April 1921, which recorded that 'the amount of three shillings and sixpence owing for the conveyance of T. Wyatt from 46 Chapel Street to the Altrincham Hospital on 2 April 1921 be remitted due to the grounds of poverty'.

Thomas's brothers, Joseph and Frank are also listed on the Chapel Street Memorial.

He is listed on the Chapel Street Roll of Honour as Thomas Wyatt, Royal Field Artillery.

Men Not Included on the Roll of Honour Who Are Known to Have Lived in Chapel Street
Private Thomas Bruce, 14th Battalion, Cheshire Regiment, Service No. 26773
Private Frank Cosgrove, 1st Battalion Royal Irish Regiment, Service No. 5907; Hampshire Regiment, Service No. 6924
Gunner Hugh Clarke, Royal Marine Artillery, Service No. 14867
Private John Clarke, 7th Battalion, Cheshire Regiment, Service No. 66544
Private Thomas Clarke, Royal Marine Light infantry, Service No. 16152
Private John Dale, Cheshire Regiment, Service No. 27456
Private William Donlan, No. 20 Supply Company, 3/5th Kings Liverpool Regiment, Service No. 22957; Pioneer, Royal Engineers, Service No. 21544
Private Richard Golden, 18th Battalion, Lancashire Fusiliers, Service No. 16304
Private Walter Harrison, 1st and 1/6th Battalions, Cheshire Regiment, Service No. 25145
Private William Hulme, Private, 11th Battalion, Cheshire Regiment, Service No. 14566
Private Dennis Hennelley, 1st Battalion, King's Own Royal Lancaster Regiment, Service No. 7704; Royal Engineers, Service No. 169311
Private John McPartland, 11th Battalion Cheshire Regiment, Service No 14432
Private Arthur Mawdsley, Shropshire Light Infantry, Service No. 23959; Labour Corps, Service No. 390604
Private Owen Mongon, 10th Battalion, Cheshire Regiment, Service No. 33088

Private Thomas Murphy, Royal Army Medical Corps, Service No. 118294

Private Patrick Pendergast, 3rd Battalion, Connaught Rangers, Service No. 6013; Labour Corps, Service No. 229806

Private John Seaman, Cheshire Regiment, Service No. 25034

Private Albert Edward Sowter, 3rd Garrison Battalion, Royal Welch Fusiliers; Service No. 6427

Gunner Walter Trueman, Royal Garrison Artillery, Service No. 77088

Private Harry Walton, Cheshire Regiment, Service No. 25609

Private Thomas Westley, 2nd Battalion, Cheshire Regiment, Service No. 8373; Indian Telegraph Department, Service No. 490

In addition, there are eleven men whose surname is known from the list published in the *Altrincham, Bowdon and Hale Guardian* on 8 Sep 1914, entitled 'Street of Soldiers': Barber, Broon, Coombes, Clynes, French, O'Hara, Priest, two men named Robson and two men named Williams.

Four of the above are known to have been killed during the conflict. Owen Mongon was killed in June 1917. He was living in Chapel Street at the time of the 1911 census, and his family were living in the neighbouring New Street at the time of his death. Thomas Clarke was killed in November 1914 in an explosion on HMS *Bulwark*. His brother Charles is on the memorial and lived at the same address in Chapel Street in 1901. William Hulme(s) gave his address as No. 4 Chapel Street when he enlisted as 5701, 3rd Royal Lancaster Regiment, in 1898. His brother James, whose name is on the memorial, is listed, with an address of Chapel Street, Altrincham, as a relative of the deceased soldier in William's Army service record for the First World War. He was killed in action on 30 December 1915 while serving with the 11th Battalion, Cheshire Regiment. Private John McPartland was killed in action on 4 September 1916. He lived at No. 53 Chapel Street in 1901 and his address was given as No. 43 Chapel Street in the Altrincham Guardian Yearbook of 1917. His military record gives an address for his mother at No. 43 Police Street, Altrincham, the home he lived in 1911.

CHAPTER 4

LIFE IN CHAPEL STREET

Life for the people of Chapel Street was governed by poverty and poor living conditions. The street was located in the centre of Altrincham and ran parallel with New Street and Normans Place. The terraced back-to-back houses were the home for countless people but unfortunately the stories of those early residents have been lost to us. One of the earliest references, the census for 1841, lists many of the surnames that are included on the roll of honour including the Bagnalls, the Wyatts and the Garners. We see that the local baker was John Southern with his wife Mary, aged forty, who had a small bakery shop on Chapel Street. The local newspaper dated 15 May 1914 stated,

> probably the business with which the people were most familiar was that carried on at the bakery establishment of Mr John Southern whose foundation goes back to the year 1820. In that year Mr Southern began life as a baker and opened a small shop opposite to the Unicorn Hotel in the Old Market Place. He was a Wesleyan and between him and the famous Mr Nathaniel Pass who chiefly ruled the affairs of the village at the time was a strong bond of friendship. Mr Southern's energy and aptitude for business were soon recognised by Mr Pass and he offered to build him a house and bakery in Chapel Street. Accepting the offer Mr Southern removed to Chapel Street and established a business there which is still conducted on successful lines by his descendants at Hale.

The majority of people who lived in Chapel Street were listed as agricultural labourers and weavers.

Chapel Street did not gain fame in Altrincham's history merely from the misery of war, it was well known for the many colourful characters that lived there over the years. One of its biggest personalities was Bridget De Courcy, a lodging house keeper of Nos 4 7, 9 and 11 Chapel Street. By all accounts she was the matriarch of the street. Born in Galway, Ireland, in 1851, she came to live in Altrincham around 1878. Bridget married six times, was widowed four times and had at least nine children. She was mentioned in the local newspapers on several occasions, including a report on her appearance at Altrincham Petty Sessions for using obscene language, involvement in a brawl and being the victim of a theft by a woman she had taken in on Christmas Day out of charity. Six members of her family enlisted in the First World War including her sons Martin and Patrick. The following extract taken from an article in the local newspaper dated June 1915 gives an indication of how Bridget was a force to be reckoned with. It stated,

> Mrs De Courcy, the proprietress of a lodging house, has a splendid record as a recruiting officer, and partly as a result of her instrumentality about 33 of her lodgers are now serving in H.M. Forces. In fact, she staunchly refuses to house eligible men and is not slow in telling them their place is fighting for their King and country. In a single day at the beginning of the war, thirteen of her lodgers left her to enlist.

Despite her reputation as a rather indomitable figure, Bridget appears to have been a respected member of the street. She died in 1943, aged ninety-three years.

The local newspaper dated 2 June 1960 tracked down some former residents from Chapel Street who reminisced about the happiness of living on the street along with some of its popular characters including an

unforgettable Italian organ grinder called Joe Tradisco who with his wife, used to entertain the people with songs and music. Mrs Tradisco would harness herself to the organ and pull it down the street with Joe at the rear making the music. Another music maker from Italy was Mary Margiotta. She used to pull a small wheelbarrow with a cage in it housing one or two canaries. People would come out of their houses to hear the birds singing. They were joined by a one-legged flute player named Tommy Hughes, who would join with the Margiottas and Tradiscos and make some very pleasant music

Originally the Rose & Shamrock was a cottage-type pub with a single room downstairs. It was rebuilt and enlarged in the 1920s. A former patron recalled that 'beer cost from one and half pence to two pence a pint and was "a much stronger brew"'. A mammoth plate of bread and cheese was a permanent fixture on the bar counter and free of charge for the customer. Although, drunken arguments and fights often ensued after a visit to the Rose & Shamrock, it was regarded 'as the scene of many convivial evenings'.

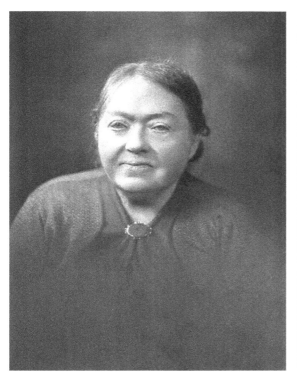 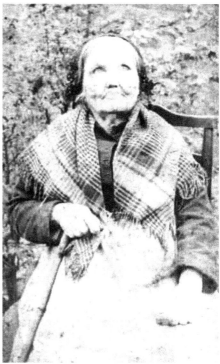

Above left: Mrs Bridget de Courcy. (Image courtesy of Charlie Oxley and Kathleen Winkley)

Above right: Charlotte Norton. Following her death the local council recognised Charlotte's contribution and the contribution of her sons during the war. In return her son Peter sent a letter to the Altrincham Urban District Council in which he said 'as one of the seven sons of the late Mrs Norton, I feel that I must extend to the Members of the Council my profound thanks for the manner in which my Mother was remembered by the leading gentlemen of this Town'. (Image courtesy of Sue Arcangeli and Ruth Hirst)

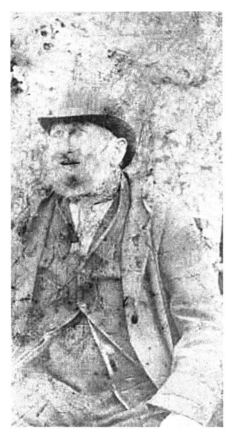

Left: Patrick Norton, who was the husband of Charlotte Norton and the father of the Norton brothers. (Image courtesy of Sue Arcangeli and Ruth Hirst)

Below: Children standing by the Chapel Street Roll of Honour, *c.* 1924. (Image courtesy of Kathleen Winkley)

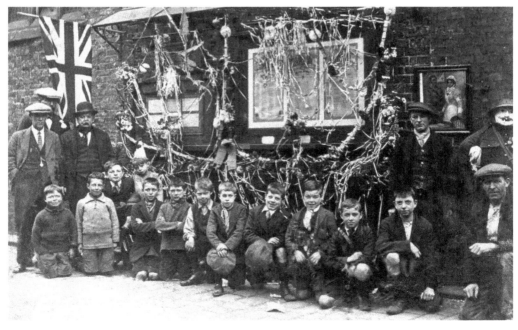

CHRISTMAS TREAT

for the CHILDREN of CHAPEL STREET, and others.

Patron: THE MAYOR OF ALTRINCHAM.
Officers of Committee: J. W. BROOKES, Secy.
Mrs. E. McDERMOTT, Treas.

TO BE HELD IN THE PUBLIC HALL,
GEORGE STREET, ALTRINCHAM.
MONDAY, DECEMBER 29th, 1924.

TEA AT 5 O'CLOCK.

Followed by Entertainment: Fenton Cross of Bolton with his Olde Punch & Judy Show, etc., Humourous Songs, Sketches, Dances, Christmas Tree Revels.
Presentation of articles of clothing given by many generous Friends.
Hearty Cheers for the Committee and all Helpers.

GOD SAVE THE KING.

250 Dec. 22. 1924

Invitation to the 'Christmas Treat' for children on Chapel Street and others, 1924. On 29 December 1924 the local newspaper reported 'The Public Hall, Altrincham was filled with appreciative youngsters on Monday evening on the occasion of the Christmas Treat, given to about 300 children. The little guests came from Chapel Street with its wonderful war reputation, and from various other streets in the locality.' (Image courtesy of Trafford Council)

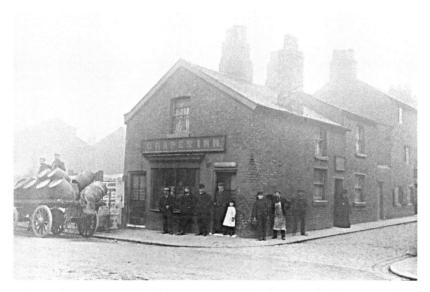

The Grapes Inn on the corner of Chapel Street, *c.* 1900s. The inn occupied the corner of Chapel Street opposite the Methodist chapel and like the chapel, it faced Regent Road but also had a side entrance onto Chapel Street. This photograph of the original inn clearly shows the entrance to Chapel Street with a lady in the doorway. On 14 September 1898 plans were approved for the demolition of this building and the erection of a considerably larger inn. When the plans were considered in 1898 the magistrates requested that the Chapel Street entrance be eliminated from the design. (Image courtesy of Trafford Council)

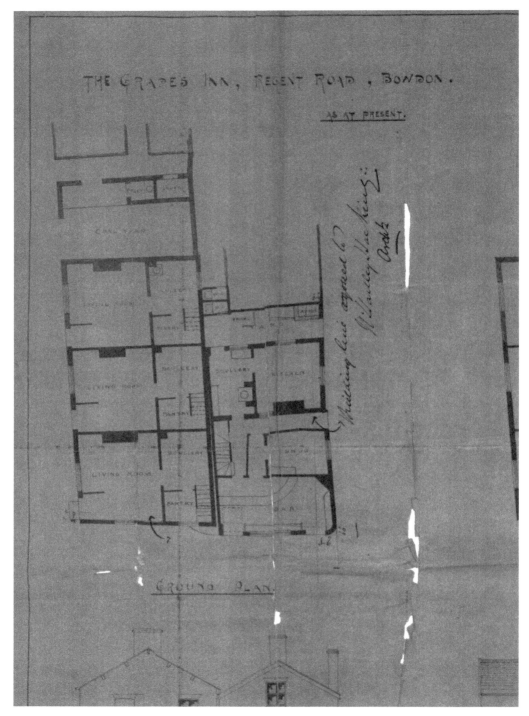

Plan of the Grapes Inn, 21 September 1898. The pub was situated on the corner of Regent Road and Chapel Street and the building still stands today (2018) and is the site of the Chapel Street blue plaque. (Image courtesy of Trafford Council)

The covered passageway between Nos 32 and 34 Chapel Street, 1934. (Image courtesy of Trafford Council)

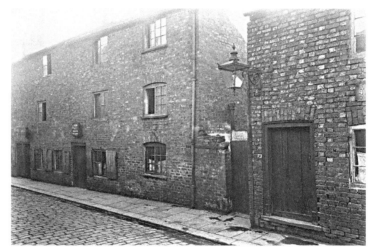

The lodging house at No. 7 Chapel Street, 1934. (Image courtesy of Trafford Council)

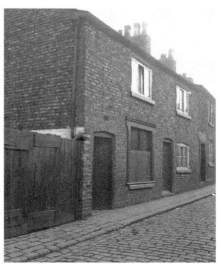

No. 19 Chapel Street, *c.* 1940s, shown here as a shop, formerly Southern's Bakery. In a 1914 article in a local newspaper, the Altrincham and District Trades Association appealed to the readers: 'The Association earnestly ask the public to buy only ordinary weekly supplies; there is no need for unusual purchases as the Food Stocks in the country are, in the opinion of those best qualified to judge, ample for the considerable time.' (Image courtesy of Trafford Council)

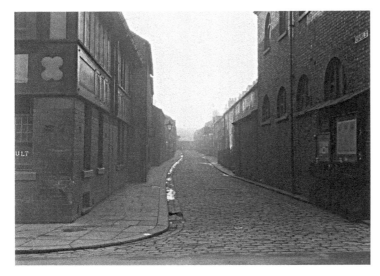

Chapel Street, 1934.
(Image courtesy of Trafford
Council)

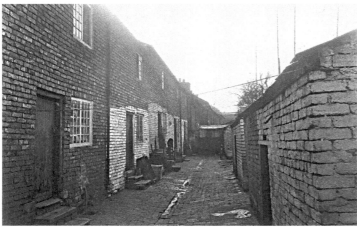

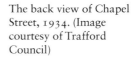

The back view of Chapel
Street, 1934. (Image
courtesy of Trafford
Council)

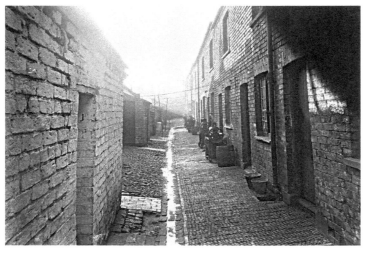

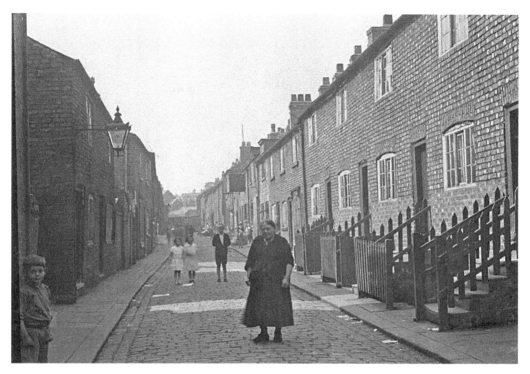

Mrs Bridget de Courcy standing on Chapel Street, *c.* 1930. (Image courtesy of Trafford Council)

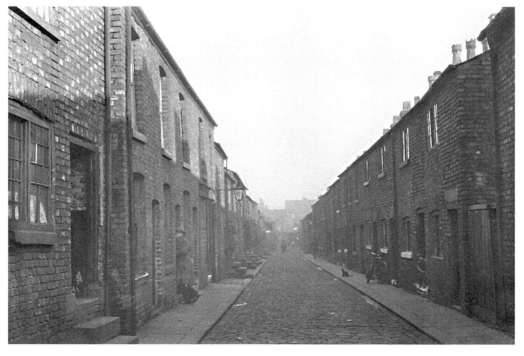

Chapel Street, 1934. (Image courtesy of Trafford Council)

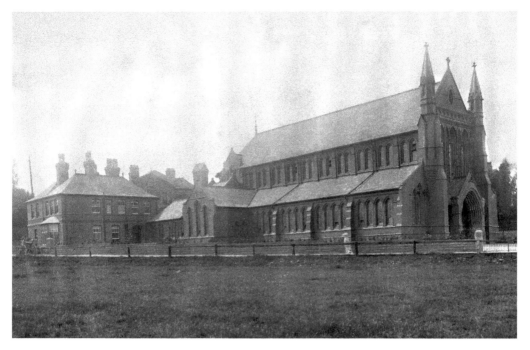

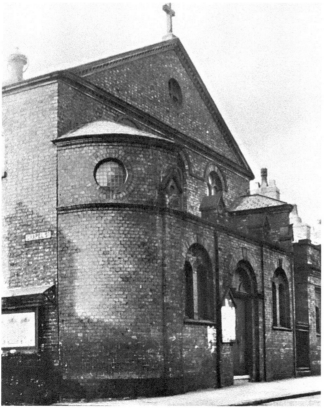

Above: The Church of St Vincent de Paul.

In his book *Bygone Altrincham* Chas Nickson described how the needs of the Catholic population were such that the Church of St Vincent de Paul had to relocate from its original location on New Street to the junction of Bentinck and Groby Road in 1904. (Image courtesy of Trafford Council)

Left: The Wesleyan chapel on the corner of Chapel Street. (Image courtesy of Trafford Council)

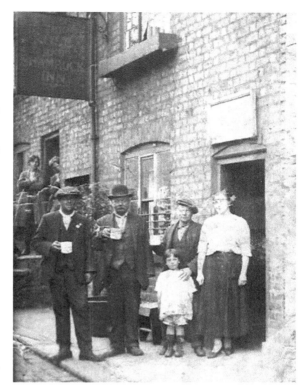

Right: The Rose & Shamrock Inn, which is suitably named to reflect the predominant mix of English and Irish residents within the street. This photograph was taken prior to 1925 and shows a delightful grouping of what appears to be three generations posing outside the original public house situated at No. 18 Chapel Street. The two young women in the background are standing in the doorway to No. 20 Chapel Street. An application to extend the inn to include No. 20 was approved by the council on 3 February 1925 on condition that the work was commenced within three years. The enlarged inn remained in business for some twelve years after the rest of Chapel Street had been demolished. (Image courtesy of Michael Byron)

Below: The Rose & Shamrock Inn, 1950s. (Image courtesy of Trafford Council)

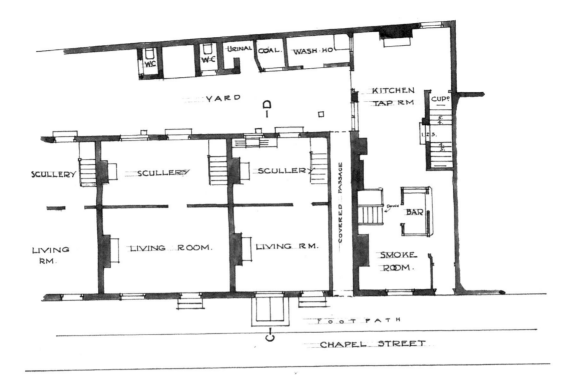

·FIRST·FLOOR·PLAN·

Above and below: Plan of the Rose & Shamrock Inn, 21 June 1920. (Image courtesy of Trafford Council)

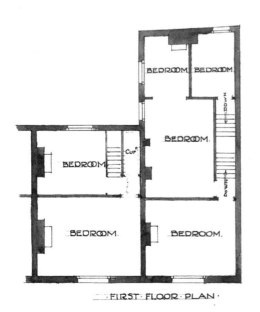

·FIRST·FLOOR·PLAN·

· EXISTING · PREMISES ·
·THE ROSE & SHAMROC
· CHAPEL· STREET ·
·ALTRINCHAM·

SCALE : EIGHT FEET = ONE INCH·

·CHAPEL· STREET·
·ALTRINCHAM·

·SCALE : EIGHT FEET = ONE INCH·

BEER.
CELLAR.

UP.

John Cocker A.R.I.B.A
Architect & Surveyor
7 Market St.
Altrincham

Right: Plan of the Rose &
Shamrock Inn, 21 June 1920.
(Image courtesy of Trafford
Council)

Below: The Rose & Shamrock
Inn. (Image courtesy of
Michael Byron)

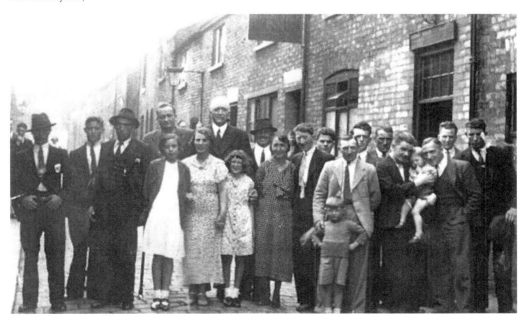

CHAPTER 5

1930s ONWARDS

Over the years the living conditions in the street had progressively worsened to such an extent that by 1936 Altrincham Council declared a clearance order with proposals to demolish. This started to gain momentum around the midpoint of 1938 when it was reported to the Building, Housing and Town Planning Committee that properties numbered 44 to 54 were dilapidated and empty, pending demolition. On 22 August 1938 minutes of the same committee record that it wanted all the owners of property in Chapel Street Clearance Area to approach the council with a view to selling their properties, preferably through one agent.

Matters progressed slowly, no doubt greatly influenced by the outbreak of the Second World War. Properties were purchased and sporadically cleared. As late as 10 June 1941 the surveyor to the council reported that during the year forty-four properties had been demolished, forty-two by the council and two by owners. The council was still negotiating with owners up until 16 November 1943 when it was reported that terms had been agreed for the purchase of Nos 5, 7, 9 and 11 Chapel Street at a cost of £325. The purchase was also to include No. 3.

The decision was taken on 15 February 1945 that Chapel Street should be considered for car parking. Five tenders were sought and received on 16 May 1946, and on 12 September 1946 the borough surveyor reported that the car park was nearing completion. This original car park was not as large as it is today (August 2018). It took up little more than the area on which the houses of Chapel Street once stood and certainly excluded Nos 18 and 20, which together comprised the Rose & Shamrock public house.

The initial car parking scheme was not a success. On 13 March 1947 the company managing the car park claimed to be out of pocket through lack of use, although by 14 March 1950 it was recorded that income had increased.

On 6 March 1956 a map prepared to identify properties to be the subject of an acquisition and clearance plan by the council, under the New Street Compulsory Purchase Order, clearly illustrates the buildings to disappear. The plan included the Rose & Shamrock Inn, which was handed over to the demolition contractor on 11 July 1958.

On 4 July 1961 Altrincham Council resolved to move the Chapel Street Memorial from its then location situated on the corner of Chapel Street to a location in the Garden of Remembrance at the junction of St Margaret's Road and Dovedale Road in Altrincham. The Methodist chapel that formed the beginning of Chapel Street's history in 1788 was demolished soon after the Roll of Honour's relocation.

The intervening years since 1919 had taken their toll on the Chapel Street Roll of Honour and by 1988 it had deteriorated to such an extent that it was in desperate need of restoration. In 1988 Trafford Council approached the North Western Museum and Art Gallery to prepare a report on the condition of the memorial. The report stated

water has run down the front of the work loosening the white ground layer and destroying much of the lettering on the left hand sheet. The left and right hand sheets are both in particularly poor condition. The image at the top of these sheets has been abraded away. There are several cracks, tears and abrasions in the primary supports. The right hand sheet has been extensively retouched along the base edge and the top right hand border with a grey, emulsion type paint. This has cracked and flaked, taking the top surface of the paper fibres with it.

The conservation work was agreed by the council and completed on 8 November 1991. The original conserved documents were remounted and placed in an oak frame and it was recommended by the conservators that the original should only be displayed in an internal environment. A copy of the original was made and placed inside the original refurbished wooden frame for outside display. A decision was made to place the original Roll of Honour in Altrincham Town Hall and for the copy to be returned to the memorial gardens. It is interesting that in the course of researching this book that some of the names listed on the memorial have been difficult to locate in any of the available resources. This may be due to the fact that the memorial had been so badly damaged by the weather conditions that the names had been incorrectly identified when the memorial was undergoing restoration.

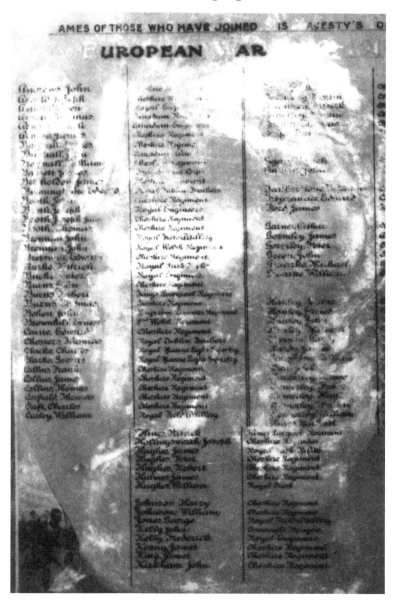

The Chapel Street Roll of Honour before restoration work. (Image courtesy of the Lancashire Record Office)

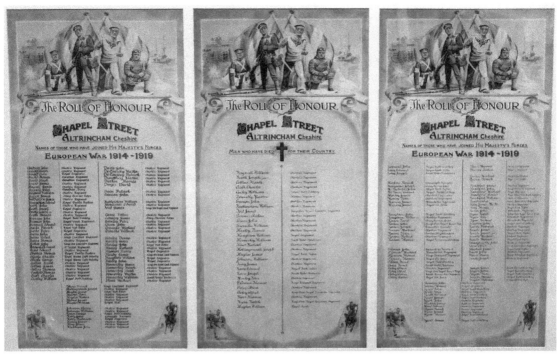

The Chapel Street Roll of Honour after restoration work. (Image courtesy of Trafford Council)

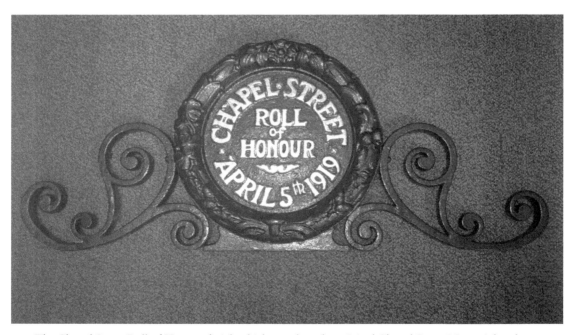

The Chapel Street Roll of Honour finial, which stood on the original Chapel Street Memorial and was restored by George Cogswell. At the time of writing (2018), the finial is displayed with the Chapel Street Roll of Honour in Altrincham Town Hall. (Image courtesy of Trafford Council)

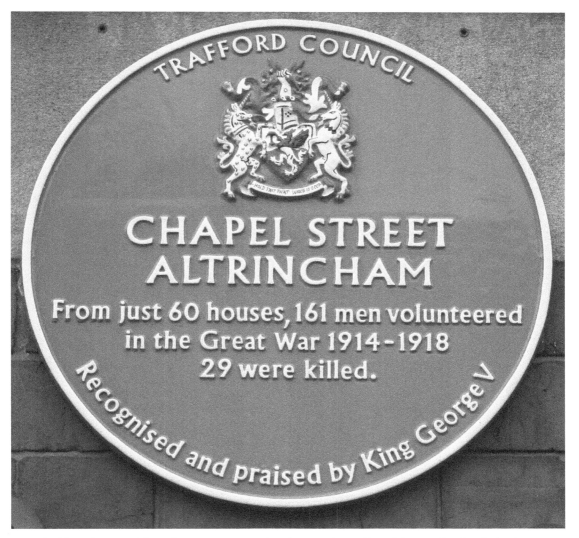

TRAFFORD COUNCIL

CHAPEL STREET
ALTRINCHAM

From just 60 houses, 161 men volunteered
in the Great War 1914-1918
29 were killed.

Recognised and praised by King George V

The blue plaque in Altrincham commemorating the men from Chapel Street who fought in the First World War. (Image courtesy of George Cogswell)

In 2009 a request was made by the late Mr Peter Hennerley to Trafford Council for a blue plaque to honour the 158 men from Chapel Street and to mark the place where Chapel Street had once stood. There had already been a small plaque erected to commemorate the street some years before, on the then Portofino restaurant, which was the original Grapes public house. Mr Hennerley was a descendant of Hugh Hennerley and had been an advocate of Chapel Street for many years ensuring that Chapel Street retained its place in history of Altrincham and would not be forgotten. Trafford Council agreed to the request and the plaque was placed on the same building alongside the earlier plaque.

The finial of the Chapel Street Roll of Honour was restored in 2014 by George Cogswell and to date (August 2018) is located with the original restored Chapel Street Roll of Honour in Altrincham Town Hall. A copy of the original memorial is in the oak frame in the memorial gardens in Altrincham.

CHAPTER 6

STATISTICS

Chapel Street Memorial Soldiers – Statistics

There is a total of 158 names on the memorial. Of these, 129 are known to have survived the war and twenty-nine are known to have died. Fifteen of those who died are known to have been killed in action, six died of wounds or gas and three more died in service. Four more who died and were named on the memorial have not been satisfactorily identified.

The identification of the soldiers on the memorial fall into four categories:
1. One hundred and eighteen soldiers for whom there is evidence that confirms that they lived in Chapel Street and evidence of First World War military service.
2. Fifteen soldiers for whom there is evidence that confirms that they lived in Chapel Street but no evidence of their First World War military service.
3. Two soldiers for whom there is evidence of their First World War military service but no evidence that they lived in Chapel Street, though they did live elsewhere in Altrincham.
4. Twenty-three soldiers who have not been identified.

Origins

Eighty-three of the men listed on the memorial are known to have been born in Altrincham. Fifteen originated from places in Cheshire, including six from Knutsford. Twelve came from places in Lancashire, mainly from Salford and Manchester, including one of Italian stock. Two were born in Yorkshire and one in each of Derbyshire, Shropshire and Staffordshire. There is conflicting information for the birthplace of another two men and no birthplace has been located for another thirty men.

Ninety-one men have been shown to have Irish origins but only eleven of them were born in Ireland. Fifty-eight of these were born in England but had at least one parent born in Ireland; another twenty-two born in England, whose parents were also born in England, had at least one grandparent born in Ireland.

Religion

Knowledge of the religious affiliations of the soldiers is surprisingly good, mainly on account of the availability of well-preserved records of the Church of St Vincent de Paul in Altrincham. Of the 119 whose religion is known, either from information on Army service records or from baptism records, ninety-eight were Catholic, twenty were Church of England and one was Wesleyan. Seventy of those of the Catholic faith were baptised at the Church of St Vincent de Paul in Altrincham.

Age

The information about dates of birth of those on the memorial is reasonably comprehensive, with the information for only thirty men being unknown. The actual dates of birth of ninety-seven of the men are known from baptism records or from the 1939 register. The year of birth is known for another twenty-five and approximate year for six more. A high proportion of the men were uncertain about their year of birth when it came to completing

official information later in their lives. This is notable on some Army forms but recruits may have altered their year of birth to enable them to enlist if they were too old, like John Henry Burns, who lost eight years on his attestation form, or too young to serve, such as Vincent McGuire, who added two years to his age of sixteen years and eight months when he joined the Royal Artillery in 1910. In many cases the day and date was correctly entered on the 1939 register but the year was entered incorrectly, usually by one year. It appears that the year of birth has been taken to be the first birthday.

Because so many of the Chapel Street men had previously served in the armed forces, there is a high number of older men from Chapel Street who enlisted for participation in the First World War. Of those whose date of birth or birth year is known, the oldest resident who enlisted was James Bellholden, who was born in 1865. Seven others were born in the 1860s: Thomas Arnold, Joseph Booth, Thomas O'Connor, Walter Oxley, James Ratchford, Peter Ryan and Ralph Ryan. In addition, there are thirty-three men who had birth dates in the 1870s. The youngest was Arthur Oxley, who was born on 5 Mar 1900, followed by Frank Owen, born on 19 November 1899.

Employment

Information about pre-war employment has been obtained from censuses, directories and Army attestation forms. The predominant occupation was labourer with fifty-six of the men working as labourers, fifteen in the building trade, ten in agriculture or in nurseries and forty-one as general labourers. The Linotype and Machinery Co. factory, which started production in 1897 in Broadheath, employed at least twelve of the men in some capacity, a die setter, a plate moulder, two apprentices, two clerks and six of the general labourers totalled above. Railways employed five men, an engine driver, a sub ganger (supervisor of a section of men who worked on maintaining the tracks) a porter and two cleaners. Six men worked as tradesmen in building. Five men were employed in golf as caddies, groundsmen and one professional golfer, William Hennerley. Two worked as colliers. Some worked in some form of retail or services: three hawkers, a fishmonger, a grocer's assistant, a coal dealer, a rag dealer, one assistant hairdresser, two window cleaners, two in the selling of alcohol, a bootmaker, a marine stove dealer and a paint mixer. Others worked in low-skilled work such as carter, rat catcher, errand boy and newsboy.

The data on occupations after the war is less comprehensive, the main source being the 1939 register. There are data on only sixty-three men. Some died during the war, others had died before the register was compiled and not all have been able to be located on the register. The war did not seem to make a great deal of difference to the men in terms of increased social mobility. Thirty-one of those for whom their post-war occupation is known were still listed as labourers on the 1939 register. A couple of notable exceptions were Joseph Norton, who worked as a Downing Street guardian, and Hugh Arnold, who had emigrated to Canada and was a building inspector after the war. Both men had won gallantry awards during the conflict.

Date of Enlistment

Perhaps because Chapel Street had, according the *Altrincham, Bowdon and Hale Guardian* published on 8 September 1914, a 'close and intimate connection with the British Army', and a well-established history of residents joining the forces, many of the residents were very quick to come forward to enlist when the First World War was declared. The same edition of the paper published a list of seventy-five men, plus six other unnamed men, who lived in lodgings, who had gone from Chapel Street to join the Army. The article pointed out that this was an average of more than one soldier from each household.

The evidence from Army attestation forms, service records, pension records, medal rolls and absent voter lists supports information contained in the article noted above. It is known that at least thirty-six men who were not already serving soldiers and for whom there is a date of enlisting, joined in the period August to December 1914, the first five months of the war, with twenty-eight of these joining in the first two months. There is evidence from Army records that twenty-eight others who were already serving or were recalled from the reserve joined before the start of the war. Another three have a joining date in 1914 but it is not known whether they joined before or after August. Seventeen men entered the theatre of war in France at a very early stage and were awarded the 1914 Star and another four entered in December 1914, just after the qualifying date for the award.

Military Service

Of the 120 whose military service has been identified, ninety-nine served at some point in their military career in the regiment as recorded on the memorial.

Many had had a long association with the armed forces. At least sixty men are known to have served in the armed forces prior to August 1914, either in the militia or in regular forces, James Bell-Holden having first served as early as 1884. There is evidence that twenty of those on the memorial served in the Anglo-Boer War and others had service overseas in places such as India, Malta or Gibraltar. An example of this long association is Thomas O'Connor, who joined the Manchester Regiment in 1887, serving in the Miranzai Expedition to quell a rising in the Northern Frontier of India in May 1891 before he completed this period of his service in 1899. He came back into the Army in February 1915 and joined the Cheshire Regiment but was discharged with a double hernia in April 1916. Undeterred, he enlisted in the RAF in 1918 and was still serving as an aircraft mechanic in 1920.

Fifty-two of the soldiers who have been firmly identified served at some point in the Cheshire Regiment. Fourteen served in the Artillery, most of these in the Royal Field Artillery, seven men served in each of the King's Liverpool Regiment and the Royal Engineers and six served in each of the King's Own Royal Lancaster and the Manchester regiments. Next came the Royal Army Service Corps and the South Wales Borderers with four men each and the Royal Irish Rifles and South Lancashire Regiment with three men in each. The remaining regiments recruited one or two men from Chapel Street.

Men who had been wounded and who were no longer sufficiently physically fit for front-line fighting were transferred to serve in the Labour Corps or the Royal Defence Corps for lighter duties. Eighteen of the Chapel Street men are known to have transferred to the Labour Corps and three to the Royal Defence Corps. Examples of Chapel Street men who ended the war in the Labour Corps include John Brennan, originally serving in the Royal Field Artillery, who received an injury to his hand and James Morley whose right arm was wounded by gunshot and, as a result, he transferred from the Cheshire Regiment. Sometimes an Army battalion was so decimated by the slaughter that it was disbanded and the soldiers transferred to another battalion or another regiment. Soldiers who served in labour battalions were regularly transferred to where they were needed most. The service record for Patrick Burke, a labourer who was recorded on the memorial as serving with the Royal Irish Rifles, in fact served with two labour battalions of the Cheshire Regiment, a labour battalion of the King's Liverpool Regiment and four different companies of the Labour Corps.

Rank

All of the soldiers from Chapel Street included on the memorial were classed in the services as 'Other Ranks', with none gaining a commission as an officer. The majority of men on the memorial served as privates or equivalent such as pioneer or sapper in the Royal Engineers, gunner in the Artillery, or rifleman in the Fusiliers. There were a number who gained

promotion to non-commissioned officers. If the highest rank achieved is considered, nine were promoted to lance-corporal, eleven to corporals or equivalent, such as bombardier in the Artillery, five reached the rank of sergeant and there was one sergeant-major instructor and one company sergeant-major. Not all these soldiers remained in these positions throughout the war as some chose to be demoted of their own volition and others were reduced to the ranks for transgressions of Army discipline.

Discharge

Of the eighty men whose discharge date is known, twenty-eight were discharged before the end of the war, of whom seventeen applied for and received the Silver War Badge. The reasons for early discharge are many and varied but usually because the men had been wounded or traumatised and were no longer useful for front line service, or because they were deemed 'unlikely to make an efficient soldier' because of some physical issue such as poor eyesight, deformed toes or general debility. As would be expected thirty-five were discharged in 1919, with sixteen leaving in March and April and nine in May and June. Twelve were discharged between 1920 and 1923 but these were mainly regular soldiers who were completing their terms of service.

Date of Death

The date of death has been confirmed for sixty-five of the soldiers. The oldest was Joseph Margiotta, who died at the age of eighty-nine, and there are four others who lived into their eighties. The youngest were Edward Lowe and Albert Oxley, who were both killed in the conflict aged nineteen. Ralph Ryan, at forty-six, was the oldest of those who died in the fighting.

Seven men whose death date is established died within ten years of the end of the war. Doubtless there were more. In some cases there is evidence that the death was a direct result of military service. It is not safe to assume that only the deaths in the immediate post-war period were the result of participation. It is known, for instance, that the death of Harry Johnson, who died aged sixty-six in 1942, can be attributed to his service.

ACKNOWLEDGEMENTS

A huge debt of gratitude is owed to all our volunteers past and present who over the last four years have spent countless hours researching Chapel Street and without whom this book would not have been at all possible. A special thank you must go to Richard Nelson, who has given up a large amount of his time researching military records. His knowledge and military expertise has been invaluable in the writing of this book. The whole project has been a team effort from start to finish and everyone has played a valuable part.

On behalf of Trafford Local Studies:

Karen Cliff
Pauline Jones
Sonia Llewellyn
Margaret Sidebottom
Rona Wilson

On behalf of Trafford Council:

Sarah Curran
Nancy Murray

On behalf of Trafford Local Studies volunteers:

Sue Arcangeli
Michael Breaks
Cynthia Hollingworth
Elizabeth Jeffery
Norine Loftus
Richard Nelson
John Rowan
Bernard Shea
Helen Wilson

Thank you all for your time and dedication to the project, without which this book would never have happened.

Special thanks to:

Cheshire Regiment Military Museum
George Cogswell for the loan of his own valuable research work on Chapel Street
Lancashire Record Office
John Rylands Library, University of Manchester, were accessed with kind permission of Dunham Massey, National Trust

Mark Saxon
Will McTaggart
North West Film Archive, Manchester Metropolitan University
Photographs Courtesy of
Sue Arcangeli
Michael Byron
George Cogswell
Gloria Collins
Stuart Anthony Hurlston
Ruth Hirst
Harry Johnson
Will McTaggart
Charlie Oxley
Jane Southern
Kathleen Winkley
Sharon Withers
Trafford Council

BIBLIOGRAPHY

Websites
Genealogical Websites
Ancestry – Birth, Baptism, Marriage and Death Records; Irish Records; Census Records; Service Records Pension Records; War Diaries; Medal Rolls; Medal Roll Index Cards; Silver War Badge Records; Records of Soldiers' Effects, National Probate Calendar; Family Trees. www.ancestry.co.uk

British Newspaper Archive https://www.britishnewspaperarchive.co.uk/

Deceased Online – Burial and cremation records www.deceasedonline.com

Cheshire Archives and Local Studies http://archives.cheshire.gov.uk

Family Search - Vital Records www.familysearch.org

Find a Grave, http://www.findagrave.com

Find My Past - Birth, Baptism, Marriage & Death Records, particularly Baptism and Marriage records of St. Vincent de Paul, Altrincham; Census Records; Electoral Rolls, 1939 Register; Absent Voters' Lists; Service Records; Army Hospital Admissions Records; Soldiers Died in the Great War; National Probate Calendar; Historic Newspaper Collection. www.findmypast.co.uk

Fold 3 - Records of Court Martial proceedings www.fold3.com

Lancashire Record Office http://www.lancashire.gov.uk/libraries-and-archives

Library and Archives Canada - https://www.bac-lac.gc.ca

New Zealand National Archives http://archives.govt.nz/

The National Archives, www.nationalarchives.gov.uk

Trafford Archives and Local History http://www.trafford.gov.uk/residents/leisure-and-lifestyle/libraries/archives-and-local-history.aspx

Trafford Lifetimes https://apps.trafford.gov.uk/TraffordLifetimes/

Military Websites
http://www.1914-1918.net

Commonwealth War Graves, www.cwgc.org

History of the Grenadier Guards, http://lib.militaryarchive.co.uk/library/infantry-histories/library/The-Grenadier-Guards-in-the-Great-War-1914-1918-Vol-2/HTML/index.asp

International Committee of the Red Cross website – prisoners of the First World War ICRC historical archives https://grandeguerre.icrc.org/

Irish Regiments, https://www.royal-irish.com/research

King's Liverpool Service Information Search – First World War database, (http://www.liverpoolmuseums.org.uk/mol/visit/galleries/soldiers/research/kingsreg/index.aspx)

King's Own Royal Lancasters, http://www.kingsownmuseum.com

The Great War Forum, http://1914-1918.invisionzone.com

The Lancashire Fusiliers Website, www.lancs-fusiliers.co.uk

The Long, Long Trail Website, http://www.longlongtrail.co.uk

The Manchester Regiment Group Website, www.themanchesters.org

McMaster University Digital Archive http://digitalarchive.mcmaster.ca for trench maps

Trafford War Dead http://traffordwardead.co.uk

Other Websites

Historical Directories of England & Wales, University of Leicester, Special Collections, http://specialcollections.le.ac.uk/cdm/landingpage/collection/p16445coll4
London Gazette https://www.thegazette.co.uk/
Manchester City Libraries on line reference library for Dictionary of National Biography and *The Times* online http://www.manchester.gov.uk/directory/127/online_reference_library
Trafford Libraries on line Reference Library for Guardian on line
Wikipedia https://en.wikipedia.org/wiki/Main_Page

Trafford Local Studies Resources

The Altrincham, Bowdon and Hale Guardian
The Altrincham, Bowdon & Hale Year Books, 1916–1918
Stretford Division Advertiser
Stretford & Urmston Journal
Slater's Directories for Altrincham

Books

Balshaw, Charles, *Stranger's Guide to Altrincham* (Altrincham: Balshaw, 1885)
Bamford, Frank, *The Making of Altrincham 1850–1991* (Nottingham: Local History Press, 1991)
Bayliss, Don, *Altrincham, a History* (Timperley: Willow Publications, 1992)
Bayliss, Don, *A Town in Crisis: Altrincham in the Mid-Nineteenth Century* (Altrincham, Bayliss, 2006)
Bayliss, Don et al., *Altrincham in 1841* (Altrincham: Altrincham History Society, 1994)
Bayliss, Hilda, *Altrincham: A Pictorial History* (Chichester: Phillimore & Co. Ltd, 1996)
Birchall, Stephen, *Dissent in Altrincham 1850–1991* (Milton Keynes: Author Home UK Ltd, 2010)
Cogswell, George, *Chapel Street Census Returns & Summary 1841–1911* (No publication data available)
Crookenden, Arthur, *The Cheshire Regiment in the Great War 1914–1919* (Chester: W. H. Evans, Sons & Co., approximately 1935)
Ingham, Alfred, *Cheshire: Its Traditions and History* (Edinburgh: Pillans & Wilson, 1920)
Ingham, Alfred, *A History of Altrincham and Bowdon* (Altrincham: Mackie, Brentnall & Co., 1879)
Fitzgibbon, Maureen, *The Bravest Little Street in England* (Manchester: Irish Ancestry Manchester Genealogist, Vol. 50, No. 4, 2014)
Fitzpatrick, Gillian, *Altrincham Past and Present* (Timperley: Willow Publishing, 1990)
Graham, Collin, *The Coalition's War: Altrincham May 1915–December 1916* (Altrincham: Altrincham History Society, 2015)
Godefroy, Antony B., *A Lesson in Success, The Calonne Trench Raid, 17 Jan 1917* (Canadian Military History, Vol. 8 No 2, P 25 – 34, Spring 1999).
Hennerley, Peter *The Bravest Little Street in England, 1919–2009: Chapel Street 90 Years On*
Nickson, Chas. *Bygone Altrincham: Traditions and History (*Altrincham & Warrington Mackie & Co. Ltd 1935; reprinted 1971 Didsbury, Manchester, E J Morten Didsbury, Manchester)
Ponsonby, Frederick, Lieut.-Colonel, The Right Hon. Sir, *The Grenadier Guards in the Great War of 1914-1918, Vol. 2* (Luton : Andrews UK, 2013)
Rawlinson, Robert, *Report to the General Board of Health into the Sewage, Drainage, & Supply of Water, and the Sanitary Conditions of the Inhabitants of Altrincham* (London: W. Clowes & Son for HMSO, 1851)

Renshaw, Michael, *Beaucourt: Battleground Somme (Battleground Europe)* (Barnsley, South Yorkshire: L. Cooper, 2003)

Thorpe, Dr. D.R., *Supermac: The Life of Harold Macmillan* (London: Chatto & Windus, 2010.)

Southern, Pat, *Altrincham: An Illustrated History* (Derby: Breedon Books, 2002)

Stamford, Earl of, *Diary 1919* (Unpublished, Special Collections, John Rylands Library, University of Manchester, 1919)

Westlake, Ray, *Tracing British Battalions on the Somme* (Barnsley: Pen & Sword Military, 1994, 2011 edition)